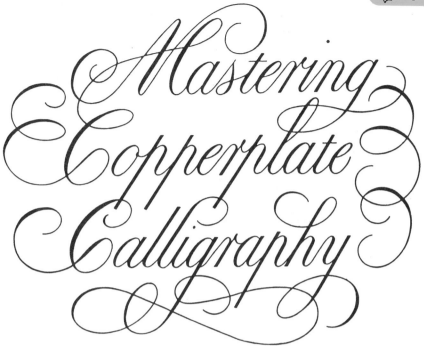

Mastering Copperplate Calligraphy

A Step-by-Step Manual

Eleanor Winters

DOVER PUBLICATIONS, INC.
Mineola, New York

Bibliographical Note

This Dover edition, first published in 2000, is an unabridged reprint of *Mastering Copperplate,* first published by Watson-Guptill, Inc., New York, in 1989. A complete alphabet has been added to pages 4–5 of this edition.

Library of Congress Cataloging-in-Publication Data

Winters, Eleanor.
 [Mastering copperplate]
 Mastering copperplate calligraphy : a step-by-step manual / Eleanor Winters.
 p. cm.
 "This Dover edition is an unabridged reprint of Mastering copperplate, first published by Watson-Guptill, Inc., New York in 1989"—T.p. verso.
 ISBN 0-486-40951-1 (pbk.)
 Writing, Copperplate. I. Title.

Z43 .W76 2000
745.6'197—dc21

00-022702

Manufactured in the United States of America
Dover Publications, Inc., 31 East 2nd Street, Mineola, N.Y. 11501

ACKNOWLEDGMENTS

Without the support and assistance of my family and friends, this book would still be in its barely legible first draft.

I am particularly grateful to John Golden for lending me his computer and patiently teaching me word processing, an astonishing art indeed to those of us who are far more at home with a pen than a computer keyboard.

Special thanks are due to my mother, Dorothy Winters, who spent many, many hours proofreading the manuscript and who, of course, feels that no thanks are due, and to Glorya Hale and Bob Fillie for their editorial and artistic skill and, no less important, their patience.

I would also like to express my gratitude to my father, Joseph Winters, and to Linda Dannhauser, Jim Galloway, Marion Gutmann, Michael Harvey, Roger Jeschke, Cynthia Kaufman, Caroline Leake, Carole Maurer, Barry Morentz, and especially Mary Kay Morrissey, for their good advice, moral support, and encouragement.

Minuscules

l l u u v o f s l

a b b c d e f f f

g g h h i j k k k l l

m n o p p p q

r r s s s t t u v w

x y y z z z

Capitals

A B C D E F G

H I J K L

M N O P Q R

S T U V

W X Y Z

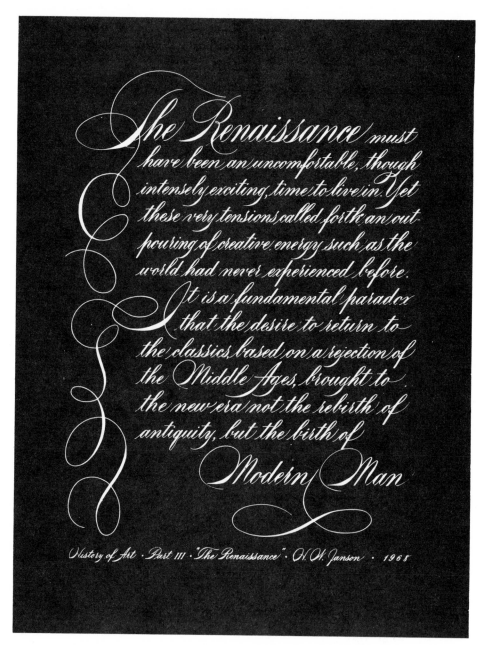

The Renaissance must have been an uncomfortable, though intensely exciting, time to live in. Yet these very tensions called forth an outpouring of creative energy such as the world had never experienced before. It is a fundamental paradox that the desire to return to the classics, based on a rejection of the Middle Ages, brought to the new era not the rebirth of antiquity, but the birth of Modern Man.

History of Art · Part III "The Renaissance" · H. W. Janson · 1968

Georgina Artigas, "The Renaissance," 1982, from The Calligraphers Engagement Calendar 1983, © Taplinger Publishing Co. Written with Principality #1 nib, Japanese stick ink, reduced approximately 30 percent.

Contents

Introduction

The purpose of *Mastering Copperplate* is twofold: to present students with a simple step-by-step manual that serious practitioners can use to teach themselves Copperplate, and to provide a fully illustrated guide for those studying with a teacher or in a calligraphy class.

The first part of this book contains a brief history of the Copperplate hand, or script, and shows examples of the art of the great writing masters of the eighteenth century.

In Part Two, the Copperplate alphabet is examined in great detail to provide a thorough analysis of the anatomical structure of Copperplate letterforms, emphasizing family relationships among the letters. Strokes and letters are shown in their incorrect as well as their correct forms. The ultimate aim of this method is to give you a clear understanding of the shape, structure, weight, and spacing of Copperplate letters so that the alphabet can be written with grace, rhythm, and intelligence. Careful and frequent practice will, of course, make it easier and faster for you to reach your goals.

The chapters in Part Three are intended to introduce you to some practical applications of Copperplate, including envelopes, invitations, place cards, simple quotes, and short texts.

Throughout the book, there are examples of the work of contemporary scribes who have used Copperplate in their commercial and fine-art calligraphy. These examples range from traditional letterforms to modern interpretations of the hand.

Although this book may seem to take a soup-to-nuts approach to Copperplate, the reader would do well to acknowledge its limitations. No calligraphy book can teach everything there is to know about lettering, nor does this one attempt to do so. Emphasis has been placed on the basics of Copperplate, but you must spend a good deal of time studying and practicing the basic strokes and the minuscule letters before attempting anything more complex or ornate.

The material in Part Three should, it is hoped, whet your appetite for further information and instruction in layout and graphic design.

All of the Copperplate examples in Part Two, Learning Copperplate, were written in the same size as you will be working. In Part Three, Using Copperplate, some of the illustrations were reduced to fit the book's format. All reductions are indicated in the text.

For clarity and accuracy, a certain amount of retouching with white paint was necessary. As you will quickly discover, it is virtually impossible to write Copperplate without some irregularities in the strokes: shaky lines, uneven curves, rough edges. These errors have been corrected to a large extent so that you will have accurate models to copy.

But remember that practicing calligraphy is not merely a matter of copying models. Learning a new alphabet (or brushing up on an old one) involves patience, concentration, and what, in academic circles, is called "good study habits." You would do well to read carefully the section "How to Practice" before putting pen to paper.

The rewards, however, are enormous. There is tremendous gratification in making an elegant curve, a beautiful letter, or even a good stroke. The opportunity to master Copperplate is offered to you for your pleasure as a student, an artist, and a calligrapher.

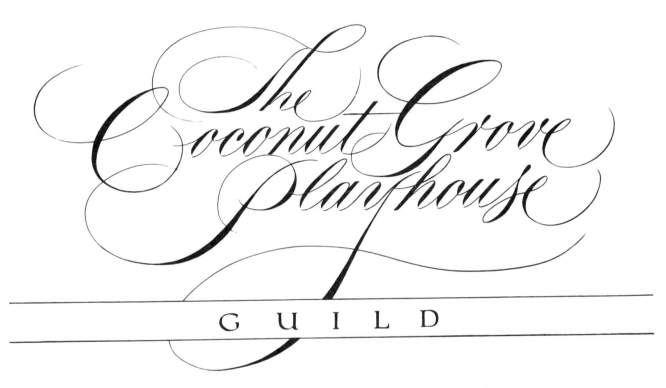

Georgina Artigas, Logo, 1987. Japanese stick ink, written same size.

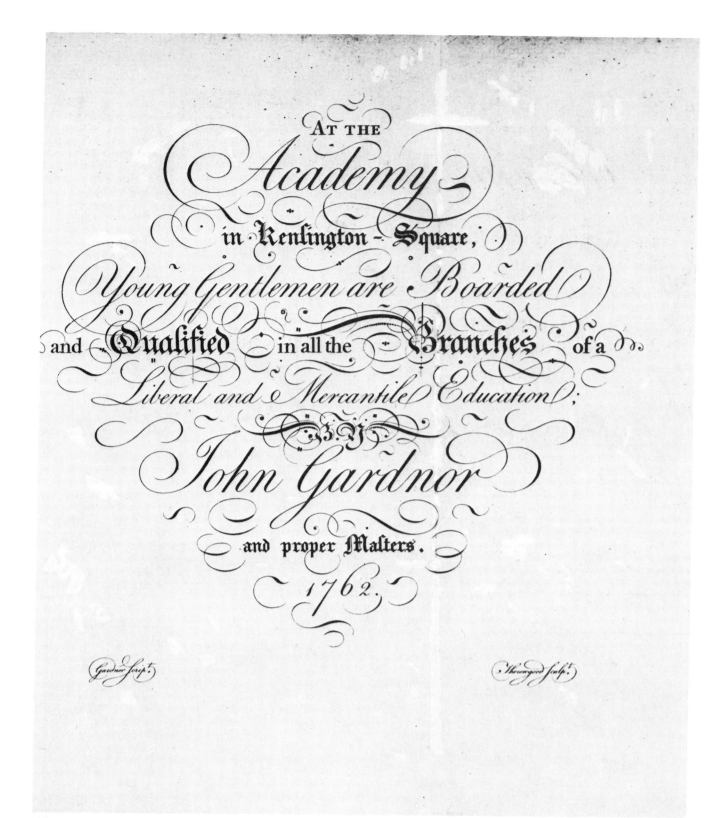

Advertisement for Writing Academy, 1762

Part One

Historical Background

The emergence of Copperplate as a calligraphic style must be examined within the context of European history. Two major factors combined to establish the importance of Copperplate in the eighteenth century: the stature of England as a major economic power and the development of metal-plate engraving.

The defeat of the Spanish Armada in 1588 gave England control of the seas, which led to a tremendous upsurge in trade. By the mid-seventeenth century, England was firmly established commercially. With the rise of a business class came the need for an ever-increasing number of scribes, educated in writing and record keeping. To fill this need, writing schools were established where enterprising young men could learn penmanship and accounting.

Education flourished and the status of the teacher, or master, rose from that of itinerant tutor to master craftsman. By the beginning of the eighteenth century, the age of the English writing masters was in full flower.

Competition among writing masters was rife. To attract pupils, they advertised their skills as penmen, teachers, and scholars in astonishing superlatives. John Ayres, one of the most important and successful writing masters of the late seventeenth century, described himself thus: "All the famous Masters of our Country are all at once outdone in the Vainglorious conceit of a Young and wonderful Author lately Drop'd from the Clouds. For he hath a fix'd unerring Judgment and also outdoes all Mortals in Writing that ever were before" (Introduction to *A Tutor to Penmanship*, 1698).

Ayres is one of more than three hundred writing masters who flourished from the late seventeenth through the eighteenth century and were listed in

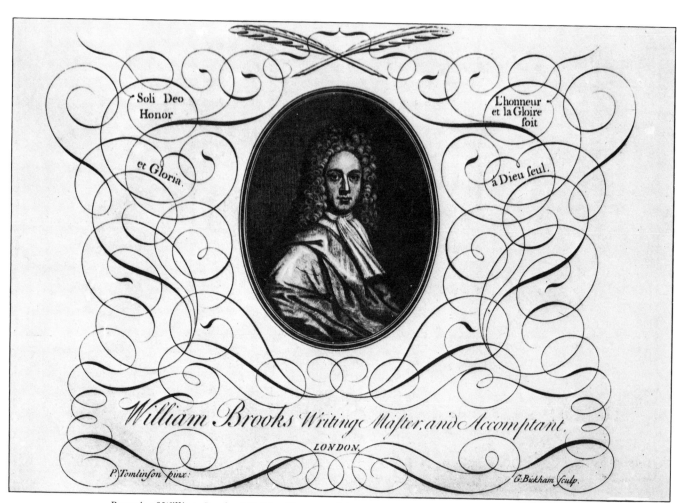

Portrait of William Brooks, "Writing Master and Accountant,"
from A Delightful Recreation for the Industrious, *1717*

George Shelley, Natural Writing in all the hands with variety of ornament, *1709*

Ambrose Heal's massive biographical and bibliographical source, *The English Writing-Masters and Their Copy-Books 1570–1800* (Cambridge University Press, 1931). Many writing masters published copybooks, printed texts from which students could copy the calligraphy of the (self-proclaimed) master scribe. These books served the multiple purpose of attracting students, advertising the penman's prowess, and denigrating the skill of the competition.

The method by which these books were reproduced was copperplate engraving, which consisted of incising fine lines onto a metal printing plate with a sharpened steel tool called a burin. The penman's designs were transferred onto the plate in reverse by the engraver and could be corrected and adjusted before printing. Thus, an imperfect line, curve, or letter could be improved, making the resulting prints far more accurate than the original art. (This is not unlike the improvements contemporary designers can make before an image is photographically reproduced.) It is important to realize that the engraved copperplate pages we see today show the hand of the master engraver as well as that of the scribe, combining to create what seem to be almost impossible curves and flourishes.

Engraving was first used to reproduce illustrations in the early fifteenth century. In 1570, the first writing book—a translation of Jean de Beauchesne's French copybook, *A Booke Containing Divers Sorts of Hands*, published in Paris in 1550—was engraved in England.

The seventeenth and eighteenth centuries saw the publication of dozens of such books, many elaborately decorated with fanciful beasts and birds, knights and angels. In contrast to these fabulously ornamented pages, by such penmen as Edward Cocker (1631–76) and John Seddon (1644–1700), the works of many of the later masters, who openly scoffed at excessive ornamentation, stressed clarity and legibility. In his preface to his copybook *The Art of Writing, In Its Theory and Practice* (published in London in 1712), Charles Snell wrote:

> I have here furnish'd a Youth with such plain, easie, and useful Examples in the several Hands, as may help to fit them for Business: And as I am certain every Judicious Man will readily allow, that this ought to be the chief Aim in Books of this kind, so I am persuaded, that even some of our late Authors, who have made

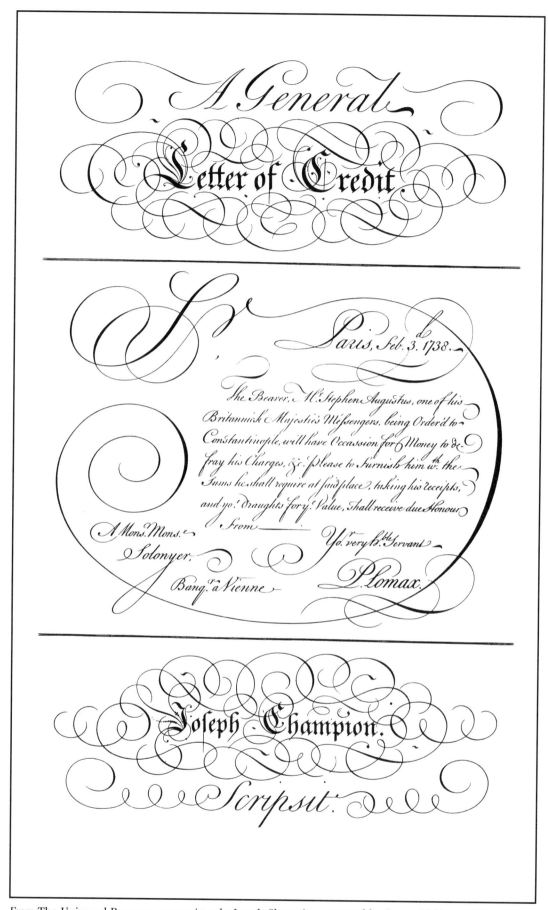

From The Universal Penman, *page written by Joseph Champion, engraved by George Bickham, 1738*

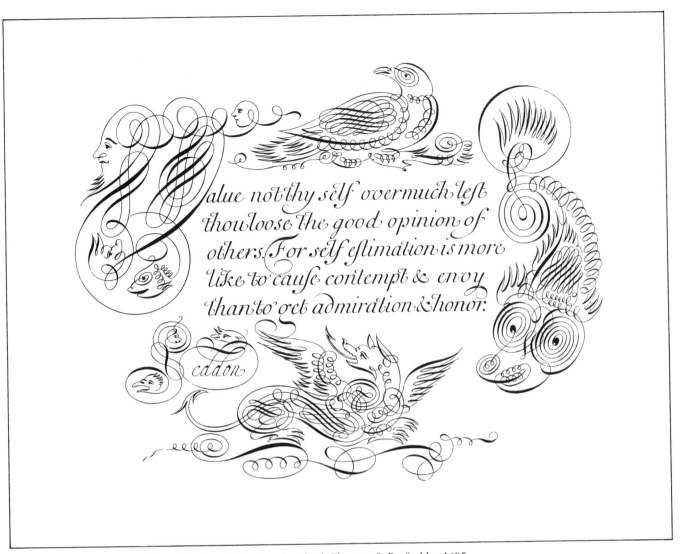

John Seddon, The Pen-Man's Paradise, both Pleasant & Profitable, *1695*

Owls, Apes, Monsters, and Sprig'd Letters, so great a Part of their Copy-Books, could not but know that Merchants and Clerks, are so far from admitting those wild Fancies...as a part of Penmanship, that they despise and scorn them: From whence it seems to me, that these Men have acted contrary, even to the little Knowledge they have, in hopes, by amusing the Ignorant, to gain the Reputation of Masters: and thus we see what mean Shifts the want of Merit drives Men to....

He goes on to exhort his readers to throw such worthless books away.

Although numerous copy books were produced in the seventeenth and eighteenth centuries, few have survived. These books were meant to be used and discarded, even more so toward the end of the eighteenth century when "head-line copy books"—in which blank spaces were left on the page for students to copy the masters' examples, came into vogue.

An invaluable source of Copperplate calligraphy is, however, easily available to modern scribes and students. Between 1733 and 1741, George Bickham, master engraver and calligrapher, called upon twenty-five of the finest pen-men in England to provide him with examples of their artwork, which he printed and distributed to subscribers in fifty-two parts. Two hundred and twelve of these engravings were later bound in book form and entitled *The Universal Penman.*

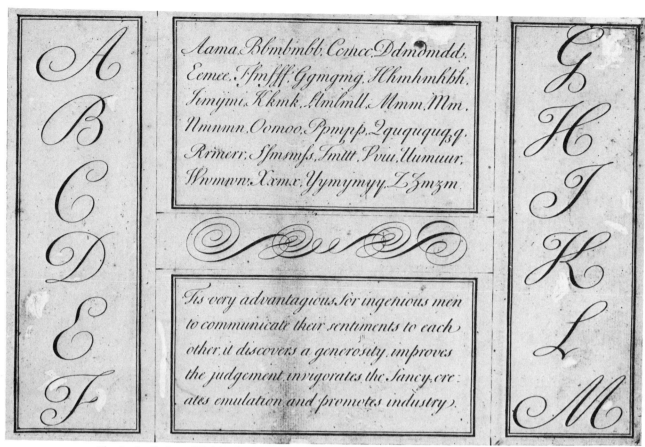

Charles Snell, Art of Writing in its Theory & Practice, *1712*

Many of the pages are in copybook format: lavishly decorated, impeccably penned admonitions to live a life of honesty, prudence, and modesty. Other pages show examples of bookkeeping, business letters, invoices and other documents needed for the scribe/accountant. A paperback facsimile of *The Universal Penman* has been published by Dover Publications and provides the twentieth-century calligrapher with models of the hand at its finest.

The calligraphic style that predominates in *The Universal Penman*, which we call "Copperplate," was known in the eighteenth century as "Roundhand." In many ways, the shapes of the letters were determined by the printing method; the combination of the pointed burin and the hard metal plate led to changes in letterforms from the Italic and secretary hands of the fifteenth and sixteenth centuries. Scribes emulated the strokes made by the engraving tool by using a flexible quill that was sharpened to a point. Curves became rounder, letter slant increased, and the contrast between fine lines and heavy strokes became more pronounced.

In England, Roundhand quickly gained favor as a business hand because of its speed, clarity, and legibility. The accomplished scribe could move his quill rapidly across the page, connecting letters in a readable cursive script.

England's commercial success gained the attention and respect of other nations, and its business script was emulated in continental Europe where it became known as *anglaise* in France, *letra inglesa* in Spain, and *lettera inglese* in Italy.

Copperplate letterforms survived through the nineteenth century, although the perfection of the script of Bickham and his contemporaries was not equalled. The vast increase in popular education in the nineteenth century created a need for teachers to teach handwriting to the masses, a need that

inevitably led to a decline in the status of the writing master and the quality of calligraphy.

The invention of the ballpoint pen in the twentieth century marked the end of an era. When the ballpoint replaced the flexible quill of the eighteenth century and the similarly flexible steel pen of the nineteenth century with an inflexible tool, the contrast between the thick and thin strokes of the Copperplate alphabet, and thus its beauty and elegance, vanished.

To revive Copperplate as a calligraphic script, it is necessary to return to the flexible pen as our tool and to the eighteenth-century masters as our source.

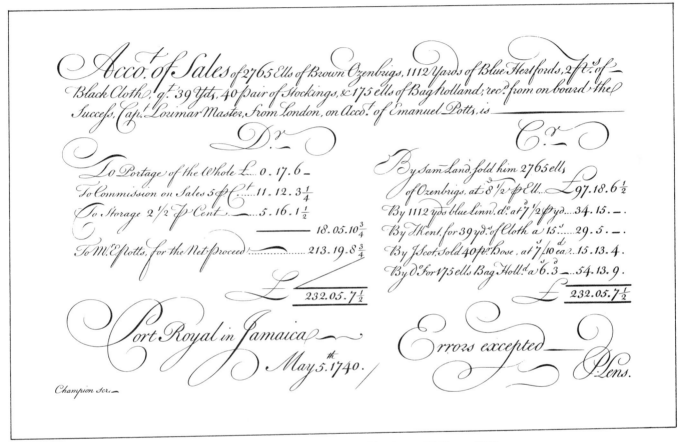

From The Universal Penman, *page written by Joseph Champion, engraved by George Bickham, 1740*

KNOWLEDGE

In Nature's Search we to the Cause advance;
But Knowledge must inform our Ignorance:
To judge of Arts we must their Objects know,
And from the Current to the Spring we go.

Merit should be for ever plac'd
In Knowledge, Judgment, Wit, & Taste;
For these, 'tis own'd, without dispute,
Alone distinguish Man from Brute.

Knowledge, by Time, advances slow and wise,
Turns ev'ry where its deep-discerning Eyes;
Sees What befel, and What may yet befal;
Concludes from Both, & best provides for All.

Nº. VIII. E. Austin scripsit.
 1734.

From The Universal Penman, *page written by E. Austin, engraved by George Bickham, 1734*

Part Two

Learning Copperplate

In the pages that follow, you will find information about the fundamentals of Copperplate — its minuscule and capital letters, from basic strokes through elaborate variations, and its numbers and punctuation. Instructions on letter connections and, most important, on spacing are also included.

The preliminary material in this section should be read carefully. An understanding of calligraphic vocabulary and the tools you will be using are essential for you to be able to learn the letterforms.

CHAPTER 1

Before You Begin

CALLIGRAPHIC TERMS

Many of the words and terms defined below will be used throughout this book. If you have studied Italic or other styles of calligraphy, you probably know most of these terms. If Copperplate is your first calligraphic experience, be sure to familiarize yourself with this vocabulary. Many of these terms are used in typography and lettering as well as in calligraphy.

Ascender. The upper part (above the waist line) of the minuscule *b*, *d*, *f*, *h*, *k*, and *l*.

Ascender line. The guideline that defines the upper limit of all the minuscules that have ascenders with loops.

Base line. Also called the *writing line*, the base line defines the lower limit of all the minuscules and capital letters with the exception of those letters that have descenders.

Counter. The space inside a letter that is either partly or fully enclosed by the thick and thin lines that define the form of the letter.

Descender. The lower part (below the base line) of the minuscule *f*, *g*, *j*, *p*, *q*, and *y*.

Descender line. This line defines the lower limit of all the minuscule letters that have descenders with loops.

Exit stroke. The hairline stroke with which most of the minuscules and many of the capital letters end.

Hairline. The finest line the pen can make. In Copperplate, this line can be very fine.

Hand. A style of calligraphy. Copperplate is sometimes referred to as "Copperplate" and sometimes as "the Copperplate hand," meaning the Copperplate style or script.

Interspace. The space between letters in a word.

Lead-in stroke. A stroke with which a letter begins. Most of the minuscule letters and many of the capital letters begin with hairline lead-in strokes. Also called an *entrance stroke*.

Letter slant or **axis.** The degree to which the letter leans away from the horizontal. For letters to be parallel to each other, they must all have the same slant.

Ligature. A connecting stroke that joins two letters in a word. In Copperplate, ligatures are always hairline strokes. They are sometimes called *joins*.

Majuscule. A capital letter. In this book, the term *capital letter* will generally be used.

Minuscule. A lowercase letter.

Thick. A heavy stroke.

Thin. A fine-line stroke. Also called a *hairline*.

Waist line. The guideline that defines the upper limit of all the minuscules that do not have ascenders.

TOOLS AND MATERIALS

Working with the proper equipment will make your calligraphic experiences infinitely more pleasant than struggling with the wrong tools and materials. If you care for your equipment properly, it will last for a long time and perform well.

The basic tools for Copperplate are few in number and fairly inexpensive. There are, of course, many wonderful treats that calligraphers can buy—handmade papers, stylish studio equipment, paints, and brushes—but a beginner merely has to be equipped with the big three: pen, ink, and paper.

PENS. There are two ways to satisfy the pen needs of a Copperplate calligrapher. One is with a straight penholder and elbow nibs; the other is with an oblique penholder and straight nibs.

The straight penholder is a standard dip penholder with a groove cut in the wider end, into which many different nibs can fit. These penholders are made of wood, plastic, or metal and are available in various weights. Find one that feels comfortable to you. A wooden penholder with cork at the nib end is quite nice to hold.

Elbow nibs are flexible, pointed nibs that have a double bend, making them look a little like lightning bolts. They are constructed this way so that the end of the nib points in the right direction when you are writing.

Elbow nibs generally come in packages of ten nibs with a plastic penholder. The nibs are rarely sold individually. They are made by the Mitchell Pen Company, and the label on their package reads "Mitchell Copper Plate Pens."

An oblique penholder is a straight penholder to which has been affixed a curved strip of metal that holds any standard pen nib. Oblique penholders, made specially for Copperplate, are available at large art supply stores that have calligraphy or pen departments. They can also be purchased through the mail from calligraphy supply companies. Hunt-Speedball makes a good penholder that comes in a package with several flexible nibs.

Straight nibs are simply pointed flexible nibs; they do not have the "elbow" shape. Many such nibs are available, and they vary in flexibility. A more flexible nib gives you a thicker, blacker line. A less flexible nib can withstand more pressure.

Gillott 404 nibs are a good choice for beginners as well as for professionals because they provide fine line quality without being too fragile. The Gillott 303 is a little softer (more flexible), but makes an elegant hairline. Some calligraphers like the very flexible Brause 66EF, which can be used for larger-scale

writing or for Copperplate with heavyweight thick lines. This nib may be a little too idiosyncratic for beginners.

Other nibs worth testing are the Gillott 170 and 1950 (for very small writing), Hunt 101 and 56, and Hiro 40. If you can find them, the William Mitchell Pedigree 0748F and 0730F are both excellent nibs.

You may well come across other brands or models of nibs that you prefer. The criteria to go by are: the nib should make a fine hairline and should be flexible enough to make thick strokes without excessive pressure.

The only way to be sure that a nib will work is to test it. Of course, as a beginner, you probably do not know what it should feel like and what your thick and thin strokes should look like. Therefore, start with a Gillott 404 or a Mitchell elbow nib. When Copperplate begins to be familiar to you, try other nibs to determine your own preferences.

INK. Use a black, nonwaterproof ink. Higgins Eternal generally provides the calligrapher with a dense black and a fine hairline. If it seems a little thin at first, try leaving the bottle open for a day or two to let some of the water evaporate.

Denser inks, like nonwaterproof india ink, tend to be blacker but will not give the fine line quality necessary for beautiful hairlines.

Thinner inks, like fountain-pen inks, make very fine hairlines but tend to be transparent.

Never use a waterproof ink for calligraphy. It clogs the pen, damages the nib, and makes thick, lumpy lines. Read the label before buying ink. If it says "permanent," that means that the ink won't fade. A permanent ink can be either waterproof or nonwaterproof.

Colored inks are usually unsuitable for Copperplate. They are either too thin or flow unevenly. Furthermore, colored inks are usually waterproof. (Writing in color is discussed in Chapter 6.)

Try a variety of black, nonwaterproof inks to see which ones you like best. Test them on the same paper, using the same nib. Compare fine line quality, density of black, and evenness of flow. Be sure to rinse and wipe your nib after testing each ink.

PAPER. A smooth, lightweight bond paper, such as layout bond, is a good choice. There are two advantages to using lightweight bond: it is smooth enough to permit your nib to move easily on the surface and is sufficiently transparent to use over a guide sheet (guidelines ruled in black). Using a guide sheet saves you the trouble of drawing lines on every page. Bienfang 100 percent rag layout bond and Aquabee 666 bond are both very good.

An even better surface is Paper For Pens, a very smooth white paper, which is heavier-weight than layout bond. It is, however, difficult to see through. If you cannot see guidelines through Paper For Pens, it may well be worth drawing pencil lines on each sheet because the pen glides so effortlessly along its surface.

Some brands of ledger bond are also fine for Copperplate, although ledger, like Paper For Pens, is hard to see through.

Though the dimensions of the page you write on are not important, you will probably want to buy a pad of paper. Pads come in such standard sizes as 9″ x 12″, 11″ x 14″, and 14″ x 17″. An 11″ x 14″ pad will give you sufficient space to work on without your having to turn the page constantly, but will not be so big as to be unwieldy. Working on a larger or smaller pad of paper or on individual sheets will certainly not affect your progress in learning Copperplate but may be somewhat less convenient.

Experiment with various papers as you do with inks and nibs. Copy-machine paper is sometimes good for practicing on, although it is smaller than the recommended 11″ x 14″ size.

Working on graph paper is not advisable. Although it often has a nice smooth surface, graph paper has too many lines. The vertical lines will interfere with the Copperplate letter slant.

Most typing paper is too rough. Imitation parchment, sometimes called "calligraphy paper," is usually pretty bad; it often absorbs the ink or causes your nib to skid out of control.

Many fine handmade papers that are suitable for broad-pen calligraphy are too rough for Copperplate. (In Chapter 7, some fine papers that can be used for finished Copperplate pieces are discussed.)

The other tools that you need include some that you have around your house and some which you may have purchased for doing other artwork.

RULER. If you haven't already done so, treat yourself to a metal ruler. For drawing lines, metal rulers are more accurate than those made of wood or plastic. A metal ruler is also essential for cutting paper or trimming artwork. A wooden ruler with a metal edge is not nearly as good.

Rulers, like pads of paper, come in standard sizes. Buy a ruler that is bigger than the larger dimension of the paper you are using. If you intend to use an 11″ x 14″ pad, buy a 15-inch ruler. If you buy a 12-inch ruler, you will regret it.

Some metal rulers have cork on the reverse side. The cork prevents the ruler from sliding on a smooth paper surface, a factor that is important when you are cutting. In addition, the cork holds the ruler just slightly above the surface of the paper so that you can draw lines without ink seeping under the edge of the ruler. The cork therefore improves the quality of the ruler. It also doubles the price. One or two strips of masking tape attached to the reverse side of a plain, uncorked ruler will serve the same purpose as the cork. So if your metal ruler has cork, that's fine; if not, tape it. A metal ruler with neither cork nor tape will skid when you least expect it.

PENCILS. A medium-hard pencil, such as a 3H or 4H is recommended for drawing lines. Lines made by a harder pencil, such as a 5H or 6H, will be hard to see. A softer pencil will make lines that are too thick and may smudge.

FINE-POINT MARKER OR TECHNICAL PEN. If you intend to draw a guide sheet (see page 27), you will need a fine-point black felt-tipped marker or a technical pen, such as a Rapidograph. A marker is considerably cheaper than a technical pen, but check that the point is fine, so you can make good-quality thin black lines that will be visible through another sheet of paper.

A technical pen makes very good lines, but if you don't already own one that you use frequently (daily or nearly daily), it is probably not worth buying one for line drawing. Such pens are expensive and tend to dry out if they are not used often and cared for properly.

PROTRACTOR. To draw slant lines, you will need a protractor. This is available in any stationery store or five-and-ten.

WATER CONTAINER AND CLOTH. A jar or cup filled with water and a soft cloth or paper towels are essential parts of your setup.

It is important to keep your nibs clean and free from dried-ink buildup. Dip your pen in water and wipe off the ink every fifteen minutes or so when you're writing. Dry the pen before dipping it into the ink or your next stroke will be thin and watery.

In addition, always rinse the nib well whenever you stop writing, whether it is for a few minutes or for the day. Take the nib out of the penholder and dry it thoroughly to prevent it from rusting.

If you neglect your nibs by allowing the ink to build up or by letting them rust, they will perform badly and will not last very long.

ERASER. A kneaded eraser is a terrific tool. It cleans up smudges and pencil lines without crumbling or leaving residue on the page and can be stretched and twisted so that it is always clean. (It's also nice to pull and squeeze in moments of stress.) Plastic erasers are also good, but usually leave little shreds on the paper which must be removed.

GUARD SHEET. A guard sheet is simply a piece of paper laid over your writing surface just below the line you are writing on that will help keep the page clean. If you lean directly on the writing surface, the oils in your hand will leave a film on the page that will make the pen skid when you write on the part you leaned on. If your hand is perspiring, the page will also become damp and will absorb the ink. All of this can be easily avoided by using a guard sheet, which should be in position before you make a single stroke. *Never* begin writing without protecting the page from your hand.

SCRATCH SHEET. A piece of paper, preferably the same kind as the paper you are writing on, should be kept near the ink and used for testing the nib after dipping it into the ink and before touching the writing surface. This way, if the pen needs coaxing or if there is too much ink on the nib, you can regulate the ink flow without the risk of destroying the page you're working on.

Although at first it may not seem very important to keep your page clean and free from drips and blots, when you are actually doing a finished piece of work, even something as simple as addressing an envelope, the good habits you established in the beginning will have become automatic. Thus, whether you are practicing the alphabet, writing a poem or prose piece on fine paper, or designing a menu or invitation for reproduction, the guard sheet and scratch sheet will protect the paper from easily avoidable disasters.

HOW TO PRACTICE

At any level of expertise, the time you spend practicing letterforms can only increase your ability as a calligrapher and your speed in mastering a hand. However, the quality of the practice time can greatly affect your rate of progress. There are right ways to practice and wrong ways, and an understanding of a number of factors can help you get the most from your practice time.

LIGHT. Adequate light, properly placed, is important when doing any calligraphy. An artist's desk lamp with a fluorescent bulb and a flexible neck is preferred by many calligraphers because the light's position can be adjusted as necessary.

Keep the lamp in front of you and slightly to the left if you are right-handed, or to the right if you are left-handed. This will prevent your hand from casting a shadow on the writing surface. The light should be shaded to avoid glare.

Some artists prefer incandescent lamps although the heat of the light can be uncomfortable. Artist's lamps are available with both fluorescent and incandescent bulbs in the same unit, so the calligrapher can use either or both. Overhead light is rarely adequate.

EYEGLASSES. If, when practicing, your eyes hurt or tire quickly, you may need better glasses. Your eyeglass prescription for reading, if you have one, may be different from the prescription needed for close work. When you go for an eye checkup, be sure to tell your doctor that you are doing close work.

POSTURE. Sitting up straight with both feet on the floor is good for your back and your writing arm. If you sit on one foot or sprawl over your paper, you will be off balance and in less control of your pen. You will also probably get tired faster.

A further advantage to sitting up straight is that you will be able to see what you are writing and will therefore be able to make reasonable critical judgments on your work. If you are lying on your paper or looking at your writing from an odd perspective, it's difficult to determine the quality of your letters.

SLANTED VERSUS FLAT WRITING SURFACE. Many calligraphers prefer to write on a slanted drawing table or board. This usually makes it easier to maintain good posture. The degree of slant is a matter of choice; it is worthwhile to experiment to find out what is most comfortable for you.

If you don't have an adjustable table or board, you can easily improvise with a piece of wood, Plexiglas, or Masonite and some books or bricks to create a slanted surface.

You may, however, find it preferable to work completely flat. If your arm and back are comfortable and you have good control of the pen, working flat is fine.

TIME. Copperplate involves some physical work; your arm may get tired fairly quickly. Many Copperplate students find that an hour is about as much as they can manage without a break. If your arm starts to hurt, by all means stop. Forty-five minutes to an hour, two or three times per week, should be the minimum practicing time for a beginner. After you know the alphabet, you will probably find yourself practicing a lot more.

In all probability, the more you practice, the better you will get. But the quality of the time is no less important than the quantity. An hour of practice time without interruptions from family, telephone, neighbors, or domestic responsibilities is far more valuable than an hour spent with one eye on a child, the oven, or the clock.

It's not always easy to manage this, especially when you're practicing calligraphy at home, and even more so when other people live there. There are a number of possible solutions. It is preferable to practice when no one will be expected home for at least an hour. If that's not possible, ask your family to leave you completely alone for an hour or so in order for you to work. If you are serious about your calligraphy studies, you should be able to impress it upon those around you that you can't be disturbed. Turn off the telephone. If you have an answering machine, turn it on.

If you can manage it, try to practice at the same times each week. By setting aside practice hours, you will get started more easily and will eventually convince your friends and family that you are not available at those times.

Choose this time carefully. If possible, set aside an hour or two when you are awake, alert, and relaxed. If you are sleepy, tense, or distracted, you will probably accomplish a lot less. There is no time of day that is most productive for everyone. Decide what is best for you and try to devote some of that time to Copperplate.

It is also helpful to practice in the same place each time, so that you can leave your materials set up and ready. You will probably be more likely to pick up your pen and start writing if you don't have to unpack your equipment and clear off your desk whenever you want to practice.

CONCENTRATION. Calligraphy involves the mind as well as the hand. Although learning to control the pen may at first seem to be merely a physical task, a full understanding of Copperplate demands that you pay careful attention to what you are doing.

Beautiful writing is not a learned motor response, but a combination of judgment and planning with rhythm and motion. Think about what you are doing while you are doing it. If you know what you're trying to achieve, whether it is a basic stroke or a complex design, you will have a far better chance of doing it right.

LETTER PROPORTIONS AND THE 55-DEGREE SLANT

Before putting pen to paper, you must understand a certain amount of theoretical information. The proportions of the minuscule letters and the slant of all the Copperplate forms are two essential visual components of this alphabet.

LETTER PROPORTIONS. In Copperplate, as in other calligraphic hands, there is a standard relationship among the three parts of the minuscule letters: the ascender, the x-height, and the descender. Generally speaking, this relationship is expressed as a ratio of 3:2:3, which translates as

$$\text{ascender} = 3 \qquad \text{x-height} = 2 \qquad \text{descender} = 3$$

This means that the ascender and the descender are each one and a half times the x-height. Thus, if you were to make an *a* or a *c* that measured two inches from top to bottom, the upper part (the ascender) of the *h* would be three inches, as would the lower part (the descender) of the *y*. The entire length of the *h* or the *y* would then measure five inches.

Working with two-inch- or five-inch-high minuscules is, of course, impracticable when learning Copperplate. (It is, in fact, quite difficult at any time.) But since 3:2:3 is a ratio, you can substitute any other number for the two and multiply it by one and a half to determine the ascender and descender measurements. If, for example, the x-height is 1 inch, the ascender and descender would each be 1½ inches; if the x-height is ½ inch, the ascender and descender would measure ¾ inch.

For our purposes, the measurements will be ¼ inch for the x-height and one and a half times ¼ inch, or ⅜ inch, for the ascenders and descenders.

The 3:2:3 ratio is based on the letter proportions of many of the eighteenth-century writing masters. You can, at times, alter these proportions to achieve a certain effect in your Copperplate or to fulfill the requirements of a particular layout. (When and how to change the ascender/x-height/descender ratio is discussed in Chapter 5.)

For the purpose of learning Copperplate, however, the 3:2:3 ratio should be maintained. These are the proportions of classically balanced minuscule letters.

LETTER SLANT. All Copperplate forms (minuscules, majuscules, numbers, and punctuation) are written at a letter slant of 55 degrees from the horizontal.

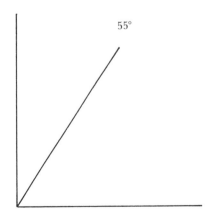

55°

Consequently, most of the strokes and all of the letter axes are parallel to each other.

Copperplate probably slants more than your normal handwriting or any other style of calligraphy that you may do. You will no doubt find it an invaluable aid to draw slant lines on your guide sheet. They will enable your hand to become accustomed to the 55-degree slant and will prevent the letters from either standing up too straight or toppling over.

DRAWING GUIDELINES

Guidelines will provide your writing with a solid foundation for letter proportions as well as letter slant. Therefore, the quality of your guidelines can have a very serious effect on the quality of your writing. As much as accurate lines can help you make good letters, inaccurate lines can work against you.

Since the only way to overcome the obstacle of inaccurate guidelines is to redraw them, drawing your guidelines carefully the first time will save you time and frustration.

PENCIL LINES VERSUS A GUIDE SHEET. Guidelines may be drawn either in pencil directly on the page you will be writing on, or in ink on a guide sheet, which can be placed under the page. This second method is only workable if your writing surface is sufficiently transparent for you to see the guidelines through the page.

The advantage of drawing pencil lines directly on the page is that they are generally easier to see than the lines on a guide sheet and can therefore ensure accuracy. The disadvantage is, of course, that you will have to draw lines on every page. Most people find this very tedious. However, some people (not many, but some) find the drawing of lines to be pleasant and relaxing.

The advantage of making a guide sheet in ink is that you will only need to do it once.

If you choose to work in pencil, use a medium-hard pencil, 3H or 4H, with a well-sharpened point. If the point is dull, it may affect the width of the white space between your lines.

If you are making a guide sheet in ink, use either a good fine-point felt-tip marker or a technical drawing pen with a zero or double zero (0 or 00) nib.

Other materials you need for drawing lines are a metal ruler, an eraser, and a protractor.

In the following pages, line-drawing instructions will be accompanied by explanatory drawings. Please note that the drawings were made on the suggested 11″ x 14″ page size but have been reduced proportionally to fit the format requirements of this book. Use these as examples, not as actual guidelines, since they are far too small to use when learning the letterforms.

DRAWING HORIZONTAL LINES

Step 1. Hold the paper horizontally. Start by drawing margin lines approximately one inch in from all four edges of the paper. The vertical margins on the left and right will provide the structure for drawing the horizontal lines. In addition, leaving white space all around the artwork enhances the beauty of the page, whether it is your first practice sheet or the final version of an elaborate piece of calligraphy.

Step 2. Starting at the horizontal line that defines the top margin and working downward, measure the following spaces along the left-margin line: ⅜ inch, ¼ inch, ⅜ inch, ⅜ inch, ¼ inch, ⅜ inch, making a small pencil mark to indicate each space. Repeat this sequence until you reach the bottom-margin line. Mark the same spaces on your right-margin line.

Step 3. Now connect the dots, positioning the ruler carefully before drawing each line. *If your lines are drawn unevenly, your letters will be uneven.* It is far better to redo your guidelines than to try to compensate for irregular lines by adjusting the size of your letters. It does not work.

Step 4. You now have a series of three-space line groups with an ascender, x-height, and descender space for each writing line. It may be helpful, at this point to mark these spaces with an *a*, an *x*, and a *d*. The base line is always the lower line of the x-height space. This step is optional, but it can make things easier for you.

SLANT LINES. Drawing slant lines is a little trickier, but will save you lots of trouble if you do it properly.

Step 1. Look at the protractor. Find the indicator at the bottom that shows you how to position it. This may be a line, an arrow, or a hole.

Step 2. Now look at the numbers on the right side of the curve and find the point on the scale that shows 55 degrees from the horizontal. It is probably marked 125 degrees, since the numbers generally start at the left.

Step 3. Position the indicator of the protractor at a point on the left margin line, toward the bottom of the page, where the margin line intersects with any horizontal line. Be sure that the 90-degree mark on the protractor lines up with the margin line and that the 0-degree and 180-degree marks line up with the horizontal line.

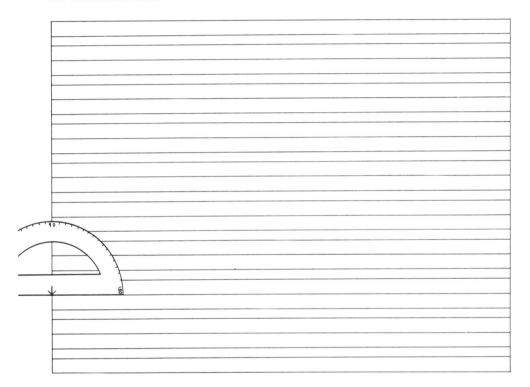

Step 4. Using a pencil, mark the point where the protractor indicator meets your guidelines with a small, but visible, dot. Make a similar mark at the 55-degree point.

Step 5. Remove the protractor from the page. Using a ruler, connect the two dots (the indicator dot and the 55-degree dot) and continue the connecting line up to the top margin line. This is your basic slant line. At this point, it is a good idea to put the protractor back on the page and double-check your measurement. It is much easier to redraw one line than to redo your entire guide sheet because your slant lines measure 45 degrees or 35 degrees instead of 55 degrees. This is a common error.

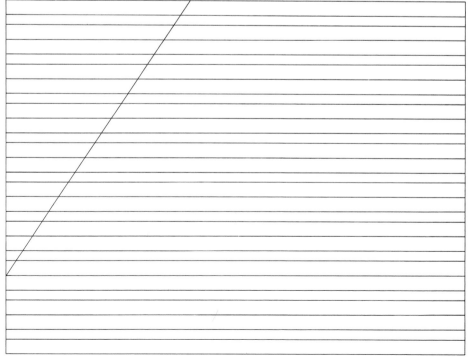

Step 6. You now have a basic 55-degree slant line on the paper. To make other slant lines parallel to this line, measure ½-inch spaces along the top margin, starting where the basic slant line touches the margin line. Then mark off ½-inch spaces along the horizontal line at the lowest end of the basic slant line.

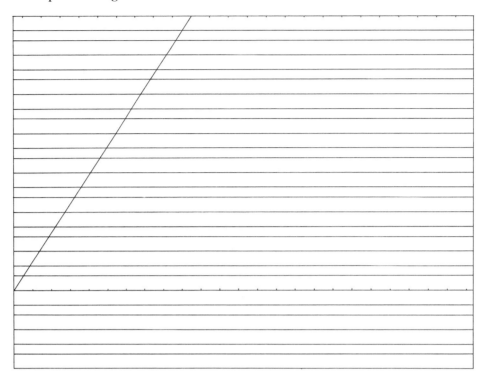

Step 7. Connect these dots, extending the lines to the lower margin. You will have to add a few more dots to fill in the upper-left and lower-right segments of your page. You can make these dots along any horizontal line as long as you start ½-inch from the nearest slant line.

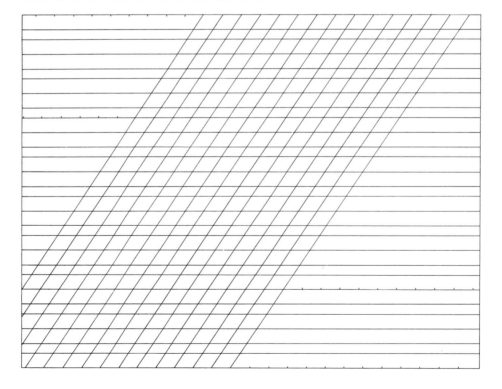

A simpler way to make parallel slant lines is to place the ruler with its left edge touching your basic slant line and draw a line along the right edge of the ruler. Then move the ruler so that the left edge touches this line and draw another line along the right edge. Move the ruler gradually across the page to make equidistant parallel lines, which will be as far apart as the width of the ruler.

The disadvantage of this method is that your slant lines may be too far apart to keep your strokes parallel. This can be remedied by adding a second series of lines halfway between the ones you just drew.

Be careful that you make your slant lines accurately. Don't forget to double-check your basic slant line before drawing any more lines. If your slant is incorrect, your Copperplate letterforms cannot be accurate.

If using a protractor brings back horrible memories of junior high school, ask someone to help you set up your basic 55-degree line. The rest of the process should be quite easy.

Drawing guidelines takes far less time than explaining how to draw guidelines.

INTRODUCTION TO THE FLEXIBLE PEN

Students who have never held a calligraphy pen before and even those who are familiar with the broad-edged pen will probably find holding the flexible pen an entirely new experience. Learning the correct method of touch and movement and developing a good relationship between nib and writing surface will go far toward making your introduction to Copperplate a pleasure.

GETTING STARTED: THE BASIC SETUP. Begin by inserting the nib into the penholder. Whether you are using an elbow nib with a straight penholder or a straight nib with an oblique penholder, insert the nib far enough so that it is secure and won't wobble.

If you are left-handed, you will be able to work with a straight penholder and a straight nib. You will probably not have to use either elbow nibs or an oblique penholder, although if you prefer to do so, you certainly may. In this respect, the left-handed calligrapher has the advantage.

The attachment on the oblique penholder should be on the left side and the nib should point to the upper-right corner of your paper, either in line with the 55-degree slant lines or slightly to the left of them.

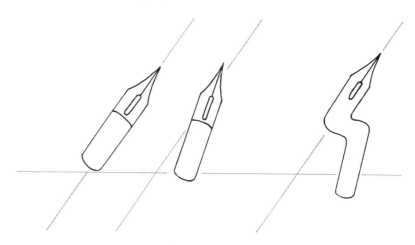

To keep the pen in that position, the paper should be slanted somewhat to the right. Find a paper slant that will enable you to hold the nib comfortably in place, pointing to your slant lines. If your paper is too straight, you will have to bend your wrist to keep the pen pointing in the right direction. If your paper is too slanted, you will not be able to see your writing well enough to make accurate letters.

Keep the paper slightly to your right so that you can see what you are writing and so that your hand and arm are comfortable. If you are using a wide sheet of paper, move your paper to the right at the start of each new line so that you will not have to cross your arm over your body, poke your elbow into your stomach, and twist your wrist. As you move your pen from left to right, you can adjust the paper position to the left so that your arm remains comfortable.

If you are left-handed, you may keep your paper straight or tip it slightly to the left, as you prefer. Try both and see which feels best.

Your basic setup should also include your guard sheet, protecting your writing surface from your hand, and a scratch sheet kept next to or under your ink. If you are right-handed, your ink, water container, cloth, and scratch sheet should be on your right; if you are left-handed, they should be on your left.

You can work either directly in your pad or on individual sheets of paper. If you are using a guide sheet, be sure that it is firmly in place under your writing surface so that it won't shift position as you work. Some people tape or clip the two pages together.

If you are not working in a pad, kept a few sheets of paper under your guide sheet, so that you are not working directly on the hard surface of a desk, table, or drawing board. Having a little padding under your paper makes writing easier.

HOW TO HOLD THE PEN. Hold the pen relaxed in your hand without gripping it too hard or squeezing it too tightly. Keep it fairly low, with the back of the penholder resting between your thumb and index finger, not pointing up toward the ceiling. If your pen is held too steeply, the nib's sharp point will catch in the paper.

Now press the nib gently against the paper. With a small amount of pressure, the end of the nib should open and spread apart.

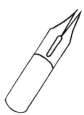

Be sure that both halves of the nib's point are in contact with the paper. Don't push too hard or you may break the nib. If the nib does not spread when you press down, try pressing a little harder. If the nib absolutely refuses to open when you press on it, it may be defective. Try another nib.

PRESSURE AND RELEASE. The entire system of writing with the flexible pen is based on the rule: *Press on the downstrokes. Release on the upstrokes.* Because pressure on the pen causes the nib to open, your downstrokes will be thick. When you release the pressure, the nib closes. Your upstrokes will therefore be thin.

With only a few exceptions, every downstroke in Copperplate will be thick and every upstroke will be thin. The variations between thick and thin lines, which make this alphabet so elegant, result from a rhythmic up-and-down motion of the pen: thin upstrokes followed by thick downstrokes followed by thin upstrokes.

In the next chapter, you will learn a series of basic strokes that will help you understand this principle.

HOW TO DIP THE PEN. The small hole on the top of the nib serves as a reservoir, which holds the ink and helps regulate its flow. You do not need a slip-on reservoir or a penholder with an attached reservoir when using these nibs, as you do with broad-edged nibs.

Dip the pen into the ink far enough for the reservoir to fill with ink. Press the nib gently against the inside of the ink bottle to allow excess ink to drip back into the bottle. Make a little test mark on your scratch sheet to be sure the pen is flowing properly. Be sure your guard sheet is in place over the writing surface so that your hand will not come into direct contact with the paper you will be writing on.

Fill your water container with clean water and have a soft cloth or paper towel handy.

You are now ready to make some strokes on your paper.

CHAPTER 2

The Minuscule Alphabet

Copperplate minuscules are characterized by compressed rounded forms, long ascenders and descenders with narrow loops, and a narrow o-form that is repeated in full or in part in more than half the letters.

Every letter in the Copperplate hand has a slant of 55 degrees. In most cases, one or more strokes will be written on the 55-degree axis. In some instances, the axis will bisect the letter, indicating its direction, although no stroke will be made directly along a slant line. Always be aware of the letter slant and pay careful attention to the 55-degree guidelines.

After you learn the following basic strokes, you will find that the alphabet can be easily assembled. All the letters are formed by combining two or three of these strokes in a logical sequence.

Spend time practicing the basic strokes before you start making letters. A good understanding of these strokes will make the lowercase alphabet surprisingly easy to learn.

When you practice, be sure to work very slowly, concentrating on the direction your nib is pointing in and on the 55-degree slant of your strokes. Practice each stroke until you're reasonably satisfied with the results before starting on the next one.

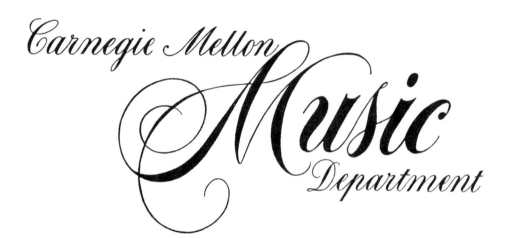

Myrna Rosen, Program Heading, Carnegie Mellon University Music Department, 1985. Written and drawn letters, Gillott 303 nib, Higgins Eternal ink.

The Basic Strokes

This is called the full-pressure stroke because the stroke is thick and equally weighted from top to bottom. Be sure the pressure on your nib is equal for the full length of the stroke.

Place the point of your nib at the top of the ascender space, directly on one of the slant lines (for the first few practice strokes, this technique will help you maintain the 55-degree slant). Press the nib so that it opens about half as wide as possible. Pause briefly.

Then slowly move the nib down along the slant line without increasing or decreasing the pressure, until you reach the base line. Be sure that both halves of the nib's point remain on the paper from the top of the stroke to the bottom. Pause. Remove the nib from the page.

The brief pauses at the beginning and end of the line will give your stroke a precise, squared-off top and bottom.

INCORRECT STROKES. Figure 1 is too thick. It was made with too much pressure on the nib. Figure 2 is too thin. More pressure is needed.

Figure 3 is too straight. It is essential that you watch the 55-degree slant lines.

If you start writing without first allowing the nib to open, the top of the stroke will be pointy (Figure 4). Similarly, if you release the pressure before you get to the base line, the bottom of the stroke will be pointy (Figure 5). Be sure to maintain equal pressure all the way down. Pausing to allow the nib to open at the top and close at the base line will help you make an even stroke.

If you press on the left corner of the nib but not on the right, the right edge of the stroke will be fuzzy (Figure 6). If you press on the right corner of the nib but not on the left, the left edge of the stroke will be fuzzy (Figure 7). Be sure both corners of the nib are in contact with the paper at all times.

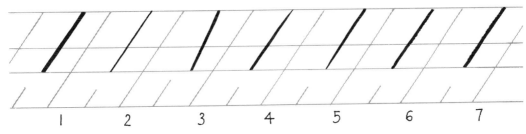

HOW TO PRACTICE. Try making a series of these strokes, about ½ inch apart. See if you can get them all to look alike.

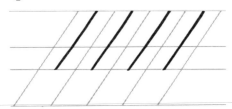

The pressure-and-release stroke starts exactly the same way as the full-pressure stroke. Just before you reach the base line, reduce the pressure on your nib so that the nib closes gradually as you reach the base line. Move the pen in a fairly narrow curve, coming up from the base line in a thin upstroke ending at the waist line. The upstroke should be parallel to the downstroke.

The distance between the downstroke and the upstroke should be approximately one-quarter the height of the stroke. Rather than measuring your stroke widths, learn to recognize a width that is harmonious with the height of the stroke. These strokes should be narrow, but they should never be cramped or pointy.

The same stroke can be made starting at the waist line. The width of the counter must be the same as it is in the long version of the stroke.

Notice that the downstroke does not start to curve until nearly the base line.

INCORRECT STROKES. The curve at the bottom of Figure 1 was started too far above the base line. The stroke is far too wide.

If the distance between the upstroke and the downstroke is too small, your counter will be too narrow, as in Figure 2. The curve at the base line should be graceful and rounded.

In Figure 3, the upstroke curves inward toward the downstroke. Be sure the upstroke is parallel to the downstroke.

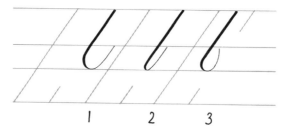

1 2 3

HOW TO PRACTICE. Try writing at least two or three lines of pressure-and-release strokes, practicing both the long and the short forms. Concentrate on placing equal weight on all the downstrokes and on keeping an equal distance between all the downstrokes and upstrokes. Be sure that the tops of the downstrokes are squared off and their edges are smooth.

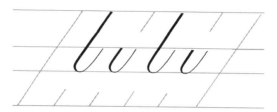

3. PRESSURE-AND-RELEASE STROKE (FIRST VARIATION)

This is a variation on the pressure-and-release stroke. In this case, use only the x-height space.

Starting at the base line, make an upstroke along the 55-degree axis. The stroke curves around to the right just before the waist line, touches the waist line, and descends to the base line. Your nib will remain closed until after you complete the curve at the waist line, and it will open gradually during the downstroke. Since the second part of this stroke is a downstroke, it should have the same amount of weight as the first two basic strokes.

When you reach the base line, pause before removing the pen from the paper so that the stroke ends with a squared-off edge.

The distance between the upstroke and the downstroke should be the same as it is in the other pressure-and-release strokes, and the curve at the top of this stroke should be the same as the curve at the bottom of the other pressure-and-release strokes.

INCORRECT STROKES. Be careful that you do not make the up and downstrokes too close together (Figure 1) or too far apart (Figure 2) and that you make the up and downstrokes parallel. If your stroke looks like Figure 3, pay closer attention to the 55-degree slant lines.

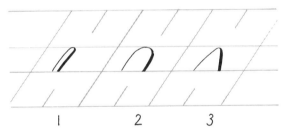

HOW TO PRACTICE. Write out two or three lines of this stroke, concentrating on consistency of weight, width, and curve. Then try alternating the three basic strokes that you have learned. All your strokes should have equally weighted downstrokes, parallel lines, and, where applicable, consistent curves and counter widths.

This is a combination of the previous two basic strokes. Although it is easily understood, this stroke has certain pitfalls.

Starting at the base line, make an upstroke, curving around to the right at the waist line. As you start the downstroke, press on your nib so that it opens, and continue toward the base line. (So far this is exactly the same as the previous basic stroke.)

Just before the base line, release the pressure on your nib and curve around and up along the 55-degree axis, ending in a fine-line upstroke, as you did in the second basic stroke.

The result should be three parallel lines connected by two equal curves with the same amount of space inside both counters.

This is difficult because you have to change direction twice, each time changing the pressure on your nib. By writing slowly and concentrating on the slant lines, you should be able to avoid the errors shown below.

INCORRECT STROKES. The strokes in Figure 1 have uneven counters. The width of the counters should be equal to each other and to the counters of the other basic strokes.

The strokes in Figure 2 have unparallel lines. All three lines should be along the 55-degree axis.

In Figure 3, the counters are too square. Always try to make beautifully rounded curves.

The downstroke in Figure 4 was made with insufficient pressure.

HOW TO PRACTICE. Practice this stroke, alternating with the previous three strokes and concentrating on consistency of weight, width, and curves.

Although the three pressure-and-release strokes (Basic Strokes 2, 3, and 4) all begin and end at the ruled lines on your guide sheets (the ascender line, waist line, and base line), letterforms that begin and/or end with a hairline often start a little below the center of the x-height space and end a little above the center.

When you start making letters, these three basic strokes will look like this:

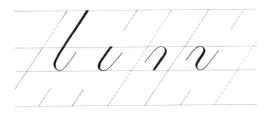

When practicing basic strokes, however, it is easier to use the base line and waist line as the starting and stopping points. Also, when the last letter in a word ends with a hairline, this stroke may be extended all the way to the waist line.

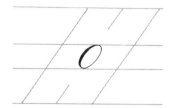

This stroke is the key to the entire alphabet. It is a narrow, rounded form with curves on the top and bottom that match the curves on the previous basic strokes.

The o-form is made in a single counterclockwise motion, beginning approximately one-quarter of the way below the waist line.

Start with a short upstroke (no pressure), curving immediately to the left. The curve is the same as in the previous two strokes, but it is counterclockwise rather than clockwise. After completing the curve, press on your nib as you begin the downstroke, which curves outward slightly and then back inward toward the base line.

Release the pressure as you approach the base line, curving slightly to the right and up. Complete the stroke with a fine-line upstroke that curves back in to meet the beginning of the stroke and to close the form.

Because you are moving in a counterclockwise direction, the thickest part of the o-form (the downstroke) will be on the left.

INCORRECT STROKES. Figure 1 is too wide. Figure 2 is too narrow, as is Figure 3, which is also pointy.

If your pressure on the downstroke is too light at the top and too heavy at the bottom, as in Figure 4, the weight of the thick stroke will be distributed too low. This distribution of weight changes the letter's axis, making the letter too upright. Be sure to be aware of when to press and release on the left side of this stroke.

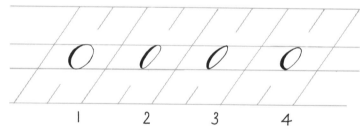

HOW TO PRACTICE. Try to make a series of o-forms with equal widths. They should look the same upside down as they do right side up. Turn your paper upside down to see if you are making the same curve on the top as you are at the bottom of the stroke.

Try starting your o-forms slightly to the right of each of the slant lines so that you can see if the 55-degree axis bisects the stroke accurately. That way it will be easier to see if you are wrong.

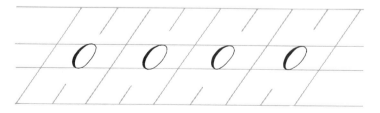

6. THE LEAD-IN STROKE

This is a hairline, the finest line your pen makes. It is used as an entrance stroke to start many of the letters and as a connecting stroke to make words.

This should be fairly easy. The lead-in stroke is a slightly curved upstroke that starts at the base line and curves upward toward the waist line. In some letters it extends all the way to the waist line; in others it ends two-thirds of the way up toward the waist line.

Notice the direction of this stroke compared with the slant lines. It is more slanted than 55 degrees.

INCORRECT STROKES. Figure 1 is too steep. Figure 2 is not curved enough.

Figure 3 curves back to the left, which will cause problems when you connect this stroke to other strokes, especially ascenders.

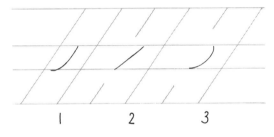

1 2 3

This stroke will be the standard shape and width for some of the letters that extend to the descender line.

The descender stroke starts at the waist line with the same press-and-pause motion as the first two basic strokes. Move the pen downward along one of the slant lines or parallel to it, pressing evenly until you are almost at the descender line. Gradually release the pressure and make a narrow curve along the descender line curving outward slightly and then inward as you approach the base line.

Cross the downstroke slightly below the base line and finish the stroke with an upstroke that ends about halfway into the x-height space. This will create a loop in the descender space that is flat on the right and curved on the left. The width of this loop is far narrower than the curves of the pressure-and-release strokes. The widest point on the loop is at the center, but the stroke should never have a wide bulge.

Notice that the thin upstroke enters the thick downstroke just slightly below the base line and exits at the base line. There should be a small gap between the base line and the loop.

INCORRECT STROKES. In Figure 1, the descender stroke is too wide. Figure 2 is too narrow.

The width of the counter in Figure 3 is uneven. The widest part of the curve should be in the center, not at the bottom, of the descender space.

In Figure 4, the upstroke crosses the downstroke too low; the gap is consequently too big. Figure 5 shows the opposite situation: the upstroke crosses the downstroke too high, and the gap is too small. This will create a problem when writing a "g" and a "y".

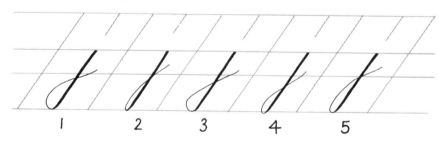

HOW TO PRACTICE. Write two or three lines of descender strokes, concentrating on making loops of consistent width and length with the widest point at the center.

8. THE ASCENDER LOOP

The ascender loop is similar to the descender stroke in its width and distribution of weight, but the method is quite different.

Start the ascender stroke at the base line with the curved hairline stroke (Basic Stroke 6) extending to the waist line. At the waist line, pause briefly and then curve the stroke out to the right as you continue upward toward the ascender line. Curve back to the left at the ascender line in an arc similar in width to the bottom of the descender stroke. As you complete this curve, start pressing on the nib and make a downstroke that matches the full-pressure stroke in all respects except for the very top.

Although the lead-in stroke and the loop are not part of the same line, they should appear to be if the stroke is made carefully.

Note that the widest point of the loop is in the center. The ascender loop is approximately the same width and shape as the descender loop.

INCORRECT STROKES. If you fail to break the stroke between the lead-in stroke and the loop, the result may look like Figure 1. The loop is both too narrow and too long. The extra outward motion of the pen when you break the stroke at the waist line guarantees a loop of the proper width and length.

In Figure 2, the loop is too wide.

In Figure 3, the lead-in stroke is too curved. The end of the hairline is sticking out on the left side of the ascender stroke.

The lead-in stroke in Figure 4 is too steep, resulting in a broken connection between the left and right sides of the ascender stroke.

| 1 | 2 | 3 | 4 |

HOW TO PRACTICE. Practice this stroke until all your loops look the same. Then alternate ascender and descender strokes.

When you can make all these strokes with an understanding of their shared weights, widths, and curves and are following your slant lines with care, you are ready to start on the Copperplate minuscules.

The Letterforms

Now that you are familiar with the basic strokes, you are ready to put these strokes together to form your first group of minuscules. Before you begin, however, it is important that you read and reread this basic rule:

All the minuscule letters are made of individual strokes. A pause and often a full stop are required between strokes in almost every letter.

This will guarantee that, where applicable, the thick strokes of your letters will have squared-off tops and bottoms. All these pauses and full stops will be indicated in the following pages.

CHECKING LETTERS FOR ERRORS. In this section, as in the previous one, some of the most frequently encountered errors will be shown. Where these have already been described (for example, the errors in the basic strokes), they will usually not be repeated. In addition, when two or more letters are similar, errors that apply to each of the letters will only be indicated the first time.

One more very important point: *Work slowly.* Copperplate is a slow alphabet. Because of the pressure-release action of the pen, Copperplate requires a slow, even writing rhythm. Moving your pen too fast will cause the nib to catch in the fibers of the paper and will result in letter forms that are sloppy and inconsistent. Don't speed up.

Robert Boyajian, "Who are a free people?" 1976. Written on handmade paper with Esterbrook 355 nib, Pelikan ink, reduced 25% percent, not retouched.

Group One: The Simplest Letters: i, t, j, a, d, g, n, m, u, y

Although there are several small additions to and variations on the basic strokes in this letter group, by and large these letters are quite straightforward.

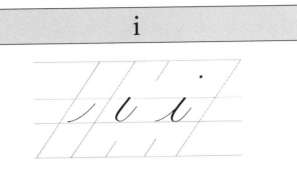

The *i* consists of two separate strokes and a dot.

Start at the base line with a hairline lead-in stroke. About two-thirds of the way up toward the waist line, lift the pen, move it to the waist line, and make the shorter version of the pressure-and-release stroke (Basic Stroke 2). Be sure to end the final upstroke about two-thirds of the way into the x-height space.

The dot on the *i* is positioned in the center of the ascender space, in a line with the 55-degree slant of the letter. Thus, if the thick stroke of the *i* is directly on a slant line, the dot will be on the same slant line. Draw the dot in a small circular motion without pressing on the nib.

INCORRECT LETTERS. The *i* in Figure 1 was made in one stroke. By hastening from the lead-in stroke to the downstroke, without a full stop and a pause for the nib to open, the squared-off top and evenly weighted downstroke have been sacrificed.

A dot that is too high (Figure 2) or too low (Figure 3), or irregular (Figure 4) detracts from the beauty of the letter. The shape of the dot in Figure 4 was caused by pressing too hard on the nib.

Be sure that you don't spoil a good letter by ending the second stroke with a careless, too rapid motion (Figure 5) or an incomplete stroke (Figure 6).

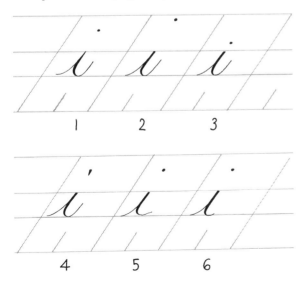

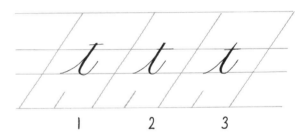

The *t* is very similar to the *i*.

Start with the curved hairline lead-in stroke, ending near the waist line. Move the pen to a point approximately one-quarter of the way above the waist line. Press on the nib. Make the same downstroke that you made on the *i*, curving around at the base line and ending in a thin upstroke.

The cross-stroke of the *t* is a thin horizontal line. It is positioned at the waist line. This is a fairly short stroke, equally distributed to the left and right of the downstroke.

INCORRECT LETTERS. In Figures 1 and 2, the cross-stroke is positioned incorrectly. It is too high in Figure 1 and off-center in Figure 2.

Figure 3 was made without lifting the pen between the first and second strokes. Thus the relationship between the two strokes is ungraceful and the top of the letter is pointy.

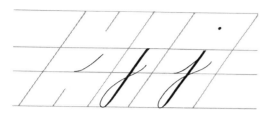

The *j* consists of two separate strokes and a dot.

The first stroke is the lead-in stroke. As in the *i*, start this stroke at the base line and curve it upward, stopping near the waist line. Move the pen to the waist line and make a complete descender stroke. Be sure to pause before you start the downstroke so that the nib opens and the top of the stroke is squared off.

Finish the upstroke by curving into the x-height space.

The dot is the same shape and in the same position as the dot on the *i*.

The *a* is made in two strokes.

Starting slightly below the waist line and moving counter-clockwise, make a complete o-form. Lift the pen and move it to the waist line. Make the short version of the pressure-and-release stroke (Basic Stroke 2), ending, as in the *i*, about two-thirds of the way up in the x-height space.

Be sure that the weight on the left side of the *a* is parallel to the weight on the second stroke:

INCORRECT LETTERS. If the weights on your first and second strokes are not parallel, your *a* may look like Figure 1. This imbalance seems to change the slant of the letter, although it is, in fact, slanted correctly.

Even though the weights are parallel in Figure 2, the letter is too straight. All the thick strokes must follow the 55-degree letter slant.

1 2

The *d* is almost identical to the *a*. It is made with the same two strokes; however, the pressure-and-release stroke in the *d* is longer than it is in the *a*.

Start the *d* by making a complete o-form in a single counterclockwise motion. Then move your pen to a point two-thirds of the way up between the waist line and the ascender line. Pause, press on the nib, and make a pressure-and-release stroke, ending the upstroke, as in the *a* and the *i*, near the waist line.

Because the proportion of the ascender to the x-height is 3:2, two-thirds of the ascender space is equal in height to the x-height space. Thus, the ascender of the *d* is equal in length to the x-height of the *d*.

RULE: Any letter with an ascender or a descender *without a loop* will extend two-thirds of the way into the appropriate space. The ascenders or descenders of these letters will, therefore, be equal in length to their x-heights.

Because the *d* has an ascender but does not have a loop, this rule applies.

INCORRECT LETTERS. If you start the ascender at the ascender line (Figure 1) instead of one-third of the way down, the length of the stroke will overpower the letter. If you start the ascender too low, as in Figure 2, the *d* will be bottom heavy.

| 1 | 2 |

HOW TO PRACTICE. Cover the ascenders of your *d*s and look at the lower half of the letters. They should look exactly the same as your *a*'s. Practice *a*'s and *d*'s alternately and compare them. Be sure that you are paying attention to your hairline exit strokes (the upstroke of the pressure-and-release stroke), as explained under *i*.

The *g* is an o-form plus a descender stroke.

As you do in the *a* and *d*, start by making a complete o-form. Then move your pen to the waist line and make a descender stroke ending, like the *j*, with a hairline upstroke that curves slightly in the x-height space.

INCORRECT LETTERS. If the upstroke of the descender crosses the downstroke at or above the base line, the descender loop and the o-form will bump into each other, as shown in Figure 1. The small gap that you were advised to leave between the loop and the base line (Basic Stroke 7) will prevent this letter from looking clumsy.

The *n* is a combination of the third and fourth basic strokes.

Start the first stroke of the *n* about one-third of the way up into the x-height space from the base line. Pause at the end of the downstroke and lift the pen from the paper before beginning the second stroke.

Start the second stroke near the base line by making a thin upstroke directly on top of the existing stroke. Press very lightly. Curve around to the right toward the top of the stroke and complete the form. The stroke ends about two-thirds of the way up to the waist line.

Try drawing a horizontal line through each *n* about one third of the way down. You should see two equal, evenly balanced arches at the top of the two strokes:

INCORRECT LETTERS. If your second upstroke swings out too low and at too sharp an angle, the second arch will be uneven and pointy. Often, calligraphers who are familiar with Italic suffer from what might be called "the Italic thrust." Rather than making evenly rounded arches, they make strokes that would be accurate if they were writing Italic letters, but are incorrect Copperplate forms. The illustration here is an example of the Italic thrust.

The *m* is made in three strokes.

Start the *m* as you would an *n*. The second stroke is a repeat of the first stroke. In both the first and second strokes of the *m*, be sure to stop at the base line so you can see the squared-off edges of the stroke (this also applies to the first stroke of the *n*).

The third stroke of the *m* is the same as the second stroke of the *n*. Check to see that the curves at the top of your strokes are evenly rounded and that the counter widths are equal.

INCORRECT LETTERS. Figure 1 suffers from the Italic thrust: pointy counters and uneven arches.

The *m* in Figure 2 is too wide. The counters in Figure 3 are uneven.

| 1 | 2 | 3 |

HOW TO PRACTICE. Try the following arching exercise:

Make each stroke separately. Concentrate on getting all the downstrokes evenly spaced, parallel, and equally weighted. Cover the bottom half of the line and see if your arches are well-rounded and nicely balanced. This is a fairly difficult exercise, but it should help you make beautiful *m*'s and *n*'s.

u

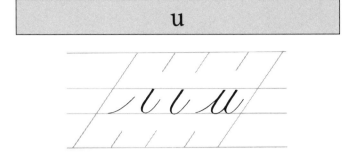

The *u* is made in three strokes. The first two strokes are the lead-in stroke and the short form of the pressure-and-release stroke. They are identical to the *i*.

The third stroke is a repeat of the second stroke. This is probably the easiest letter you have made so far.

INCORRECT LETTERS. The Italic thrust tends to show up in the *u*, too. In Figure 1, the counter is too pointy on the bottom and the upstroke is at too sharp an angle. The counter looks too much like that of an Italic *u*. The curve at the bottom of the *u* should be the same as the curve at the top of the *m* and *n*.

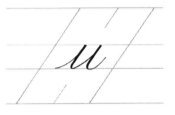

HOW TO PRACTICE. Alternate *u*'s and *n*'s. Compare the counter widths and shapes and the form of the curves.

Do another arching exercise. This time, base the arches on the *u*, with all the curves at the base line instead of at the waist line.

Try to get all the counters equal and the curves identical. Alternate a group of these underhand curves with the overhand curves you practiced when learning the *m* and *n*. Turn the paper upside down and see how they compare.

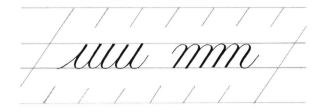

y

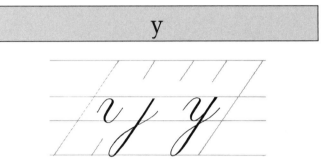

The *y* is another simple letter. The first stroke is the combination form of the pressure-and-release stroke, starting approximately one-third up from the base line and ending one-third below the waist line.

The second stroke, which starts with a pause and a squared-off top, is the descender stroke. Be sure to calculate carefully the point of intersection of the upstroke and the downstroke on the descender. If these strokes cross too high, you will have the problem illustrated on p. 49, under *g*.

Group Two: The Looped Letters: l, h, k, e,

Although the j and the y are considered looped letters, they were discussed in the previous section because they are very simple forms. Four of the letters in this group have ascender loops. The ascender loop is a little more difficult to make than the descender, but if you practiced your basic strokes sufficiently, these letters should be easy.

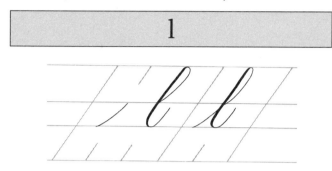

The l is a variation of Basic Stroke 8, the ascender loop.

Start with a lead-in stroke that breaks at the waist line and swings out slightly to form the loop. Continue up to the ascender line, make a narrow rounded turn to the left, and press on the nib to make a thick downstroke almost as far as the base line.

Thus far, the l is identical to Basic Stroke 8. The variation occurs just before you reach the base line. Release the pressure and complete the stroke with a curve to the left and a hairline upstroke, as you do in all the pressure-and-release strokes. The l is thus a combination of the ascender loop and the basic pressure-and-release stroke.

INCORRECT LETTERS. The l in Figure 1 is far too curved. Be sure to follow the 55-degree axis almost all the way to the base line before curving around. It is important to pay attention to this rule so your l's don't look like capital C's.

The loop in Figure 2 is too narrow. Review Basic Stroke 8.

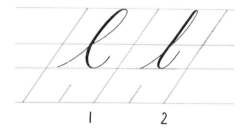

1 2

HOW TO PRACTICE. Alternate l's with Basic Strokes 2 (the pressure-and-release stroke) and 8 (the ascender loop). This will help you make all the downstrokes parallel to each other and evenly weighted. They should look like this:

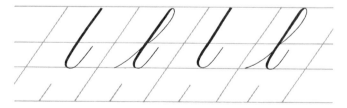

Think of the l as a pressure-and-release stroke with a loop, or as a looped ascender stroke with a curve and an upstroke at the base line.

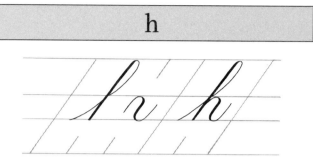

The h is an easy letter. Start with the basic ascender stroke, stopping at the base line. As you did in the m and n, replace the pen on the downstroke near the base line and make a lightweight upstroke directly on the thick line, curving outward as you approach the waist line.

The second downstroke is parallel to the first stroke and equally weighted. Finish this stroke, as you do the second stroke of the n, with a curve and a hairline upstroke.

INCORRECT LETTERS. The curve of the second stroke of Figure 1 is too close to the waistline. As a result, the two curves bump into each other. There should be a small gap between the bottom of the ascender loop and the top of the second stroke. This is the reverse of the problem shown on p. 49 (Incorrect Letters: the g).

The h in Figure 2 is a victim of the Italic thrust. To avoid this, make sure that the curve in the second stroke is even and round, not angular and pointy.

1 2

HOW TO PRACTICE. Alternate l's, h's, and n's. Concentrate on making loops of equal size and evenly weighted, parallel downstrokes. Compare the counters of the h's and the n's for width, curve, and weight.

The *k* is a little harder to do because its lower part contains several pressure-and-release points within a very small space.

The first stroke of the *k* is the same as the first stroke of the *h*.

The second stroke starts near the base line, sliding up on the existing downstroke and curving out to the right near the waist line, as in the *h*. Curve down and then in to the left to form a small loop that touches the first stroke at the midpoint of the x-height space. When making this loop, press on your nib briefly so that the downstroke portion of the loop is thick. Release the pressure before touching the first stroke so that the end of the loop is a thin line.

Pause before beginning the next stroke. For the final part of the *k*, make a small curve outward and then down to the base line, curving around at the base line and back up. The beginning of this curve will be a thin stroke; the downstroke will be thick; and the final upstroke will, of course, be a hairline.

INCORRECT LETTERS. The loop in the second stroke of Figure 1 is too big, leaving insufficient space for the final downstroke. The bottom of this *k* is topheavy.

The final downstroke of Figure 2 starts with a stroke that extends too far to the right. This stroke should turn downward almost immediately.

The curve in the final stroke of Figure 3 has been eliminated, changing the shape of the letter. This will cause spacing problems when the *k* is followed by another letter in a word.

In Figure 4, the pressure in the center of the second stroke is too heavy. This part of the letter should be a fine line.

The *e* is similar to the *l*. Start the *e* with a curved hairline stroke that ends in the middle of the x-height space. Break the stroke, as you do your ascender loops, and curve outward and back inward toward the waist line. Curve around at the waist line and make a downstroke as if you were making an o-form, ending with an upstroke. The weight on the left side of the *e* should be the same as it is on the o-form: tapered at the top and bottom and widest at the center of the curve.

INCORRECT LETTERS. In Figure 1, the lead-in stroke is not broken. The stroke is therefore too steep, and the loop is too narrow.

The loop in Figure 2 is too wide. The difference in direction between the lead-in stroke and the outward curve of the loop should not be this great. Like the ascender loop, the letter *e* should give the appearance of being made in a single motion.

In Figure 3, the weight on the left side of the letter is too low. Start pressing on the nib immediately after completing the curve at the waist line.

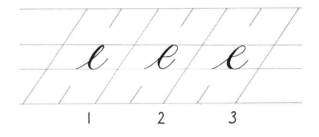

1	2	3

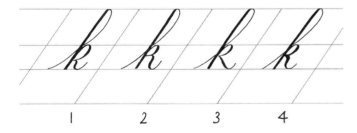

1	2	3	4

HOW TO PRACTICE. Try doing the second part of the *k* separately, working larger than usual. Concentrate on the pressure-release variations. You will probably find it easier to do *k*'s if you isolate the difficult part first and then do the entire letter.

Group Three: The Filled-In Dot: b, o, v, w, c

The next six letters all have a small stroke that can be described as a "filled-in dot."

The filled-in dot is similar to the o-form, but it is much smaller. It is formed by moving the pen in a counterclockwise oval motion, pressing very briefly on the nib during the downstroke.

Start the stroke at the bottom right and make a very short upstroke, followed by a curve and a downstroke. The nib will open during this motion. End at the bottom of the curve, where the stroke began. This shape looks like this:

Notice that the right side is slightly flatter than the left.

HOW TO PRACTICE. Working larger than normal, make several filled-in dots. Then try the following group of letters.

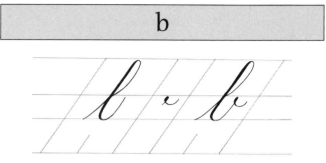

The *b* consists of an *l* plus a filled-in dot. Follow the instructions for making an *l*. Finish the hairline upstroke at the end of the *l* and continue up to the waist line, curving to the left and down into the filled-in dot.

At the bottom-right corner of the dot, pause, let your nib close, and finish the letter with a hairline exit stroke. This stroke should curve upward and end at the waist line. You may find that you have to come to a full stop before making this final hairline.

INCORRECT LETTERS. If you do not allow your nib to close completely before making the final exit stroke, you will drag the ink into the hairline, making this stroke look bulky and awkward (Figure 1).

In Figure 2, the final upstroke of the *l* part of the *b* curves inward. The upstroke and the downstroke should be parallel.

In Figure 3, insufficient pressure has been applied to the nib on the downstroke of the filled-in dot, making it a small loop instead of a closed form.

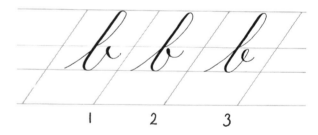

1 2 3

HOW TO PRACTICE. Alternate *l*'s and *b*'s. This will help you avoid the error shown in Figure 1 above.

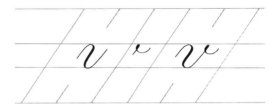

The *o* is an o-form with a filled-in dot and a hairline exit stroke.

Make an o-form. As you complete the form, curve around and back down to make a filled-in dot, which will close the shape and serve as a visual balance to the heavy downstroke on the left side of the letter.

Pause and then finish the *o* with a curved hairline exit stroke.

INCORRECT LETTERS. The exit stroke in Figure 1 is too straight. This makes the letter ungraceful.

In Figure 2, the filled-in dot and exit stroke are too low. This *o* might be mistaken for an *a*.

The final exit stroke in Figure 3 was made without pausing after the filled-in dot. The ink from the dot was dragged into the hairline, thickening the stroke and spoiling the exit stroke.

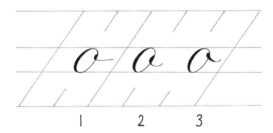

| 1 | 2 | 3 |

The *v* is an easy letter. It consists of Basic Stroke 4 and a filled-in dot.

Start the *v* with a pressure-and-release stroke: upstroke, curve, downstroke, curve, upstroke. Be sure that all three lines are parallel. As you do when making a *b*, finish the final upstroke by continuing up to the waist line and curving around to the left and down, briefly, in a filled-in dot.

Complete the *v* with a pause and a hairline exit stroke.

HOW TO PRACTICE. Alternate *n*'s and *v*'s. Compare the counter widths, the curves, and the weight of the downstrokes.

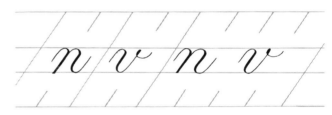

The *w* starts like the *u* and ends like the *v*.

Begin with a hairline lead-in stroke, stopping just before the waist line. Move the pen to the waist line, pause, press on the nib, and make a downstroke, a curve at the base line, and a hairline upstroke. End this stroke just before the waist line.

Move the pen to the waist line and repeat the same motion to create the same form. At the end of the second upstroke, curve around to the left to make a filled-in dot and finish the letter with a hairline exit stroke.

The counters of the *w* should be equal, as should the weight of the two downstrokes.

INCORRECT LETTERS. The *w* in Figure 1 starts like the *v* rather than the *u*. Although this is not an unattractive form, it can be ambiguous. Start the *w* with an underhand curve from the base line, not with Basic Stroke 4.

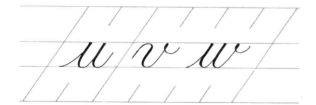

HOW TO PRACTICE. Alternate *u*'s, *v*'s and *w*'s. Compare curves, counters, filled-in dots, and stroke weights.

The *c* is made without pausing or lifting the pen.

Start slightly below the waist line with a filled-in dot. In this case, the filled-in dot begins at the top of the form rather than at the bottom, as it does in the *b*, *o*, *v*, or *w*. When you complete the filled-in dot, continue up to the waist line, then curve around to the left and back down, exactly as you do when making an o-form.

At the base line, curve outward and up into a hairline, swinging a little wider than you would if you were making a closed o-form. The final hairline of the *c* is thus further to the right than the filled-in dot.

INCORRECT LETTERS. If the final upstroke of the *c* is too narrow (Figure 1), the form will close, like an *o*. If this stroke is too wide (Figure 2), or too flat (Figure 3), the *c* will not be graceful.

The filled-in dot in Figure 4 is too high. Be sure to start this stroke below the waist line so that the letter will have a hairline curving up and around at the waist line.

The filled-in dot in Figure 5 is incorrect in shape. This dot should be made in a counterclockwise motion so that it is a miniature version of the o-form. The dot in Figure 5 was made like the dot on an *i*. It looks like a cherry on a stem.

1	2	3	4	5

HOW TO PRACTICE. Alternate *o*'s and *c*'s. The filled-in dot on the *o* should be lower than it is on the *c*. The left side of both letters should be the same, but the right side of the *c* should appear wider.

If you have trouble with the relationship between the filled-in dot and the rest of the *c*, try doing the following: Using a pencil, draw a spiral, working in a counterclockwise direction, starting in the center. Make it oval-shaped. Then try it with pen and ink, starting with a filled-in dot.

Group Four: The Exceptions: f, p, q, r, s, x, z

The letters in this group are all characterized by slight variations on the basic strokes or particular subtleties that make them unique. These are not difficult letters, but they need to be studied as a special group.

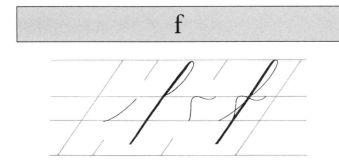

The *f* has several unusual characteristics. It is the only letter in the Copperplate alphabet that has both an ascender and a descender.

The *f* starts like an *h* with a hairline lead-in stroke, an ascender loop, and a heavy downstroke.

Continue the downstroke past the base line, stopping approximately two-thirds of the way into the descender space. The rule explained on p. 49 (under *d*) applies to the *f*. Because the descender of the *f* has no loop, it is equal in length to the x-height.

Be certain that this stroke is evenly weighted all the way down and is not heavier than any of your other letters. There is a tendency to increase the pressure on this stroke because it is so long. Do not permit this to happen or your *f*'s will be bolder and will therefore look bigger than your other letters.

The cross-stroke of the *f* is made without pressing on the nib. Start at the base line, directly on the thick downstroke. Slide up and curve immediately out to the left, curving around at the waist line and slightly downward in a stroke that crosses the downstroke of the *f* and curves immediately back up to the waist line. The curves of the cross-stroke should be graceful and evenly balanced. In most cases, the stroke touches the waist line twice.

INCORRECT LETTERS. The downstroke in Figure 1 is too heavy. In Figure 2, the weight on the downstroke is distributed unevenly.

The cross-stroke in Figure 3 is pointy on the left and curves downward too much. In Figure 4, the cross-stroke is heading uphill. This stroke should be parallel to the base line, even though it is a curved stroke.

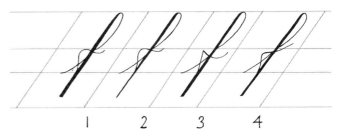

HOW TO PRACTICE. If you are having difficulty with the weight of the downstroke of the *f*, make the first stroke of the *h* followed by the first stroke of the *f*. You can even add an intermediate step: a stroke that extends one-third of the way into the descender space, halfway between the length of the *h* and the length of the *f*. Concentrate on maintaining an equal pressure on the nib *no matter what the length of the downstroke* and on ending the stroke with an even, squared-off edge.

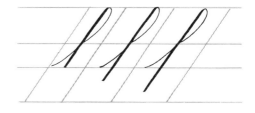

If you are having trouble making graceful cross-strokes, make some cross-strokes independent of the rest of the letter. Then make the whole letter.

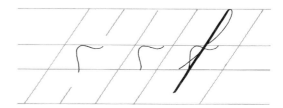

p

The *p* has no new strokes, but it has certain subtleties.

Start with a hairline lead-in stroke. Move the pen one-quarter of the way into the ascender space to the point where you would start a *t*. Make a downstroke, extending, as in the *f*, two-thirds of the way into the descender space. This stroke is the same as the first basic stroke, a full-pressure stroke beginning and ending with a squared-off edge.

Move the pen back to the base line and make a pressure-and-release stroke (Basic Stroke 4) with curves at the waist line and at the base line. Be sure that you do not curve the second downstroke inward; make the two downstrokes parallel.

INCORRECT LETTERS. The first downstroke in Figure 1 starts at the waist line rather than above it. There is not enough strength in this stroke to support the second stroke of the letter. Be sure to start the first downstroke above the waist line.

The downstroke in Figure 2 is too long. End the stroke two-thirds of the way into the descender space.

In Figure 3, the second stroke curves inward. This is the wrong shape. All the downstrokes must be parallel.

1 2 3

q

The *q* is made in two strokes: an o-form and a variation on the descender stroke.

Start the *q* with a complete o-form, as you would an *a* or a *d*. Move the pen to the waist line and start making the downstroke of a descender. As you reach the descender line, curve to the right, around and back up, making a form that is similar to the standard descender, but in the opposite direction. Thus, the curve of this descender is on the right and the straight line is on the left.

Curve in to meet the downstroke at the waist line and swing outward and up into the x-height space.

INCORRECT LETTERS. The bottom of the descender in Figure 1 is pointy. Be sure to release the pressure on the downstroke just before the descender line so that the bottom of the *q* will be rounded.

HOW TO PRACTICE. Alternate *g*'s and *q*'s. The upper parts of these letters should be identical. Compare the descenders for the weight of their downstrokes and the width and shape of their counters.

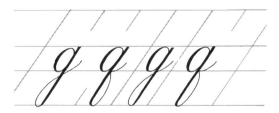

The *r* is made in two strokes. The second stroke intersects the waist line and is a little different from the other Copperplate exit strokes.

The first stroke of the *r* is Basic Stroke 3, a pressure-and-release stroke, ending at the base line. Pause, then slide the pen back up along the downstroke until you intersect the waist line. Extend the upstroke a short distance into the ascender space and then make a short curved downstroke, dipping below the waist line and then curving back up. Press on the nib briefly at the beginning of this stroke; then release the pressure to make a graceful hairline exit stroke.

INCORRECT LETTERS. In Figure 1, the short pressure stroke (top of second stroke) is squeezed in under the waist line. This results in a letter form that is short and cramped.

In Figure 2, the second upstroke is at too sharp an angle. The letter therefore leans too far to the right.

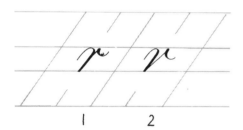

| 1 | 2 |

The *s* breaks two basic rules: it has a pointy top (not rounded or squared off), and the downstroke is not along the 55-degree axis.

Start the *s* with a lead-in stroke that continues to the waist line and slightly above it.

Start the downstroke above the waist line without pressing on the nib. Allow the pen to open as you make the downstroke. This stroke should be almost vertical; it slants very slightly to the left.

Before you reach the base line, decrease the pressure and curve around to the left, making a small filled-in dot, similar to the dot on the *i*.

The 55-degree axis should divide the letter in half.

INCORRECT LETTERS. In Figure 1, the top of the *s* is squared off. Remember that the downstroke of the *s* starts without any pressure on the nib so that the top will be pointy.

The downstroke in Figure 2 swings too far to the right. The counter is therefore too wide and the *s* is on a vertical axis rather than on a 55-degree axis. In Figure 3, the downstroke is on the 55-degree line, making the counter too narrow and the letter too slanted.

The base-line dots in Figures 4 and 5 are incorrect. In Figure 4, the dot has been left open rather than filled in; and in Figure 5, the dot is too big.

In Figure 6, the top of the *s* is at the waist line rather than slightly above it. Because the weight of the downstroke does not begin at the top of the stroke, this letter appears to be too short. Be sure to start the downstroke above the waist line so that its weight will be evenly distributed in the x-height space.

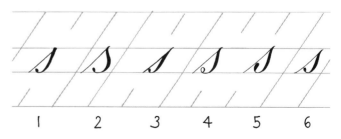

| 1 | 2 | 3 | 4 | 5 | 6 |

The *x* is made of two opposing curves.

The first stroke is a reverse (clockwise) curve. It begins with a hairline upstroke that starts about halfway up in the x-height space and has the same shape as the o-form, but in the opposite direction. Do not press on this downstroke. This is the only downstroke in the minuscule alphabet that is made without pressing on the nib. Be sure to concentrate when making the first stroke of the *x*, so that you make a hairline for the entire length of the stroke.

Curve up from the base line and around to the left, ending the stroke as you do an *s* with a filled-in dot. This final brief ending is the only heavy part of this stroke.

The second part of the *x* is a *c*, made in its entirety according to the instructions on p. 56. Be sure that this stroke overlaps the first stroke in the center of the x-height space so that the thick downstroke of the second stroke serves as the weight for both parts of the *x*.

INCORRECT LETTERS. In Figure 1, pressure was placed on the nib in both strokes. In addition, the two strokes do not overlap accurately, so that the center of the *x* contains a double thickness.

The second stroke in Figure 2 has overshot the mark. It overlaps the first stroke too much.

The first stroke in Figure 3 is too vertical; this shifts the *x* off its 55-degree axis. To prevent this, swing the first stroke further to the left, so that the letter slants accurately.

In Figure 4, the end of the first stroke and the beginning of the second stroke are too curvy.

HOW TO PRACTICE. Concentrate on the first stroke, since you are already familiar with the *c*. Make a series of reverse curves, being sure to keep the pressure light on the nib so that it won't open, and to observe the 55-degree guidelines.

Then add the second stroke. If you make the first stroke of the *x* correctly, the letter is easy.

The *z* consists of a reverse curve, an open loop on the base line, and a descender that is curved on the left as well as the right.

Start the *z* with a hairline, curving up to the waist line, around to the right, and downward, allowing the nib to open on the downstroke. This form should resemble the first stroke of the *x*.

When you reach the base line, swing the stroke to the left, make a small, rather flat loop that rests on the base line, and curve downward to make the descender. The descender of the *z* is essentially the same width and approximate shape as the standard descender, but it is slightly curved on both sides. The thick stroke should be along the 55-degree axis, slightly to the right of the thick stroke of the upper part of the *z*.

The final upstroke crosses the downstroke slightly below the base line and curves into the x-height space, ending about two-thirds of the way up.

INCORRECT LETTERS. The descender loop in Figure 1 is too far to the right of the upper part of the *z*, thus making the letter appear too vertical. By making the small loop on the base line further to the left, it is easier to position the descender accurately.

The descender loop in Figure 2 is far too wide. This loop should conform in width to the standard descender form, although the shape is slightly different.

The final exit stroke in Figure 3 curves downward instead of upward. A careless exit stroke will spoil an otherwise accurate letter.

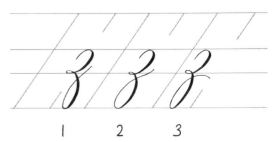

HOW TO PRACTICE. Practice all the letters with descender loops—the *g*, *y*, *q*, and *z*. Although there are three kinds of loops. they should conform to each other in width and weight, and in the overall look of the counter.

Letter Connections and Spacing

The transition from writing individual letters to making words is an exciting moment for every calligraphy student. To do this successfully, you will have to turn your attention to two separate but closely related areas of study: letter connections and spacing.

The rules for connecting Copperplate letters are quite simple. Learning to space properly is a little more difficult.

Before you begin, it is important to remember: *do not speed up*. Copperplate is always written slowly, and though you may be tempted to increase your speed, don't.

There is a natural tendency to write a little faster when making words because you may be thinking of the next letter or even the next word. If you can manage to concentrate on the letter you are writing and pay attention to its shape and form, your calligraphy will continue to improve. If you speed up, in all likelihood your letter forms will deteriorate. The shapes of your letters and your control of the pen must always be of primary importance.

Good spacing is the key to fine writing. Beautiful letter forms, badly spaced, cannot be considered calligraphy.

DEFINITION: A RUNNING HAND. A running hand is a written script, which means that it is a script in which words are written without removing the pen from the paper between letters. Because you must lift the pen from the page to make the individual strokes of almost every letter in the Copperplate alphabet, Copperplate cannot be considered a running hand.

Words written in Copperplate, however, give the appearance of being written without lifting the pen. In some cases, you lift your pen between letters; in other cases, you do not.

BASIC SPACING RULE. *The space between letters in a word is visually equal to the space inside the letters.*

This rule means that the basic counter width — the width inside the *o* or the *a* — determines how much space should be left before and after each letter in a word. The actual shapes of the letters and how they connect to each other will further indicate where to put each letter relative to the previous letter.

By and large, the spaces between thick strokes should be equal or visually equal. How this rule applies to various letter combinations will be discussed in the following pages.

LETTER CONNECTIONS. Copperplate letters are connected by means of hairlines. In most cases, the entrance and/or exit strokes become the connecting strokes.

The following chart should help simplify the rules about letter connections. It may look confusing, but it really is not.

Groups 1 and 2 are the left-hand letters (letters you are connecting from). Groups 3 and 4 are the right-hand letters (letters you are connecting to).

GROUP 1	GROUP 3
a c d e g h i	b e f h i j k
j k l m n p q	l m n p r s t
t u x y z	u v w x y z

GROUP 2	GROUP 4
b f o r v w	a c d g o q

CONNECTION RULE. Every letter which ends with a hairline connects to every letter that begins with a hairline by combining the exit stroke of the first letter with the entrance stroke of the second letter without lifting the pen.

This rule applies to every letter (all the letters in Groups 1 and 2) except the *s*, connecting with the letters in Group 3.

The exit strokes of all the letters in Group 1 begin at the base line. The connections between these letters and the letters in Group 3 look like this:

ab ae af ah ai aj ak

al am an ap ar as at

au av aw ax ay az

cb de ef gh hi ij jk

kl lm mn np pr qu

SPACING. Notice that the spaces between the *a* and the *b, e, f, h, i, j, k, l, p, t, u,* and *w* are all equal to the space inside the *a*.

The space between the *a* and the first downstroke of the *m, n, r, s, v, x, y,* and *z* is a little bigger than the width of the *a*. This is because the downstroke of the *a* and the first downstroke of each of these letters is broken by the hairline connecting stroke. Compare the difference between the *a-i* connection and the *a-n* connection.

ai an

The space between the downstroke of the *a* and the hairline lead-in stroke of the *n* is smaller than the counter of the *a,* but the space between the thick strokes (downstrokes) is somewhat bigger.

SPACING RULE. When a hairline connecting stroke divides the space between two thick (down) strokes, this space is wider than the counter of the *a.* When the two thick strokes are connected but are not divided by a hairline, the space between letters is equal to the counter of the *a.*

HOW TO PRACTICE. Connect all the letters in Group 1 to all the letters in Group 3. Compare the space between downstrokes. For example, the distances between the downstrokes of *i-b, i-e, i-f, i-h, i-i, i-j, i-k, i-l, i-p, i-t, i-u,* and *i-w* are closer than the distance between the *i* and the first downstrokes of *m, n, r, s, v, x, y,* and *z.*

The same is true of *g-b, g-e, g-f, g-h, g-i, g-j, g-k, g-l, g-p, g-t, g-u,* and *g-w.*

Of course, many of these letter combinations don't exist in English, but it is good practice to try them all.

CONNECTION RULE. When connecting letters whose exit strokes begin in the middle of the x-height space or near the waist line (Group 2), the hairline connecting stroke is a short, graceful curve in the center of the x-height space.

SPACING. The *b, o, v,* and *w* end with a filled-in dot before the exit hairline. Although the dot does not serve the spacing function of a full-length downstroke, it breaks the space between the thick downstroke of the *b, o, v, w,* and the next letter. The letter that follows each of these letters should therefore be closer than a full counter space away from the dot but not too close.

HOW TO PRACTICE. Connect each of the letters in Group 2 to Group 3. Observe that the *b*, *o*, *v*, and *w* are all a little further away from the letter that follows than is the *f* or the *r*.

bb be bf bh bi bj bk bl bm

fn fp fr fs ot ou ov ow ox oy

vb ve vf vh vi vj vk vl wm

You will find that your judgment will develop quickly and you will soon know how close to each letter to put the succeeding letter.

CONNECTION RULE. When connecting any of the letters in Group 1 or 2 to the letters in Group 4, lift your pen after the exit stroke of the first letter and move it to the point where the next letter begins (since the Group 4 letters are all based on the o-form, you will have to move your pen to the point below the waist line where the counterclockwise motion begins.)

Then write the *a*, *c*, *d*, *g*, *o*, or *q* so it touches the exit stroke of the preceding letter. The letters should look as if they have been joined without lifting the pen.

Remember: the o-form always starts on the right and is made in a counter-clockwise direction.

SPACING. The same spacing rules apply. Be sure to move your pen to the correct starting point for each of the letters in Group 4 to maintain visually accurate spacing.

HOW TO PRACTICE. Connect each letter in Groups 1 and 2 to the six letters in Group 4. Since the letters in Group 1 have exit strokes that begin at the base line, spacing should be quite straightforward. In most cases, the space between letters will be exactly equal to the counter of the *a*. The space after the *c*, *e*, and *x* will be a little larger, however.

aa id eg co xa

Calculate the space between the letters in Group 2 and Group 4 according to whether the Group 2 letters end with a filled-in dot.

CONNECTION RULE. The *s* does not connect to any succeeding letter. Carefully position the letter following an *s* so the spacing is visually correct although the letters do not touch.

The hairline entrance stroke of the Group 3 letters will occasionally touch a preceding *s*, but the connection should not be forced. The letters in Group 4 never touch the *s*.

HOW TO PRACTICE. Try following the *s* with each of the other letters, paying close attention to spacing. Note the two possibilities for connections with Group 3 letters: the lead-in stroke can start at the base line or one-third of the way between the base line and the waist line. Examples of both are shown here.

MAKING WORDS. Now that you have patiently connected every letter in the alphabet to every other letter, it's time to make words. Keep your writing speed slow and pay careful attention to letterforms, spacing, and connections.

SPACING RULE. The space between words is small. It is approximately equal to the width of an *a* or an *n*. You should be able to see several words at the same time when you look at a line of writing but nonetheless determine where one word ends and the next begins.

HOW TO PRACTICE. Try writing some of the following alphabet sentences. They contain all the letters of the alphabet. Several of these sentences have been passed down from teacher to student for many years.

1. Brown jars prevented the mixture from freezing too quickly.
2. Pack my box with five dozen liquor jugs.
3. I quickly explained that many big jobs involve few hazards.
4. The junior office clerks were quite amazed at the extra reward given by their generous employer.
5. Picking just six quinces, the new farmhand proved strong but lazy.
6. Judge Power quickly gave six embezzlers stiff sentences.
7. Mad brother Jarvis was quickly axed for crazy praying.
8. Sphinx of black quartz judge my vow.
9. Seven wildly panting fruit flies gazed anxiously at the juicy bouncing kumquat.
10. Calligraphy requires just a very few basic needs: pen, ink, dexterity, and, most of all, zeal.

The advantage of practicing alphabet sentences is that they give you the opportunity to use all the letters in the alphabet equally, rather than emphasizing *a*'s and *e*'s to the disadvantage of *x*'s and *z*'s.

When you practice alphabet sentences, try writing the whole sentence without rewriting any letter or word until you have completed all of it. Don't worry about capital letters or punctuation at this point.

Try copying the examples opposite.

In the eighteenth and nineteenth centuries, students of penmanship often used "headline" copy books. These were ruled notebooks with a line of "correct" writing printed, or written, in the writing master's hand at the top of the page, followed by blank spaces. The student had to repeat the sentence over and over, trying to approximate the master's penmanship. The quality of the student's writing frequently deteriorated as he or she became increasingly bored. This method of practicing is, however, not without some merit. It is advantageous to repeat the same line or lines of practice work, but only if you think about what you are doing while you are doing it.

Try the following practice method:

1. Choose an alphabet sentence or any ten-to-fifteen-word sentence, and write it carefully, concentrating on letterforms, spacing and connections. Write it out, thinking carefully about what you're doing, but without rewriting individual letters or words.

2. Put down the pen and pick up a red marker or brightly colored pen that will contrast with the black ink.

3. Using any system of notation (circles, arrows, checks), indicate the places in your work that need to be corrected or improved. For example, if two letters are too close, mark it. If they are too far apart, mark that. If your slant has varied or if your letter shapes are irregular, indicate the position of these errors. Start with the most glaring mistakes, and then pick out a few other obvious ones rather than starting with the first letter of the first word and picking apart every stroke (that's too discouraging).

4. Then, directly below this sentence, rewrite the same sentence, trying to correct each error you have pointed out. If you don't have room to rewrite your sentence on the same page, use another sheet but keep your marked-up first attempt in front of you.

sphinx of black quartz

judge my vow.

pack my box with five

dozen liquor jugs.

mad brother jarvis was

quickly axed

for crazy praying.

You will probably find that your second attempt is an improvement over the first, although you will certainly make a few spacing or lettering errors that you didn't make the first time.

After you have tried this once, pick another sentence and repeat the process. It will probably be even better this time.

Here is an example of calligraphic self-correction by a Copperplate student:

The five boxing wizards jumped quickly

The five boxing wizards jumped quickly.

The advantage of this practice technique is that it forces you to look at your work. It is far too easy to fill a page with writing, turn the page, and continue writing, without stopping to look carefully at your calligraphy. By writing the same line twice, with a few minutes to analyze your errors in between attempts, you can only improve. Being aware of your mistakes will help you overcome them. And circling them with a red pen will force you to see them.

RHYTHM. After you understand the rules of spacing and connections, you will begin to find that you are developing a writing rhythm. Despite the slowness of the pen and the frequent pauses and stops, there is a regular up-and-down, pressure-and-release motion to Copperplate that has a gentle swing and an even pace.

The concept of rhythm in calligraphy is not simple. It involves more than an even motion or a regular pressure-and-release variation. When you begin to write with rhythm, you will find that your pen moves easily from one stroke to another and your forms flow from the motion of the pen. Rhythmic writing looks as if it is done easily, if not effortlessly.

At this point, you will probably find this happening for the duration of a word or perhaps a line of writing. With practice, you will write rhythmically more easily, especially after the first few warm-up minutes.

Many people enjoy writing to music, partly because it's relaxing, but also because it helps them develop a writing rhythm. Try this and see how it affects your work.

PRACTICING IN PENCIL. Now that you are familiar with the Copperplate minuscules and are beginning to find your own writing rhythm, it's time to try a different practicing technique.

Put your pen down, close your ink bottle, and find an ordinary No. 2 pencil. Try writing Copperplate with your pencil, following the pressure-and-release rules that should now be almost automatic when you are using a flexible pen. Press on the downstrokes; release the pressure on the upstrokes.

Surprisingly, a soft pencil will give you a nice thick/thin contrast, although, of course, the tops and bottoms of the strokes won't be squared-off, and the weight of the lines won't be as consistent as when you use a pen. But a pencil never catches in the paper, splattering ink, and the upstrokes are never shaky or broken.

The value of practicing with a pencil is that you can practice the letterforms, spacing, and connections without worrying about the nib. You can also practice at odd moments when you do not have pen and ink handy.

Here's what pencil Copperplate looks like:

pencil copperpate demands

extra concentration.

only press on the downstrokes.

When practicing with a pencil, it's important to remember to pay attention to your letters so you don't absentmindedly press on the upstrokes. Unlike a pen, a pencil will give you heavy upstrokes as easily as downstrokes. If you aren't careful, you may find yourself doing something like this:

don't press on your pencil

on the wrong strokes.

Also remember to lift the pencil from the page at the right times (at the tops and bottoms of strokes, for example), just as you would a pen.

And sharpen the pencil frequently or your thin lines will be too thick.

Variations on the Minuscules

The minuscule alphabet already described should give you a solid foundation for writing Copperplate. There are, however, variations on many of these letterforms, some of which are simpler and some more elaborate.

The primary reason to learn these variations is to increase your calligraphic range. Sometimes a particular layout calls for letterforms that are simpler, perhaps to create a sense of space or strength. Or the combination of letters in a word may be more attractive if you use one form of a letter rather than another. In addition, you may find that some of these letter variations are more comfortable to write or more visually pleasing to you.

The letters that follow are by no means the only possible variations on Copperplate minuscules. Look at eighteenth- and nineteenth-century facsimiles or at calligraphy history books. You will find many other letters to choose from. It should be noted, however, that some of the eighteenth-century forms are not suitable to twentieth-century calligraphy because they are ambiguous. The long *s*, for example, can easily be mistaken for an *f*. And the eighteenth-century *w* looks something like an *n*.

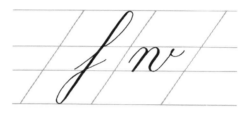

SIMPLIFIED ASCENDERS. The ascenders of the *b, h, k,* and *l* can all be written without a loop. In each case, start with a lead-in stroke from the base line (Basic Stroke 6). Lift the pen and move it to a point one-third of the way down from the ascender line to the waist line. This is the same position as the top of the second stroke of the *d*. Press on the nib so the top of the downstroke is squared off. Then complete each of these letters exactly as you would with a looped ascender.

The length of each of these ascenders is equal to the x-height. Using simplified ascenders instead of looped ascenders will make your letters look bolder and your page less decorative. Letters made with loops tend to be more graceful and elegant.

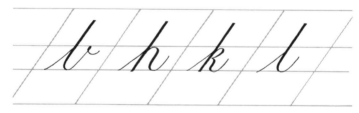

HOW TO PRACTICE ASCENDERS. Alternate each of these letters with its looped counterpart. Be sure that the weight of the downstroke is equal in every letter.

Try writing words with ascenders in both styles.

hulk hulk bald bald

hello hello skilled skilled

Then write a sentence including words with many ascenders. Compare the effect with and without loops.

the bald hillbilly was

badly bothered by the

lack of thrills

the bald hillbilly was

badly bothered by the

lack of thrills

THE MANY FORMS OF THE f

The minuscule *f* is the most versatile letter in the alphabet. Since it has an ascender and a descender, you may put a loop on the top or on the bottom or both. In addition, when words have a double *f,* there are several attractive ways to combine the two letters.

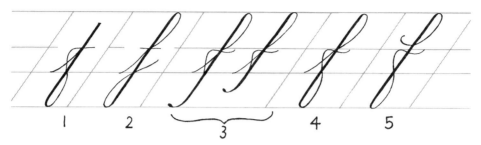

In Figure 1, the loop on the ascender of the standard *f* has been moved to the bottom. Start this letter, as you do the four simplified ascender letters, with a lead-in stroke from the base line and a downstroke with a squared-off top. The downstroke begins one-third of the way down between the ascender line and the waist line. Continue this stroke down to the descender line and, with the curve on the right side, make the descender loop of the *q.* Cross the down-stroke at the base line and continue the stroke up to the waist line and back across the downstroke to make the cross-stroke.

To make the *f* in Figure 2, start the letter as you do the standard *f.* Continue the downstroke all the way to the descender line, turn to the left and curve up to make a basic descender. The cross-stroke is a straight hairline at the waist line, like the cross-stroke of the *t.*

The descender in Figure 3 is a new form. Start this letter as you would a standard *f.* Approximately two-thirds of the way between the base line and the descender line, start to release the pressure on the nib. Curve around to the left in a smooth rounded hairline stroke, ending with the filled-in dot of the *s.* To make a shorter version of this descender, start releasing the pressure sooner and end the letter just below the center of the descender space.

Figure 4 is a combination of the standard *f* and the descender of Figure 1. A variation of this letter is shown in Figure 5. The lead-in stroke begins in the ascender space with a hairline curve to the left, down, to the right, and then up into the ascender loop. This form can be used effectively as the first letter in a word.

The lead-in stroke of Figure 5 can also be used with the looped forms of the *b, h, k,* and *l.*

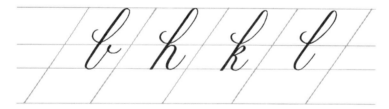

When making this form of the *l,* be sure the downstroke does not curve or it will look like a capital *C.*

Now try some of the double *f* combinations.

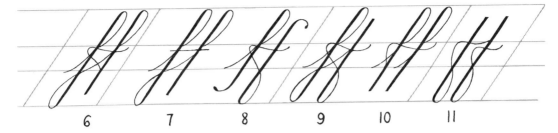

6 7 8 9 10 11

Figure 6 is a combination of the *f* in Figure 1 and the standard *f*. Notice that the descender of the first *f* and the ascender of the second *f* are made in one continuous stroke. In fact, after the initial lead-in stroke, you do not lift the pen again until you reach the bottom of the descender of the second letter. Make sure you have enough ink in the pen and that your arm and hand are relaxed before starting this stroke. Cross the two *f*s with a single cross-stroke that starts on the second letter, swings back to the left of the first letter, and crosses both in a single stroke.

Figure 7 is a combination of the same two *f*s as Figure 6, with the exception of the cross-stroke, which is a straight horizontal line connecting the two letters.

The first *f* in Figure 8 is shown in Figure 3. The second *f* starts in the ascender space, just below the ascender line, with a filled-in dot and a hairline curve up and around to the left. As you complete the curve, start pressing on the pen and finish the letter in the form of Figure 1. Be sure to swing the cross-stroke back to include the first *f* as well as the second. This combination of letters was frequently used in the eighteenth century, often with the bottom curve of the first letter and the top curve of the second letter exaggerated.

The combination in Figure 9 starts with the double-loop *f* shown in Figure 2. The exit stroke of the first *f* curves up to the waist line. Stop at that point and move your pen into the ascender space. Make the second *f* as explained in Figure 1, and cross the two letters with one cross-stroke.

Other combinations are possible, including two identical standard *f*s with a single cross-stroke (Figure 10) or two identical *f* variations, such as the simple forms in Figure 11.

SPACING. Be extra careful when spacing double *f*s. The space between the downstrokes should be equal to the standard counter width.

HOW TO PRACTICE *f*s. Write some words with double *f*s—*difficult, baffle, huff, cliff, afford, miffed, daffy, griffin.* See which combinations you prefer. You will find that some combinations work in one word and are not as successful in other words.

OTHER VARIATIONS

The other letter variations will be explained in alphabetical order. In some cases, the sequence of strokes will be immediately apparent; in other cases, more explanation will be given.

g, y

The *g* and *y* shown above both have the descender variation of *f* (Figure 3). These forms usually look better at the end of a word, rather than in the middle, because they do not have exit strokes. If you pay careful attention to spacing, however, you can use them anywhere.

k

The second stroke of this *k* variation is different from the standard *k*. Start with a lead-in and ascender stroke, with or without a loop. Then move the pen to the waist line and make a curved stroke that looks like a bracket. Start with a hairline, press briefly on the nib for the center of the upper part of the bracket, and release the pressure at the point where the bracket touches the downstroke. Like the standard *k*, this should be in the center of the x-height space. The final downstroke of the *k* is the same as it is in the standard *k*.

Try the lower part of the *k* separately, concentrating on all the pressure-release transitions. Then make the entire letter. It sometimes helps to practice the difficult portions of a letter by writing them bigger.

There are several possible variations of the *p*. In the first example, the first stroke is the same as the standard *p*. Begin the second stroke just above the base line with an upstroke superimposed on the first stroke. Curve up to the waist line, around to the right, and back down toward the base line. This downstroke, unlike the standard form of the *p*, curves back in toward the first stroke. Without touching the first stroke, loop up and through the center of the second stroke, exiting in a hairline to the right. The curve on the right of this *p* should be the same as the curve of an *o*.

The other two *p*s are cursive variations of the standard *p* and of the alternate *p* described above. In each case, release the pressure on the downstroke of the descender just before the stroke ends and curve the stroke in a very small arc to the right. Make a hairline upstroke, close to and parallel to the downstroke, all the way to the waist line, and then complete the letter in either of the two forms.

These two *p*s were generally used for rapidly written Copperplate and may not be suitable for more formal purposes.

This form of the *r* is slightly more modern looking than the standard form. Start with a lead-in stroke that intersects the waist line and curves around to the left and back down to the waist line to make a filled-in dot. The bottom of the dot is on the waist line. Release the pressure on the nib and make a short, straight, diagonal hairline stroke, downhill to the right. Pause, press on the nib, and complete the letter with a pressure-and-release stroke which has a squared-off top, a curve at the base line, and a hairline exit stroke.

The filled-in dot must be above the waist line or the letter will be too small, as shown below:

are are

CORRECT INCORRECT

Like the *p*, there are two new possibilities for the *s*, plus a third that combines the first two. The first example is a combination of the standard *s* and the looped ending of the alternate *p*. This form of the *s* works best at the end of a word. It has a cursive quality because it can be connected to the next letter without lifting the pen. In words that have a double *s*, this form looks quite different from the standard *s*, as in the word "possess":

"Possesses," written with the alternate forms of both the *p* and the *s*, looks almost like a decorative design:

The second alternate form of the *s* must be written more slowly than either the standard or the first alternate form. Start the letter as you do a standard *s*. The hairline lead-in stroke intersects the waist line and continues a little way into the ascender space before curving to the left and back down into a filled-in dot.

At this point, stop, but don't remove the pen from the page. The downstroke, which is the same as in the standard *s*, must begin without pressure. Press on the nib after you begin the downstroke, so the stroke swells gradually. Complete the letter in the standard form.

The third possibility is a combination of the two forms; it has the filled-in dot of the second variation and the looped exit stroke of the first.

X

This form of the *x* was often used in the eighteenth and nineteenth centuries. It may be a little fussy for our purposes, although the capital *X* uses these loops to good effect (see p. 100).

Start this *x* as you do a standard form, with a reverse curve: up, around to the right, and down along the 55-degree axis. At the base line, swing out to the left and loop back through the downstroke, as in the alternate *p* or *s* crossing the downstroke in the center of the x-height space. Continue the curve up to the waist line, around to the left, and back down, making the second downstroke without pressure, directly on the first downstroke. This form of the *x* can be written more quickly than the standard form because you don't lift the pen between strokes.

Z

There are three possible variations on the *z*, the third of which is a combination of the first two.

The first variation has no descender. Start with a short hairline upstroke, about one-third of the way below the waist line. At the waist line, curve around to the left and down, making a small filled-in dot. Pause at the bottom of the dot, release the pressure, and continue to curve back up to the waist line making a horizontal hairline stroke. Pause again. Then make a diagonal stroke, beginning the stroke without pressure. Press on the nib to open for most of the diagonal, but release the pressure just before the base line. The final stroke is a curve along the base line which begins with a hairline upstroke; has a short, heavy downstroke in the center; and ends with another hairline upstroke. Although this form of the *z* is quite pretty, it has so many starts and stops that it may interfere with your writing rhythm.

The top of the second variation has the same form as the bottom of the first variation: a hairline upstroke; a short, heavy downstroke; and a hairline upstroke. As with the previous *z*, pause at the end of this stroke and make a diagonal, beginning and ending without pressure. Start the descender with a short upstroke, placed directly on the diagonal, and curve around to the right and down, making the descender of the standard *z*, but without a loop.

The third form of the *z* starts with the filled-in dot and the horizontal curve of the first variation and continues in the same form as the second variation.

HOW TO PRACTICE z. Write some words with *z*s and double *z*s using the standard form and the variations. See which forms feel most comfortable and look best.

Sometimes a word with a single *z* looks fine using one form of the letter, whereas a word with a double *z* is unsuccessful using the same form. And *zy* or *zzy* can present a whole new problem. Try some combinations without connecting the *z*s. Sometimes this is a better solution than a forced connection.

wizard wizard wizard

jazz jazz haze hazy

dizzy dizzy dizzy dizzy

CHOOSING LETTER VARIATIONS. When choosing which variations to use, you must consider two important factors: the sequence of letters in the word and your personal taste. Although there are some letter sequences which most people would agree are more successful than others, you must be the final arbiter of your own letter choices.

How do you make these choices? The only way is to test them. There is no book that will tell you that "*z*-number 3" should never be followed by "*y*-number 2" or that a looped *s* followed by a standard *s* is good or bad. Try the various combinations and make your own decisions.

When doing a finished piece of writing, keep a No. 2 pencil at hand to help you make quick decisions on a separate piece of paper. It is better to write several variations of a word on a separate page and then choose the best version than to make a bad decision in ink on a finished piece of work.

With Love & Laughter

*Alexis Catherine Gordon
welcomes a new sister
Ashley Michelle
born to Anne Marie & Ron
on April 9, 1986
at 2:42 in the afternoon
weighing 8 pounds 11 ounces
and 20½ inches long*

Caroline Leake, Birth Announcement, 1986. Written on bond paper with Gillott 404 nib, Higgins Eternal ink. Outside ("With Love & Laughter") written same size, inside reduced 15 percent.

CHAPTER 3

The Capital Letters

Copperplate capitals are a delight. From the simplest forms to the most elaborate, they are fun to write and enchanting to look at. After the strict discipline of the minuscules, learning capital letters is a treat.

Like the minuscules, the capitals are graceful and elegant, but they are also expansive, decorative, and generously spaced. There are, moreover, countless options and variations, most of which are quite easily done after you are familiar with the basic forms.

Before you begin to practice this new group of letters, please read the following words of caution: Don't start learning capital letters until you are in very good control of the flexible pen. These letters tend to be bolder in concept and freer in form than the minuscules. Until you are quite at ease with the pressure-and-release system and the 55-degree letter slant, practicing capital letters may do you more harm than good (so if you skipped Chapter 2, go back and read it.)

And, once again, don't speed up. The word *freer* should not be confused with "out of control." As you do when writing minuscules, pay careful attention to the weight and direction of the strokes and the beginnings and endings of every letter. If you write too quickly, you will sacrifice beauty.

LETTER HEIGHT

The height of the capital letters is equal to the x-height plus the ascender. They are therefore the same height as the minuscule *b, h, k,* and *l.* In some cases, capitals are written considerably larger than the minuscules, generally when they are used for decorative purposes. In a standard piece of writing, however, all the capitals should fit between the ascender line and the base line, with the exception of the *J, Y,* and *Z,* which have descenders.

Basic Strokes

Four basic body strokes and five decorative lead-in strokes are explained in the pages that follow. These forms, combined with some of the minuscule strokes, should make the Copperplate capitals fairly easy to learn.

The basic downstroke is a "swelled" stroke, so called because the stroke begins and ends without pressure. Starting slightly to the right of a 55-degree slant line, begin this stroke with a small downward curve to the left followed by a downstroke along the slant line. Just before the base line, make another small curve away from the slant line, releasing the pressure on the nib as you enter the curve. This second curve should touch the base line and curve back up very slightly. The pen should start to open at the end of the first curve and should start to close as you begin the second curve.

The basic downstroke needs a finishing stroke. Try these two options:

The first finishing stroke is a filled-in dot. Continue the upstroke of the second curve and turn back toward the base line, allowing the nib to open on the downstroke. Pause momentarily to be certain that the dot is neat and even.

The second option is a clockwise spiral. Extend the upstroke from the second curve of the basic downstroke to or above the waist line and curve back down (pressing on the downstroke) and then around and back up to make a spiral. Be sure that the spiral ends with a thin line.

Note that the spiral is oval and slants along the 55-degree axis:

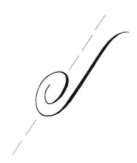

INCORRECT STROKES. Figure 1 starts like a minuscule downstroke, with a squared-off edge rather than a swelled stroke. Be sure to start the downstroke with a thin line and let the pen open as you complete the first curve rather than immediately.

The curves in Figure 2 are too round. The basic downstroke should have a graceful sweep; this one looks like a straight line with a circle added to each end.

In Figure 3, the spiral ends with a thick downstroke. It is preferable to end a spiral with an upstroke, but if you do end with a downstroke, do not press on the nib.

The spiral in Figure 4 is far too small, and in Figure 5, it is too round. The axis of the spiral in Figure 5 is vertical, rather than slanting at 55-degrees.

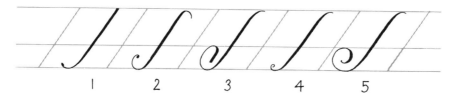

1 2 3 4 5

THE BASIC UPSTROKE

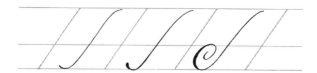

This form is exactly the same as the basic downstroke, but because the pen is moving up rather than down, the stroke is a hairline.

If you find that the pen bumps along on the upstroke, making a shaky line, try to keep it relaxed in your hand and let it slide gently up the page, rather than pushing into the paper. Be sure that the angle of the penholder is not too steep or the point of the nib will catch in the paper. If you are tense and grip the pen too tightly, the line will probably be unsteady. Take a deep breath, loosen your grip on the penholder, and try again.

Like the basic downstroke, the upstroke is incomplete. In this case, since the stroke begins at the base line rather than at the ascender line, the finishing stroke of the downstroke becomes a lead-in stroke. The lead-in stroke of the basic upstroke can be a filled-in dot or a spiral.

To start the basic upstroke with a filled-in dot, begin slightly above the base line with a short upstroke, curving to the left and back down. This motion will make the filled-in dot, which then continues into the hairline upstroke.

The second option is a counterclockwise spiral. Start with a short upstroke a little above the base line, and curve up to the waist line, around to the left, and down (allowing the nib to open) to the base line. Continue the curve into the basic upstroke. This spiral, like the one used as the finishing stroke of the basic downstroke, is oval, with an axis of 55 degrees.

THE O-FORM

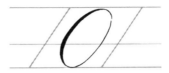

This form is almost identical to the basic minuscule o-form, explained in Chapter 2. It is a little wider and, of course, more than twice the height.

If you can make a minuscule o-form, you can certainly make a capital O-form.

THE (NEARLY) VERTICAL SWELLED STROKE

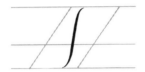

The word *vertical* is, in this case, a comparative term. The stroke is closer to 70 degrees (20 degrees off the vertical), although in some letters the slant varies by a few degrees. But compared to the 55-degree slant of the basic up- and downstrokes, this stroke is much closer to the vertical. For the sake of clarity, this stroke will be called "the vertical stroke," even though it is not generally a 90-degree line.

Like the basic upstrokes and downstrokes, this stroke starts and ends with a curve, but the curves in the vertical stroke are more subtle than in the other two. Start the stroke at the ascender line with a narrow fine-line curve, which swells almost immediately as you make your vertical downstroke. Release the pressure near the base line, and end with a narrow, hairline curve to the left.

Try making this stroke along a vertical axis and along an axis of 80 degrees. Compare these two strokes to a basic downstroke.

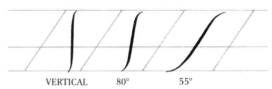

VERTICAL 80° 55°

INCORRECT STROKES. Figure 1 is too curved. Figure 2 is too straight and starts with a squared-off edge. Remember that this is a variation on the basic downstroke, not on the pressure-and-release stroke of the minuscule alphabet.

1 2

The Lead-In Strokes

The first three of these strokes will generally extend from the ascender line almost down to the waist line. The other two lead-in strokes are wider, but shorter.

The size of any of these strokes can vary substantially, depending on the degree of flamboyance of the capital letter. They should always be balanced with the other flourishes in the same letter. As you learn each of the capital letters and its variations, the concept of "balanced flourishes" will become clear.

THE SPIRAL LEAD-IN STROKE

The spiral lead-in stroke has the same shape as the spiral used with the basic upstrokes and downstrokes. It is a clockwise form that begins with an upstroke and then curves up and to the right, down, around, and back up to the ascender line. Finish the stroke with a hairline at the ascender line.

THE LOOP

The loop is similar to the spiral. Start in the middle of the ascender space with a curved hairline upstroke. At the ascender line, curve around to the right and back down, allowing the pen to open on the downstroke. At the bottom of this curve, near the waist line, swing back up and intersect with the downstroke just below the ascender line, making a loop that ends with a curve along the ascender line.

Both this stroke and the spiral lead-in stroke have axes of 55 degrees. The two upstrokes in each of these forms are parallel to each other:

INCORRECT STROKES. Both lead-in strokes in Figure 1 are slanted incorrectly. Keep an eye on your 55-degree guidelines so that these forms have the correct slant.

Figure 2 begins with a downstroke rather than an upstroke. This initial stroke makes the form look incomplete and awkward.

The first upstroke in Figure 3 is not parallel to the second upstroke.

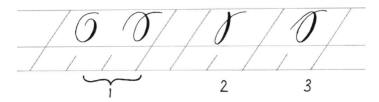

THE PRESSURE-AND-RELEASE LEAD-IN STROKE

This stroke should be familiar to you. It is almost identical to the basic pressure-and-release stroke of the minuscule alphabet. In this case, however, the final upstroke curves very slightly to the right at the ascender line. This is a subtle shift in direction that will make the tops of several capital letters more graceful than they would be without the curve.

THE HORIZONTAL LEAD-IN STROKES

Figure 1 is a single curve. It begins at the ascender line with a curve to the left, down, to the right, and then back up to the ascender line. Although there is a very short downstroke, it is generally preferable to make this stroke without any pressure on the nib. If the curve on the left is very deep, the pen may open; otherwise the stroke should remain a hairline from beginning to end.

Figure 2 is similar to the crossbar of the minuscule *f*. It is a double curve that touches the ascender line twice. This stroke, like the single-curve horizontal stroke, is a hairline.

HOW TO PRACTICE. Your familiarity with the Copperplate pen should make these strokes fairly easy to master. However, before you start the actual capital letters, be sure you understand the action of the pen during the swelled stroke, and the shape and slant of all the strokes.

Practice the four basic body strokes and the five lead-in strokes until they flow easily from your pen and are graceful and well-balanced.

The Letterforms

Although the instructions for the minuscule letters were arranged by letter group, the capital letters are explained in alphabetical order. A few new strokes will be introduced as we progress, but there is nothing here that can't be managed quite well by a competent handler of the flexible pen.

To help you organize your practicing, the alphabet is divided approximately into thirds: *A* to *H*, *I* to *Q*, and *R* to *Z*. At the end of each section, there is information on connecting capital letters to minuscules and suggestions on how to practice. Just remember to work slowly, keep the pen relaxed in your hand, and think about each stroke as you make it.

The letters that follow are among the simpler forms of the capitals. Often, one or two variations are shown, usually based on the optional beginnings and endings of the basic strokes explained in the previous chapter. After you understand these letters, you will certainly enjoy trying some of the more decorative alternatives shown later in this chapter.

By now it is assumed that you are automatically pressing on the downstrokes and releasing on the upstrokes. Instructions about when to press and release are, therefore, not given unless particular exceptions or subtleties have to be pointed out.

In some cases, letters will be shown in an "exploded view"; that is, the strokes will be shown individually.

Jeanyee Wong, "The Philadelphia Ladies Association," finished lettering for "American Heritage" magazine. Written with Gillott 303 nib, India ink, reduced for reproduction.

Jeanyee Wong, "Almond Trio" and "Almond Quartet," for cosmetic packaging. Drawn letters based on Copperplate forms, written with Gillott 303 nib, reduced for reproduction.

Group One: A to H

A	B

The *A* consists of the basic upstroke, a downstroke along the 55-degree axis, and a hairline cross-stroke.

Start the upstroke with either a spiral or a filled-in dot, and make an upstroke that is slightly more slanted than 55 degrees. If your upstroke is made directly along the axis, the counter space of the *A* will be too narrow. Just below the ascender line, finish the upstroke with a curve to the right, and, leaving the top slightly rounded, start back down toward the base line.

The downstroke should be the same as the basic pressure-and-release downstroke of the minuscule *l*, ending with a curve at the base line and an upstroke. Note that the very top of this stroke curves gently from the left.

The cross-stroke of the *A* is a horizontal hairline positioned at the waist line.

INCORRECT LETTERS. The upstroke in Figures 1 and 2 follows the 55-degree slant line. The counter of Figure 1 is consequently too narrow. The wide curve at the top of Figure 2, which allows sufficient counter space, makes the letter look too angular. The counter of the *A* should be wider at the base line than at the top.

The cross-stroke of Figure 3 is too high. Because the A's counter is narrower at the top than at the bottom, the cross-stroke should be below center to divide the counter space visually.

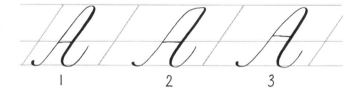

The *B* is made in two strokes.

Start with a basic downstroke, ending with either a filled-in dot or a spiral.

The second stroke starts with either a spiral or a loop, curves up to the ascender line, crosses the downstroke, and swings out to the right to form two curves on the right side of the downstroke. These two curves are separated by a small loop positioned slightly above the center of the space. This loop sometimes touches the downstroke.

To make the right side of the *B* properly, start pressing on the nib after the second stroke crosses the first stroke, just below the ascender line. At the point where they intersect, these two strokes should both be hairlines. Press on the nib as you make the upper curve, release the pressure to make the loop, and press again to make the lower curve.

The lower curve of the right side of the *B* is slightly wider than the upper curve. End the second stroke with a hairline upstroke inside the lower curve.

Either form of the second stroke of the *B* (spiral or loop lead-in stroke) can be combined with either first stroke. The size of the upper flourish depends on the size of the lower flourish. Thus, with a filled-in dot at the base line, a large flourish (spiral or loop) may be used at the top. With a spiral at the base line, the flourish at the top would be smaller.

INCORRECT LETTERS. The loop separating the two curves in Figure 1 is too low.

In Figure 2, the lower curve is too wide. The lower counter should be bigger than the upper counter, but not this much bigger. Avoid making bottom-heavy B's.

In Figure 3, the space between the first downstroke and the curves is too wide. The center loop should be close to the first downstroke so that the B's form is not distorted.

In Figure 4, too much pressure was placed on the nib at the top of the ascender space. Crossing two thick lines is not as graceful as crossing two hairlines.

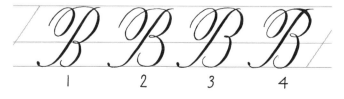

The *C* is made in one stroke. It is a combination of a lead-in stroke, an O-form, and a counterclockwise spiral finishing stroke. Note that the upper flourish fills about one-half of the ascender space and that the lower flourish extends above the waist line.

INCORRECT LETTERS. The flourishes in Figure 1 are too small.

The *C* in Figure 2 is not based on an O-form. It is important that you curve around to the left on the downstroke and then back to the right (forming the left side of the O-form) rather than follow the 55-degree slant line. This guideline serves as an axis for the *C*, not as a line to trace.

The final stroke in Figure 3 has a blunt ending. Be sure to release the pressure on the nib and curve back up to complete the spiral with a hairline.

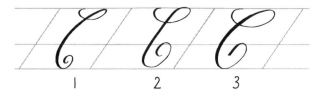

1 2 3

HOW TO PRACTICE *C*'s. If you're having difficulty with the basic shape of the C, go back to the capital O-form. Make some large O's. Then superimpose the *C* on the O:

The *D* is made in two strokes, although it looks like a single-stroke letter. It is important to know where the first stroke ends and the second one begins.

The first stroke of the *D* is the basic downstroke that ends with a flattened loop along the base line. The stroke ends exactly where the final hairline touches the downstroke.

The second stroke begins with either a spiral or a loop that curves up to the ascender line and around to the right, crossing the downstroke and making a wide arc. At the base line, the stroke curves very slightly back up and ends at the same point as the first stroke, giving the illusion that the *D* was made in a single stroke. The *D* can be made in one stroke, but this necessitates making the arc on the right side of the letter as a hairline upstroke. Since it is easier to move the pen down than up, you can control the shape of the curve and the quality of the line by making the letter in two strokes.

INCORRECT LETTERS. The two strokes in Figure 1 are not connecting properly because the first stroke extends too far to the right. It is almost impossible for two fine lines to join perfectly. Connecting the two strokes of the *D* at the point of intersection with the downstroke allows a small margin of error; if the strokes don't meet perfectly, it is much less noticeable.

The curve of Figure 2's second stroke is warped. Try to make a graceful, nicely balanced curve that does not head downhill too suddenly.

The loop at the base line of Figure 3 is too round. This form should be wider than it is high.

1 2 3

The *E* is based on the O-form. It is made in a single stroke.

Start the *E* as you do a *C*, with a curved lead-in stroke beginning at the ascender line. Like the *B*, the *E* has two large curves separated by a small loop. To make these two curves, press on the nib on the downstroke, but be sure to release the pressure when making the loop.

The loop is located above the center of the letter space. The lower curve is therefore larger than the upper curve. It also extends further to the left. If you draw a 55-degree line through the downstroke of the upper curve, it will fall to the right of the downstroke of the lower curve, as indicated above.

Complete the *E* with a counterclockwise spiral, ending in a fine-line upstroke.

INCORRECT LETTERS. The lead-in stroke in Figure 1 dips down too low, bumping into the loop at the center of the letter.

In Figure 2, the flourishes are too small. Undersized flourishes always look silly.

The lower curve in Figure 3 is on the same slant line as the upper curve. This makes the letter too vertical.

In Figure 4, the lower curve is exaggerated. It is too round and swings back too far to the left, making the letter look as if it's about to topple over.

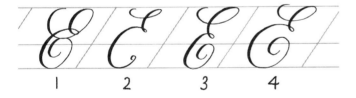

The *F* shown here is made in three strokes, although there are numerous variations that can be written in two or even one stroke (these will be discussed later). This form is the simplest.

Start the *F* with the top stroke — a combination of either the spiral or the loop lead-in stroke with the horizontal double curve. The horizontal stroke is made without pressure and touches the ascender line twice.

The second stroke is the basic downstroke. Start below the ascender line, leaving a little space below the first stroke. End the second stroke with either a filled-in dot or a spiral. Note that the spiral's axis is in line with the upper flourish, as shown above.

The cross-stroke of the *F* may be a simple horizontal hairline or a hairline that curves up at the beginning and again at the end. The cross-stroke is positioned at the waist line.

Either base-line stroke and either cross-stroke may be combined with either lead-in stroke. Using various combinations of the two lead-in strokes, two base-line endings, and two cross-strokes, you can make eight different *F*'s:

There are actually many more *F*'s. We'll deal with them later in this chapter.

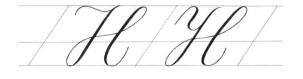

The *G* is a two-stroke letter. The upper part of the *G* is a combination of the lead-in curve and an O-form. The second stroke is an enlarged basic descender stroke.

Start the *G* at the ascender line, as you would a *C*, with a curved lead-in stroke looping around in a form similar to the O-form. About two-thirds of the way down from the waist line to the base line, curve back up to a point about midway between the ascender line and the waist line.

The second stroke is a descender stroke with a squared-off top and a loop that is somewhat fuller than the standard descender loop. The upstroke of this descender crosses the downstroke at the base line.

A standard minuscule descender loop is too narrow to support the upper part of the *G*:

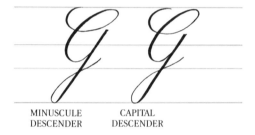

MINUSCULE DESCENDER CAPITAL DESCENDER

The *H* is made in one stroke with a pause between the end of the lead-in stroke and the beginning of the first downstroke.

The lead-in stroke can be either the simple double curve, the double curve starting with a spiral, or the pressure-and-release stroke. At the end of the lead-in stroke, pause briefly and begin your basic downstroke with a small curve. Start to press on the nib after the downstroke is no longer touching the lead-in stroke.

At the base line, swing around to the left and up, making a loop that crosses the downstroke and continues on a slight diagonal up to the ascender line, around to the left, and back down to the base line. The path taken by this stroke will form the cross-stroke of the *H* and a second loop on the upper right, balancing the one on the lower left.

End the letter with a hairline upstroke from the base line.

Be sure that your two downstrokes are parallel and not too close and that the diagonal stroke does not go uphill at too sharp an angle.

INCORRECT LETTERS. In Figure 1, the first downstroke is too heavy at the top. Be sure to make a hairline before starting to press on the nib.

The cross-stroke in Figure 2 is too steep. This steepness pulls the two downstrokes too close together. A flatter diagonal will create a more attractive counter.

The second downstroke in Figure 3 is too curved. This stroke should not be based on the O-form.

1 2 3

Connections

Of the letters *A* to *H*, only the *A*, *G*, and *H* end with exit strokes to the right of the letter. These letters can be joined easily to the next letter in a word:

Anna George Harvey

Note that the cross-stroke of the *A* should be made after you complete the word so that you do not interrupt your rhythm.

The *B*, *C*, *D*, *E*, and *F* do not connect to the letters that follow them, unless the form of the final stroke (in the *B*, *C*, *E*, and *F*) is varied. This will be shown later in this chapter. Judge your spacing carefully when starting words with these letters.

Barry Carole Daniel

Eleanor Frank

HOW TO PRACTICE A to H. Now that you are familiar with one-third of the capital letters, spend some time working on them before you start the next group. It would be a mistake to let your minuscule letters go unpracticed, so try writing some words beginning with each of the first eight capital letters.

Write boys' names, girls' names, names of cities, countries, flowers, foods or anything you choose. Try to come up with long words so you can concentrate on lowercase spacing and connections. Here are some samples:

Artichoke Blueberry

Canteloupe Dandelion

Eggplant Fennel Grape

Honeydew

Try making up a sentence starting each word with one of the capitals, if possible using the letters sequentially. It needn't make sense.

Now try writing each of these capital letters with a No. 2 pencil. Remember to press only on the downstrokes; since it's just as easy to make a heavy stroke on an upstroke with a pencil, you have to pay close attention to what you are doing.

You will probably find that your curves and flourishes are easier to make with a pencil. Try writing them larger to feel the rhythm of the stroke.

You will have to sharpen the pencil frequently to get a reasonable thick/thin contrast.

Group Two: I to Q

I		J

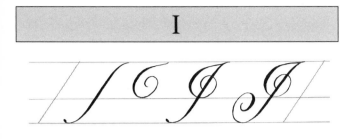

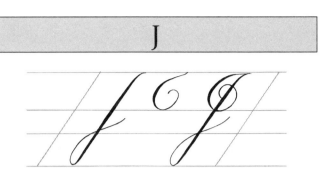

The *I* is made in two strokes.

Start with a basic downstroke, ending with either a filled-in dot or a spiral.

The second stroke is a new form. Put your pen on the point where you started the first stroke and make a short curved stroke to the left. Then swing outward and back in to the right, crossing the downstroke slightly above the middle of the stroke. Curve back upward into a counterclockwise spiral. This stroke, enlarged, looks like this:

Notice that the end of the spiral is a downstroke made without any pressure.

INCORRECT LETTERS. Too much pressure was placed on the nib at the top of Figure 1. The two strokes must be started with hairlines so the letter doesn't look too thick at the top.

The ending of the second stroke of Figure 2 is too heavy. Although this is a downstroke, a hairline ending is far more graceful than a thick stroke.

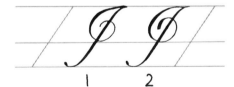

The *J* is similar to the *I*.

Start with a basic downstroke, which continues all the way to the descender line and curves around to the left and back up to form a descender. The upstroke of the descender crosses the downstroke at the base line. As it is with the capital *G*, the counter of the *J*'s descender is longer and fuller than that of the minuscule descender.

The second stroke is the same as the second stroke of the *I*.

K

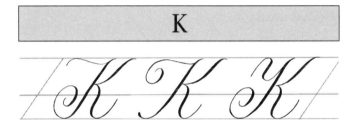

The *K* is made in two strokes.

Start with a lead-in stroke with or without a spiral. Pause at the end of this stroke, as you do when making an H, and make a basic downstroke ending with either a filled-in dot or a spiral.

The second stroke starts at the ascender line and is a swelled stroke that looks like a bracket. The upper part curves in to meet the first downstroke at the center of the stroke and then swings back out and down to the base line. The stroke ends with a hairline upstroke.

The lower part of this "bracket" is the same as the lower part of the minuscule *k*, only larger. Observe the pressure and release variations on this stroke:

You will be making four transitions from thin to thick or thick to thin in the same stroke. Make this stroke slowly so the center is a fine line and the curves are graceful.

The *L* is a one-stroke letter.

Start the *L* with a curved lead-in stroke that swings across to the right and up to the ascender line, around to the left and back down to the base line, making a basic downstroke.

The loop at the bottom of the downstroke is flattened and elongated like the loop at the bottom of the *D*.

Without putting any pressure on the nib, continue the stroke across the base line, curving down and back up. This final stroke is similar to the double curve lead-in stroke.

INCORRECT LETTERS. The loop at the top of Figure 1 is too small. It should be an elegant curve with a generous counter.

In Figure 2, pressure was placed on the nib during the base line stroke. Because this is essentially a horizontal stroke, the pen does not open easily during the movement from left to right. This stroke is therefore uneven and shaky.

The *M* has two upstrokes and two downstrokes.

The first upstroke, like the upstroke of the *A*, is slightly more slanted than 55 degrees.

The second stroke is a swelled downstroke: the 80-degree version (approximately) of the vertical swelled stroke. Release the pressure before you reach the base line and curve the stroke very slightly to the left.

The second upstroke (third stroke) is parallel to the first upstroke, and the final downstroke is parallel to the first downstroke but ends with a curve to the right at the base line, and a hairline upstroke.

INCORRECT LETTERS. The top points and center point of Figure 1 are too thick. Both of the downstrokes must be swelled strokes, which begin and end with hairlines.

The two downstrokes in Figure 2 are not parallel. The counters are therefore uneven and the letter is off-balance. In Figure 3, the two upstrokes are directly on the 55-degree slant line. The downstrokes are therefore too vertical and the letter does not slant enough.

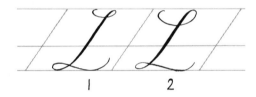

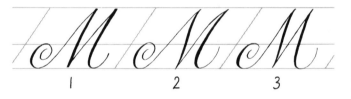

HOW TO PRACTICE *M*s. Use your 55-degree guidelines to bisect each segment of the *M*.

Analyze your *M*s by drawing lines through each stroke to see if the two upstrokes and two downstrokes are parallel. Be sure that the counters are visually equal.

Check that the center point on the base line and the two top points at the ascender line are hairline strokes.

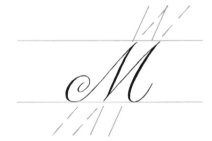

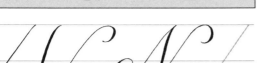

The N is similar to the M, although the counters of the N are wider than the counters of the M. The N is made in three strokes.

Start the N with a basic upstroke, following the 55-degree slant line. Pause at the ascender line, then make a vertical swelled stroke, pausing again at the base line.

Make a second upstroke, parallel to the first, and curve around at the ascender line and down part way into the ascender space.

INCORRECT LETTERS. The downstroke in Figure 1 is slanted to the right. This makes the letter too wide and off balance.

In Figure 2, the curves of the swelled downstroke are too prominent. They should be very subtle.

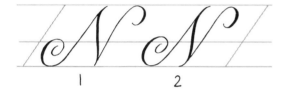

1 2

The O is essentially a simple letter that may not be so easy to do well. It is based on the capital O-form and is made in one stroke.

Start below the ascender line and make a capital O-form in a counterclockwise motion. As you complete the upstroke, curve to the left, back down and around to the right, intersecting the upstroke to form a loop. End in a curved hairline exit stroke. The exit stroke is just above the waist line.

The reason an O is difficult to make is that in such a simple, undecorated letter, any irregularities in the shape are noticeable. In addition, the long upstroke on the right side of the letter is sometimes less smooth than it should be.

INCORRECT LETTERS. In Figure 1, the exit stroke from the loop crosses the upstroke too low. This letter might be confused with an A.

The loop in Figure 2 is too small. Not only is this flourish insignificant and foolish looking, but it also leaves a long thin upstroke that should have been broken by the intersection of the exit stroke.

The upstroke in Figure 3 is too straight. Be sure to curve out and then back in on the upstroke to make a nicely balanced counter.

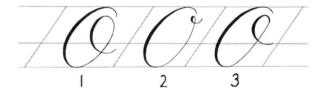

1 2 3

HOW TO PRACTICE O's. If you're having difficulty with the basic form of the O, review the capital O-form in the previous chapter. Make a series of O-forms in pencil, then in ink without the loop and exit stroke, and then make the complete O.

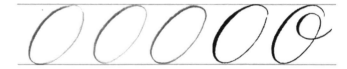

Like the *B*, the *P* can be made of various combinations of lead-in strokes and flourishes, built upon the basic letter form.

Start with a basic downstroke ending in a filled-in dot or a spiral.

Start the second stroke with either a spiral or a loop and swing around at the ascender line, cross the downstroke, and curve to the right, down, and around to the left. Complete this form with either a filled-in dot or a hairline upstroke. This shape is about one-half the height of the letter.

You can combine the various loops, spirals, and ending strokes to make eight variations on the *P*.

The *Q* combines a clockwise spiral, the capital O-form, and the loop and exit stroke of the *L*.

Start the spiral in the *Q* in the middle of the ascender space and curve up, around, down, around, and back up to the ascender line. At the ascender line, swing around to the right and down to make a form like the O-form, but in the opposite direction (the thick downstroke is on the right in the *Q*, on the left in the *O*).

The downstroke of the *Q*, however, does not follow the O-shape all the way to the base line. About two-thirds of the way down from the ascender line, curve to the left and across the base line. Finish the *Q* with a flattened loop and a horizontal exit stroke that touches the base line and curves back up. This is the same as the loop and exit stroke of the *L*.

Note the relationship between the base-line loop of the *Q* and the lead-in stroke, along the 55-degree axis:

INCORRECT LETTERS. In Figure 1, the base-line loop is too far to the right. The downstroke must curve further to the left before making this loop, or the letter will be too vertical.

The downstroke in Figure 2 is too slanted. The shift to the left must come out of a graceful curve, not a sharp diagonal.

1 2

Connections

The *J*, *K*, *L*, *M*, and *Q* connect to the minuscule letters by means of the hairline exit stroke. Shorten this stroke slightly in the *L* and *Q* so you don't leave too large a space between the capital and the minuscule:

In the case of the *O*, the exit stroke can connect to minuscule letters that have ascenders. It is equally acceptable, however, not to do so, and to start the ascender at the base line:

Do not connect the *O* to minuscules without ascenders. To do so, you would have to dip the exit stroke of the *O* down too far, thus making the *O* look like an *A*.

The *I*, *N*, and *P* don't connect with the next letter. As with *B*, *C*, *D*, *E*, and *F*, space the capital and minuscule carefully without having them touch each other.

HOW TO PRACTICE I to Q. You have now completed the second third of the capital letters. This is a good time to take a break and review these nine letters. Reread the "How to Practice" suggestions for A to H.

Allow yourself plenty of time to practice these letters, both in pencil and in ink. Concentrate on such unfamiliar strokes as the tops of the *I* and *J* and on the more difficult letters: the *M*, *N*, and *Q*.

Take some time to review the first eight letters as well. You'll find that after practicing *I* to *Q*, *A* to *H* seem easier.

Group Three: R to Z

R	S

The *R* is quite simple. If you can make a *B* and a *K*, you can make an *R*.

Start with a basic downstroke.

The second stroke is the same as the *B* as far as the center loop on the right side of the letter. The final downstroke is the same as the lower part of the *K*.

As in the *B* and the *P*, you can combine the various downstroke options with either of the two lead-in strokes.

The *S* is made in one stroke.

The upstroke of the *S* is different from the basic upstroke. Start with a hairline upstroke, which curves up, flattens out slightly, and curves up again to the ascender line. This stroke looks like the top of the *F* made on an uphill diagonal.

At the ascender line, curve around to the left and back down along the 55-degree axis, making a basic downstroke, which touches the base line and curves up into a spiral, which intersects the upstroke twice. Note that this spiral is rounder than the standard form:

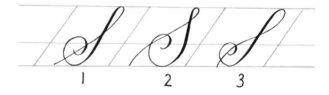

STANDARD SPIRAL "S" SPIRAL

INCORRECT LETTERS. The upstroke in Figure 1 starts with an underhand curve rather than an overhand curve. The counter is therefore too narrow. An overhand curve will prevent the counter from closing.

The downstroke in Figure 2 is too vertical. This stroke must slant along the 55-degree axis or the letter will be too upright.

The loop at the top of Figure 3 is too large. This loop should extend approximately one-third of the way down between the ascender line and the base line.

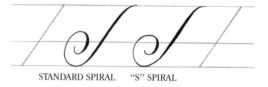

1 2 3

HOW TO PRACTICE the S. Try making the upstroke of the *S* independently of the rest of the letter. It should be a graceful double curve.

T

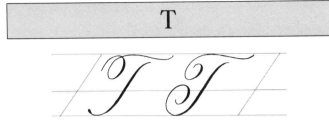

The *T* is easy. Follow the directions for the *F* minus the cross-stroke (see p. 89).

U

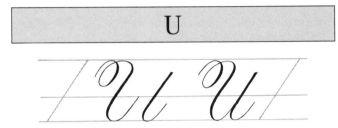

The *U* is a two-stroke letter.

The first stroke of the *U* starts with either a spiral or a loop, which continues into a downstroke. About three-quarters of the way down (between the ascender line and the base line), start to curve the stroke to the right, down to the base line, around and back up to the waist line. The inside shape of the lower part of the *U* should be nicely rounded, neither too narrow nor too angular.

The second stroke of the *U* is a basic minuscule pressure-and-release stroke with a squared-off top. Start this stroke about one-third of the way down from the ascender line (the height of the minuscule *d*). The distance between the downstroke and the upstroke (the exit stroke) should be a little greater than in the minuscule *u*.

INCORRECT LETTERS. The downstroke in Figure 1 starts to curve to the right too close to the base line. This creates a narrow counter.

In Figure 2, the second stroke starts at the ascender line. This make the counter look elongated. A counter with a shorter stroke on the right is more graceful.

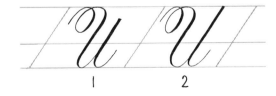

1	2

V

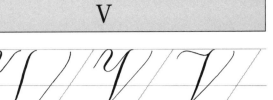

The *V* has several subtle curves and should be written slowly.

Start with either the pressure-and-release lead-in stroke or a horizontal hairline curve. If you choose the pressure-and-release stroke, end with a small curve to the right.

Pause at the ascender line and make a downstroke that is almost vertical, slanting just a little to the left. This is a swelled stroke; it begins and ends in a fine line.

The final stroke is an upstroke, which curves in briefly, then out to the right, and then back in toward the ascender line. This final inward curve is gradual; it starts about halfway up.

Notice the relationship between each of these strokes and the 55-degree axis:

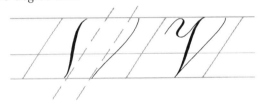

INCORRECT LETTERS. In Figure 1, the downstroke slants to the right. The *V* is therefore too vertical.

In Figure 2, the downstroke slants along the 55-degree axis. This *V* leans too far to the right.

The upstroke in Figure 3 is too curvy, weakening the letter. The two curves in the upstroke should be more subtle.

The second curve of the upstroke of Figure 4 is too round at the ascender line. This curve is not a decoration; it is part of the upward sweep of the stroke.

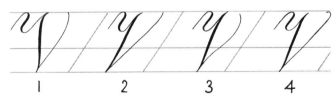

1	2	3	4

HOW TO PRACTICE THE V. If you're having difficulty finding the correct axis for the *V*, start the downstroke a little to the left of a slant line and end this stroke at the point where the slant line touches the base line. When you make your upstroke, try to leave the same amount of space between the slant line and the upstroke as there is between the slant line and the downstroke.

The *W* is actually a double *V*, although the counters of the W are a little smaller than the counter of the V.

For the *W* to have elegant points at the ascender line and the base line, it's necessary to pause at the beginning and end of each downstroke.

Start the *W*, as you do the *V*, with a lead-in stroke, followed by a pause and an almost-vertical downstroke. Slant this downstroke just slightly more to the left than the downstroke of the *V*. This will create a counter that is a little narrower than the *V*'s counter.

The first upstroke of the *W* is different from the *V*'s in that it does not curve to the left at the top but maintains a straight diagonal direction after the initial curve.

The second downstroke is parallel to the first downstroke and is exactly the same form.

The second upstroke is the same as the upstroke of the *V*; it curves inward toward the ascender line.

Be sure that the counters are visually equal and the two upstrokes and two downstrokes are parallel. The 55-degree axis should bisect each of the counters.

INCORRECT LETTERS. The counters in Figure 1 are too big because the downstrokes are vertical.

In Figure 2, the downstrokes do not show the thin/thick/thin variations of the swelled stroke. Instead, they are thick from top to bottom (it is also possible to make this error in the *V*). Writing slowly and pausing at the top and bottom of these strokes will prevent this.

The second downstroke of the *W* in Figure 3 is not parallel to the first downstroke.

1	2	3

HOW TO PRACTICE THE *W*. Try making each of the strokes of the *W* separately. This will help you analyze the relationships and will ensure that the tops and bottoms of the downstrokes are fine lines.

The *X* is made in a single stroke. If the loops on the lower left and the upper right are nicely balanced, this is a lovely letter.

The first stroke is the same reverse curve as the first stroke of the minuscule *x*. Do not press on the nib. The arc of this curve should be the same as the right side of an *O*.

At the base line, curve around to the left, up and to the right, intersecting the downstroke in the center. Continue this stroke to the right and up to the ascender line. This hairline cross-stroke (the upper part of the left loop and the lower part of the right loop) is almost the same as the first stroke of the *S*.

At the ascender line, curve to the left and back down to the base line in the same stroke as the *C*. This stroke should be directly on top of the first downstroke for the middle third of both strokes:

The 55-degree axis should bisect the *X*.

Keep in mind that the first downstroke of the *X* is made without pressure.

INCORRECT LETTERS. The downstrokes in Figure 1 are too vertical. If the first downstroke is made correctly, the rest of the letter will generally fall into place.

In Figure 2, pressure was placed on the nib during both downstrokes. The center therefore has a double thickness.

The counters of the two loops in Figures 3 and 4 are uneven. This unevenness makes the *X* top-heavy in Figure 3 and bottom-heavy in Figure 4.

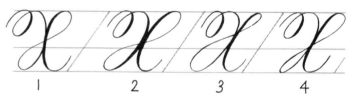

1	2	3	4

The *Y* is a combination of the *U* and the *G*.

The first stroke of the Y is the same as that of the U except that it does not extend all the way to the base line. Like that of the *G*, the curve of the *Y* sits about two-thirds of the way down between the waist and the base lines.

The second stroke is the same descender stroke as the *G*'s. It is a little wider than the minuscule descender and crosses the downstroke at the base line.

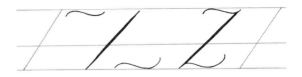

The Z consists of three strokes. The first and third strokes are like the horizontal lead-in stroke but with deeper curves.

Start the first stroke with a hairline or a spiral, curving up to the ascender line. Curve downward a little more than in the standard lead-in stroke.

At the ascender line, pause and make a straight diagonal down to the base line. This stroke should swell: it starts thin, then thickens, and ends at the base line with a hairline. When making this stroke, aim for a point on the base line to the left of the first stroke so that the letter will slant properly.

The third stroke is similar to the first stroke. It has two curves, both of which are fuller than the standard lead-in stroke. The nib should open in the center of the stroke. End with a curve up to the waist line and around to the left.

INCORRECT LETTERS. In Figure 1, the center stroke is unvaried. This stroke should be lighter in weight at the top and bottom than it is in the center.

The first and third strokes of Figure 2 are too flat. This makes the letter look boring.

The first curve in Figure 3 is unbalanced. It is too deep on the right, which makes the letter look a little squashed. In addition, the base-line end of the diagonal is directly under the lead-in stroke; the letter is therefore too vertical.

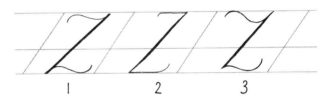

1 2 3

Connections

The rules for connecting the letters *R* to *Z* are the same as the rules for the previous seventeen letters. The *R*, *U*, *X*, *Y*, and *Z* connect to the minuscule letters by means of their exit strokes. The *S*, *T*, *V*, and *W* do not connect.

Roger Steven Thomas

Ursula Victor Wendy

Xavier Yolanda Zachary

HOW TO PRACTICE. Practice this last group of letters as you did the two previous groups. Work slowly. Think about what you are doing.

Write words and sentences, trying out the variations of each letterform and comparing similar letters: the *M* and the *W*, the *G* and the *Y*, the *S* and the *X*, the *T* and the *F*. Write all the capitals sequentially, concentrating on consistency of basic strokes, counters, curves, and flourishes.

The Capital Letters: Variations

The eighteenth-century writing masters displayed their highest skills in ornate, flourished capital letters and in decorations, cartouches, and ornamentation. Although a student of Copperplate cannot compete with penmen who devoted many years of their lives to perfecting their calligraphy (and whose every unsure or irregular stroke was corrected by the engraver's burin), there are many ways you can embellish your letterforms.

Some of the capital letters in this section are simpler than those you have already learned. Most, however, are more elaborate. None are difficult. By combining elements from these letters—a baseline flourish from one letter and an exit stroke from another, for example—you should be able to create many letterforms not shown on these pages.

Many of the letters in this chapter are selections from or interpretations of the engraved Copperplate exemplars of such eighteenth-century writing masters as Joseph Champion, George Shelley, Willington Clark, and Charles Snell. *The Universal Penman* is a sumptuous source of ideas and examples from the pens of these masters. No serious student of Copperplate should be without a facsimile of this book. Looking at reproductions of the artwork of these writing masters and copying them or even tracing them will help you learn more about Copperplate.

After you are familiar with the basic Copperplate capitals as shown in the previous section and have tried some of the variations in this section, you will be ready to create some of your own. The variations on the capital letters are only limited by your imagination and good taste.

If you studied the last section carefully, you now know the rules about basic downstrokes, basic upstrokes, and some simple flourishes. Consequently, the instructions in this section are not as detailed as in the previous chapter. In some cases, the strokes are indicated by arrows and numbers. In other cases, particular subtleties are explained or relationships noted.

You will probably like some of these letters better than others. You may dislike some of them. Or you might select certain examples and improve upon them, perhaps by widening a counter or making a flourish bigger or smaller. But you should certainly try them all. It is too easy to use a single set of capital letters without ever exploring other possibilities. And, as with the minuscule letters, the more you know, the more options you have.

Jeanyee Wong, "Happy Anniversary", personal greeting card. Written with Hunt 108 nib, Higgins Eternal ink, same size.

A

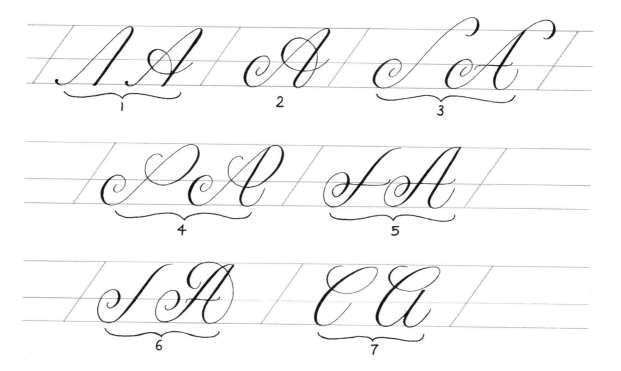

Figures 1 and 2 are fairly simple forms that are similar to the capital *A* already discussed in this chapter. The variation is in the cross-stroke, which starts at the bottom of the downstroke and is a counterclockwise loop intersecting the upstroke twice. In Figure 1, the cross-stroke is the second stroke; in Figure 2, it is part of the first (and only) stroke.

The *A*'s in Figures 3, 4, and 6 are all ornate. Note the double curve of the cross-strokes in Figures 3 and 6. The cross-strokes in Figures 4 and 5 are each part of the first stroke of a two-stroke letter. They must, therefore, be positioned carefully without the visual aid of the right side of the letter.

Figure 7 is based on the minuscule *a*. Notice that the lead-in stroke, loop, and curved downstroke are similar to the capital *C*. The second stroke starts approximately halfway between the ascender line and the waist line.

Figures 1 to 4 are all single-stroke letters. Figure 1 is deceptively simple; the upstroke must be smooth and perfectly rounded or the effect will be spoiled. The variation on this, Figure 2, is actually a little easier to do.

Try to make the two loops on the base line in Figure 3 equal.

Figures 5 and 6 each have two strokes. Figure 5 is somewhat more conservative than the other variations, and Figure 6 is a little more elaborate. The two flourishes in Figure 6 must be quite big for them to intersect properly.

There is a similarity between B in Figure 4 and A in Figure 5 opposite. The strokes from the base line into the flourish of each of these letters curves downward to form a loop. If this curve is too small, the loop will be positioned badly and the flourish will be weak.

CORRECT INCORRECT CORRECT INCORRECT

C

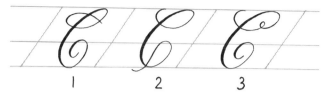

There aren't too many variations on the capital C.

The lead-in stroke in Figure 1 is a double loop that starts on the right side, about halfway between the ascender line and the waist line. To make this stroke, start with a curve that begins and ends on the same horizontal plane. At the furthest point to the left, curve down, around, and up to the right as far as the ascender line, then back to the left, and down. The two loops should be approximately equal in area. The left-hand loop is lower than the right-hand loop.

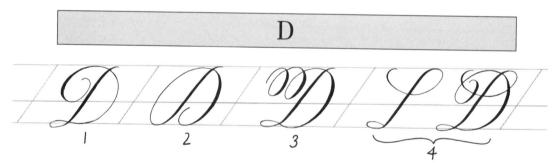

This lead-in stroke continues downward into the standard form of the C.

This "double loop" lead-in stroke can also be used in the E, G, and L.

The C in Figure 2 has an exit stroke that loops through the curve of the letter and continues below the base line. It is necessary to release the pressure as you make this loop, even though it is a downstroke; otherwise the exit stroke will be too heavy.

D

The first D (Figure 1) is the same shape as the standard D, but it is made in a single stroke, which necessitates a long, smooth upstroke to form the letter's right side. This upstroke may be difficult unless the paper is quite smooth and your hand is steady and relaxed.

There is a similar difficulty in making Figure 2, although the upstroke forming its left side is easier to do than the upstroke on the right side of Figure 1. This is because the curve on the left side can vary somewhat; that is, it can be less than perfect, without affecting the basic letterform, but the curve on the right side must be shaped exactly right (see p. 88 for an explanation of the basic D shape).

The other two D's are made in two strokes with the same base-line connection as the standard D. The flourish at the top of Figure 4 is similar to the B's base-line flourish in Figure 3.

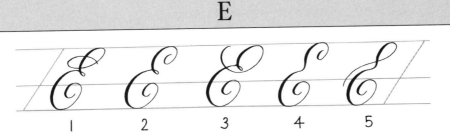

1	2	3	4	5

Figures 1 to 3 are the standard *E* with variations on the lead-in stroke. Be sure to curve this stroke downward sufficiently in Figure 3 so the curve does not bump into the small loop.

The *E*'s in Figures 4 and 5 have a slightly different basic structure: the two curves are less rounded than in the standard *E*, and they are separated by a small curve, rather than by a loop. Release the pressure on the nib when making this curve. The variations of pressure should look like this:

Notice that the lead-in stroke in Figure 5 is similar to the first stroke of the *S*.

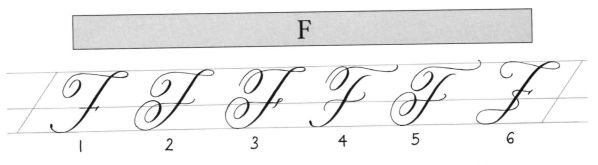

1	2	3	4	5	6

Like the minuscule *f*, the capital *F* has numerous variations. Some of these are made in a single stroke, others in two or three.

Most of these letters are self-explanatory. There are some variations on the cross-stroke, including the sweeping double curve in Figure 4, which makes a very simple letter look more graceful. Try the same *F* with a small, straight horizontal cross-stroke and compare them.

To make the base-line flourishes in Figures 2, 3, and 5, follow the instructions on p. 87, where correct and incorrect forms of the *A* and *B* are shown.

The final *F*, Figure 6, is rather idiosyncratic, but it has a graceful cursive quality.

G

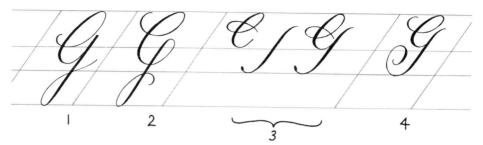

1 2 3 4

Figures 1 and 2 have the same proportions as the standard *G*. Figure 1 is made in two strokes with a squared-off edge at the beginning of the second stroke. Figure 2 has one stroke; it is a particularly graceful letter.

Figures 3 and 4 both fit between the ascender line and the base line and are each made in two strokes. The second stroke of both letters begins about halfway between the ascender line and the waist line and is a short form of the basic downstroke. Start this stroke with a small curve from the right, and remember that the basic downstroke is a swelled stroke.

H

1 2 3 4 5 6

There are many elaborate forms of the *H*, most of which are quite easy to do. It is, however, important to maintain a well-proportioned counter, no matter what the flourishes or embellishments may be.

Figures 1 to 4 are all variations on the simple *H* shown in the previous sections. Note that, of the four, only Figure 2 is made in two strokes; the others are single-stroke letters.

Figure 5 has four strokes, with a simple horizontal cross-stroke connecting the two downstrokes. The second downstroke of this *H* is rounder than most of the other downstrokes.

When making the second stroke of Figure 6, be sure to estimate the length and position of the horizontal curve carefully so the cross-stroke and the counter will be accurate.

I

1 2 3

The danger when using an alternate form of the *I* is that it may be mistaken for a *T*. Keeping the lead-in stroke short and lightweight will generally help to avoid ambiguity, but before switching to an alternate *I*, be certain that there is no doubt about what letter it is.

Notice that the base-line flourishes in Figures 2 and 3 are both rather large; they extend up above the waist line.

J

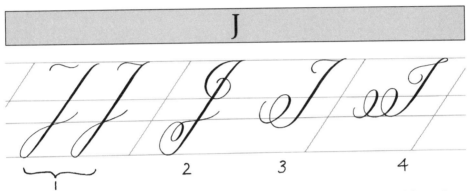

1 2 3 4

The *J*, like the *I*, is sometimes ambiguous and can be confused with an *I*.

The first stroke of Figure 1 is a lead-in curve written slightly smaller than it is on an *H* or *K*.

Figure 2 is a variation on the standard *J*, with a decorative loop in the descender, like the A in Figure 5.

Figures 3 and 4 are both made with a single stroke. Figure 4, with its rather ornate ending, should be used with discretion. It is this form of the *J* that might be mistaken for an *I*.

K

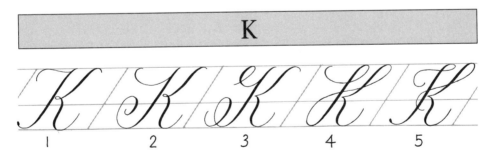

1 2 3 4 5

Like the *H*, the *K* has many variations, but the basic letter, consisting of a basic downstroke and a bracket-shaped second stroke, remains unchanged despite the addition of loops and curves.

Figures 1 and 2 are similar to the standard *K*. They have a small loop at midpoint, and longer lead-in strokes.

In Figures 4 and 5, the trick is to position the horizontal stroke, which cuts across both downstrokes, above center so that it does not conflict with the midpoint loop. You may have to try this more than once to determine the proper positions of the strokes.

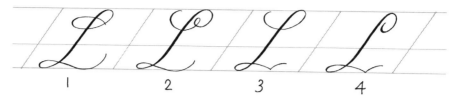

L

The variations on the *L* are fairly simple.

Figures 1 and 2 show variations in the lead-in stroke. These loops should fill more than half of the ascender space. If they are too small, the letter looks weak.

The exit stroke of Figures 3 and 4 was used often in the eighteenth century as a cursive form; that is, where possible, the next letter was connected without lifting the pen. When used as initials, these forms look somewhat unfinished; at the start of a word, however, they are more effective. This form of ending may also be used on the *M*.

M

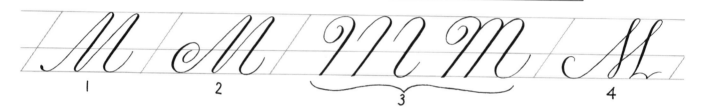

Figures 1 and 2 are made in one stroke. The rounded tops and bottoms of these letters make them easier and faster than the standard *M*, which has four separate strokes.

The *M* in Figure 3 is a large-scale minuscule *m*, with a decorative spiral lead-in stroke. Like many such simplified forms, this works better when written in small scale, rather than large. You might, for example, use this *M* in the middle of a paragraph but would not use it in the headline.

Figure 4 is similar in form to the standard *M*, but it has loops at the top and bottom center. These loops, like the curves in Figures 1 and 2, make it a more easily written form than the standard four-stroke *M*, because the starts and stops are eliminated. The exit stroke is explained above.

N

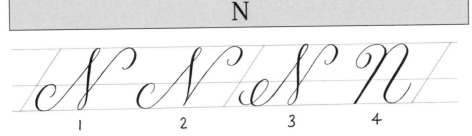

1 2 3 4

The *N*'s in Figures 1, 2, and 3 are variations on the standard *N*. With its two loops, Figure 1 can be made in a single stroke.

A pause is necessary at the bottom of the diagonal in Figure 2, so that the nib can close before starting the upstroke.

The addition of a loop in the base-line lead-in stroke of Figure 3 makes this variation more ornate than the others. This is also a one-stroke letter.

Figure 4, like the *M* in Figure 3 on p. 110, is based on the minuscule form of the letter.

O

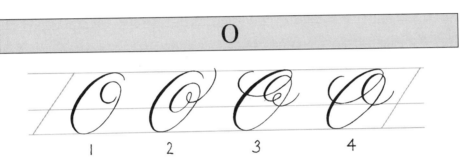

1 2 3 4

Each of these *O*'s is made in a single stroke. Figure 2 is part of the same family as the *L* in Fig. 2 (p. 110) and the *C* in Figure 3 (p. 107).

The *O*'s in Figures 3 and 4 can be joined to the letter following it more easily than in Figure 2 because the exit stroke is a little lower.

Figure 4 begins with the lead-in stroke of the standard *C*. This variation might be considered a little excessive.

P

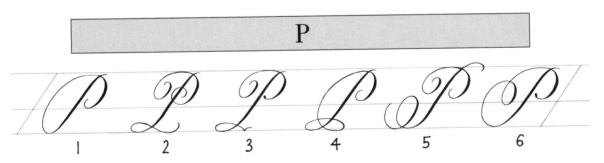

1 2 3 4 5 6

Many of the variations on the *P* are the same as those of the B. You can try the ones that are different.

The first stroke of Figure 5 must begin with a big swing from the right; if the curve is not wide enough, there won't be sufficient space for the second stroke.

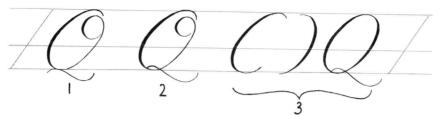

1 2 3

The standard form of the Q in the eighteenth century looked like the arabic numeral *2*. These variations on the Q are based on the O-form. They are more modern-looking.

The only one of the three examples that requires an explanation is Figure 3. In order that the connecting points of the two sides of the O-form not be visible, it is necessary to begin and end each of these strokes in the correct place. You can try the following procedure to learn how to do this: Using a 55-degree slant line as your central axis, start the first stroke just below the ascender line and a little to the right of the slant line, curving up to the ascender line and around to the left to make the left downstroke of the O-form. End with a curve along the base line and a short upstroke a little to the right of the slant line, curving up to the ascender line and around to the left to make the left downstroke of the O-form. End with a curve along the base line and a short upstroke a little to the right of the center line.

Start and end the second stroke the same way, but moving in the opposite direction. The two strokes will, of necessity, overlap for a very short distance at the ascender line and the base line.

The overlap at the ascender line easily hides the connection of the two strokes. At the base line, the connecting point, if it shows, can be hidden by the tail of the Q.

The eighteenth-century 2-shaped Q is certainly easier to do, but may not be as recognizable to the twentieth-century reader.

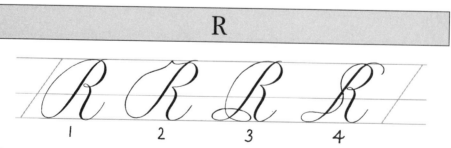

1 2 3 4

Figure 1, 2, and 3 are just three of the many R variations that have the same decorative strokes as the B and P.

Note that the top and bottom counters of the right side of the R can be separated by either a loop or a curve. This also applies to the K.

The elaborate R in Figure 4 is made in one stroke. It starts, like the P in Figure 5 (see p. 111) with a big swing from right to left.

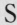

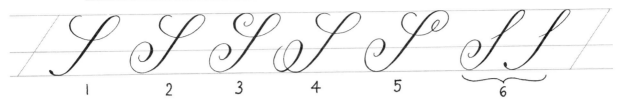

Once again we are faced with the dilemma of ambiguity. Are these S's or are they G's or T's? The more modern form of the S, shown on p. 98, is more recognizable, but these variations certainly have their own merit.

The two examples in Figure 6 are the eighteenth-century precursors of the modern S, but they are also the least interesting of the letters shown.

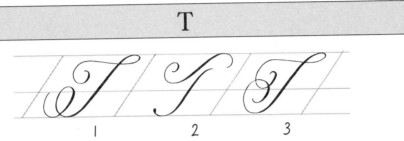

The top stroke of Figure 2, like the top stroke of the standard T, is made first. If you start this stroke at the right, the stroke can be weighted in the center, but only if the downward slant is sufficient for the nib to open.

Figure 3 is made in one stroke. As in the B in Figure 6 (p. 105), the two spiral flourishes in Figure 3 must be large enough to create a new space when they overlap. If they merely bump into each other, the result is unsatisfactory.

INCORRECT

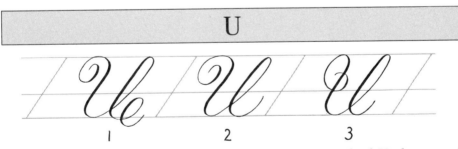

All of these U's are made in one stroke. Unlike the standard U, the second downstroke of these letters is the same height as the first downstroke because of the loop. The hairline upstroke that forms the right side of the loop must swing out to the right in order for the two downstrokes to be the correct distance from each other.

When making the final flourish in Figure 1, release the pressure before the end of the stroke, so that the exit stroke is a hairline. Sometimes, in endings such as this (or of the C in Figure 2 — see p. 106 — and of the T in Figure 1), it is preferable to do the final downstroke without pressure to avoid risking an unsightly thick stroke. Similarly, the first small curve in Figure 3 might be made without pressure, even though it includes a short downstroke.

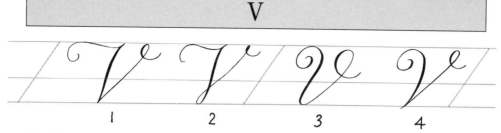

V

Fig. 1 is very similar to the standard *V*, with the small variation of the loop at the beginning of the exit stroke. This *V* must be made in three separate strokes to guarantee that the top and bottom of the swelled stroke are hairlines.

In Figure 2, the loop at the base line makes it easy to swing right into the upstroke. The filled-in dot ending of this *V* can be used with other *V*'s and *W*'s.

The rounded shape at the base line in Figure 3 and the big curve of Figure 4 were both used by the eighteenth-century scribes more than they are today.

W

There are many *W*'s to choose from, and additional ones can be created by varying the beginnings, endings, points, and loops.

The final stroke of Figure 2 curves above the ascender line. Try this ending on the *V*.

The *W* in Figure 4 is similar in shape to the *U*.

Figure 5 differs from the other letters in that it has rounder counters. The center loop in Figure 5 is also wider than the loop in Figures 1 and 3.

Note also that the center strokes of Figures 4 and 5 are shorter than the strokes to the left and right.

X

The first two *X*'s are fancier forms of the standard *X*. An additional loop is formed in the center by positioning the second downstroke to the left of the first rather than superimposing one upon the other. If this center loop is wide enough, both downstrokes can be made with pressure on your nib. If the loop is too narrow, however, the center of the *X* will outweigh all your other strokes.

The very simple *X* in Figure 3 might be used for small-sized Copperplate, as explained in the discussion of the M in Figure 3.

Y

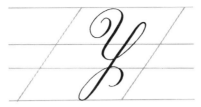

The *Y* in Figure 1, like the three alternate *U*'s, can be written a little faster than the standard *Y* because of the loop connecting the upstroke with the second downstroke. Notice the downward curve of the exit stroke, which intersects the base line.

Z

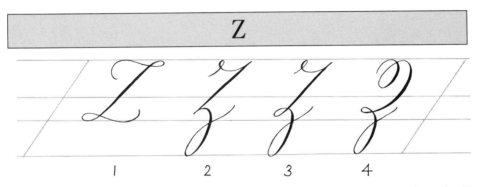

1	2	3	4

With its two loops connecting what are ordinarily three separate strokes, the *Z* in Figure 1 can be written more quickly than the standard form and is, perhaps, more graceful. It might, however, be mistaken for an *L*.

Figures 2 and 3 are combination forms of the standard *Z* and a descender stroke. Figure 2 is made in three strokes, but Figure 3 can be done in two because of the base-line loop.

Figure 4 is similar to the minuscule form of the *Z*. Notice that the base-line loop is actually above the base line in Figures 2, 3, and 4 to allow enough space for the descender.

CREATING OTHER CAPITAL LETTER VARIATIONS

If you wish to rearrange flourishes, lead-in strokes, and exit strokes to create new letterforms, a certain amount of critical judgment is in order. Be careful that you adhere to the basic letter shape and the proportions of its parts.

You might, for example, add any number of loops and curls to the left side of a *B*, but the relationship between the basic counters of the *B* should not vary. Be certain that you understand the essential shape of each capital letter before you try to redesign its embellishments.

Caution is also advised when using exaggerated letterforms, especially the descenders of the *G*, *Y*, and *Z*. A lengthened descender can create problems. There must be empty space beneath it, or it will bump into the next line of writing. You may, of course, wish to use exaggerated ascenders or descenders for decorative purposes, but plan your designs carefully so that your letters don't collide with each other.

And, finally, be selective about using any of these variations or any others you may discover or design. Think about the size of the letters and of the importance of the word or words on the page. Also consider the relationship of each capital letter to the other capital letters on the page.

Learning to make these decisions can help you to be a good designer as well as a good calligrapher.

CHAPTER 4

Numbers & Punctuation

The rules for numbers and punctuation in Copperplate are straightforward. They are all fairly simple and should be practiced carefully because mistakes are harder to hide in undecorated forms. (You should, of course, practice all your letters carefully, but a fancy flourish can camouflage a less-than-perfect letter. You have no such option with numbers and punctuation.)

NUMBERS
There are two groups of numbers to learn. Although the shapes and strokes are generally the same, the size of the numbers and the position on the writing line sometimes varies between the two groups. For our purposes, they will be referred to as the "Old-Style" and the "Modern" numbers.

Old-Style Numbers

These are the only numbers you'll see in eighteenth-century engravings. These numbers are characterized by a "moving" writing line; that is, the bottom of the *4, 7,* and *9* is positioned differently from that of the other seven digits. In addition, the *1, 2, 3, 5,* and *0* are smaller than the other numbers.

A comparison of exemplars from the writing masters of the eighteenth century shows many variations in the height and position of the numbers. For the Copperplate student, however, it is advisable to learn one set of rules but to realize when and how these rules can be changed. A fairly standard and generally well-proportioned (vis-à-vis the letters) set of old-style numerals looks like this:

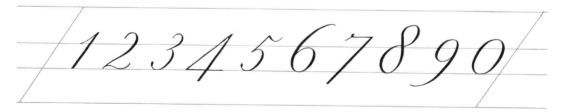

In the instructions that follow, some of the frequently observed size variations will be pointed out.

The *1* is made in a single stroke. It is the height of the minuscule *t* and sits on the base line.

Start the *1* with a slightly curved hairline lead-in stroke. The downstroke is a swelled stroke; it does not have a squared-off top but is squared-off at the base line.

2

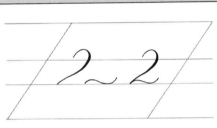

The *2* is the same height and in the same position as the *1*.

Pull the first stroke to the left as you approach the base line, so that the *2* has the correct slant, as indicated above. Start the second stroke with a short upstroke and curve down and back up, like the top of the capital *T*.

3

The *3* is generally the same height as the *1* and *2*, although it is sometimes written with the bottom curve extending approximately one-quarter — or a little more — of the way into the descender space.

Whichever way you choose to do it, make the lower curve bigger than the upper curve and pause or stop before making the second curve, so that the midpoint is a fine line. The weight of the lower curve is slightly to the right of the upper curve, along the 55-degree axis:

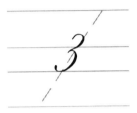

The lower curve ends with a filled-in dot, made by curving around and back down at the end of the hairline, as indicated above.

The *4* extends from the height of the *1* to a point approximately one-third of the way between the base line and the descender line. Visually, it is a very simple form, but there are several ways to do it wrong.

Start the *4* with a wide diagonal downstroke without pressing on your nib.

At the base line, make a straight cross-stroke to the right. To help gauge the length of this cross-stroke, start your downstroke at any slant line and continue the stroke beyond the slant line about one-half again as far as the distance between the beginning of the stroke and the slant line. This is easier to see than to explain:

The second stroke is a downstroke along the 55-degree axis. Like the *1*, this stroke starts without any pressure and ends with a squared-off edge.

INCORRECT FORMS. If you press on the first stroke of the *4*, as in Figure 1, the counter will be too narrow and the letter will be top-heavy.

The diagonal downstroke in Figure 2 is not wide enough.

In Figures 3 and 4, the length of the cross-stroke has been miscalculated; it is too long in Figure 3 and too short in Figure 4.

The *5* is made in three strokes. It is the same height as the *1*, *2*, and *3* and sits on the base line.

The first stroke is a hairline downstroke. It extends about halfway down toward the base line and slants at a more radical angle than 55 degrees.

The second stroke is the same as the lower curve of the *3*, ending with a filled-in dot.

To complete the *5*, make a short, slightly curved diagonal stroke, pressing on your nib to give it some weight. Since this stroke is made in an almost horizontal direction, it is difficult to put more than a little pressure on the nib without having the point catch in the paper. Turning your pen may help, but remember that the eighteenth-century engravers turned the plate to facilitate horizontal thick strokes, a trick that we cannot do while using pen and ink because it breaks the rhythm of the writing. The modern form of the *5* (p. 122) eliminates this problem.

The old-style *5* is more difficult than the modern *5* because of the hairline downstroke and the extreme slant of the number.

| 1 | 2 | 3 | 4 |

The 6 is the same height as the minuscule *d*, extending two-thirds of the way up between the waist and the ascender lines.

The first stroke is similar to the first stroke of the capital *O*, although the beginning of the stroke is further to the right than the ending, relative to the 55-degree line.

Start the second stroke with an upstroke, which touches the waist line and curves out, around, and back down to meet the first stroke. The counter of the lower part of the 6 is not circular; it is compressed and closer in shape to the capital *O* than to the minuscule *o*.

In eighteenth-century exemplars, as the above illustration also shows, the beginning of the second stroke was not always attached to the first stroke.

INCORRECT FORMS. The second stroke in Figure 1 starts with a horizontal motion, rather than an upstroke, and destroys the shape of the counter.

The lower counter of Figure 2 is too big. The top of the second stroke should be halfway between the top of the 6 and the base line.

The 7 is the same size as the 4. It begins in the ascender space and ends in the descender space.

Start the 7 with a very short upstroke that curves to the left and back down to form a filled-in dot. Release the pressure on your nib and make a horizontal stroke.

The downstroke is a straight diagonal, at a greater slant than 55 degrees. Like the *1*, it starts without pressure and has a squared-off edge at the bottom. Do not curve this stroke.

In the eighteenth century, this downstroke was often extended quite a bit further. The long version of the 7 in the illustration above is the same length as the descender of the *p*. It extends two-thirds of the way between the base line and the descender line.

1 2

The 8 is made in three strokes. It is generally the same height as the 6, although in some instances it is equal in height to the shorter numerals: the *1, 2, 3, 5,* and *0.*

The first stroke is a double curve, made with somewhat less pressure than the standard downstroke.

Start the second stroke as you do a capital *O,* by overlapping the first stroke to hide the connection. Curve outward to the right, so that the widest part of the second stroke is in a 55-degree line with the lower curve of the first stroke:

The second stroke starts at the center point of the first stroke.

Start the lower curve slightly higher than the bottom of the upper curve. This will give the counters the correct balance.

Be sure to begin and end every stroke of the 8 without pressing on your nib.

INCORRECT FORMS. The first stroke of Figure 1 is too round. In order to maintain the 55-degree slant in this example, the writer increased the width of the second and third strokes; Figure 1 is therefore too wide.

In Figure 2, the second and third strokes are connected. The stroke thickness is too pronounced at the center, and the lower counter is too small.

The oversized lower counter in Figure 3 is also incorrect. Although the lower counter should be a little larger than the upper counter, the difference should not be this extreme.

The 9 is an upside-down 6. It is the same size and in the same position as the 7.

The first stroke is the second stroke of the 6 in reverse.

Start the second stroke by overlapping the first stroke, and make a curve that extends into the descender space and to the left of the axis line, as shown above.

The 9, like the 6, may be made without connecting the two strokes in the center.

The *0* consists of the same two strokes as the capital *Q.* Be careful that your strokes meet properly at the base line as well as at the top.

The height of the *0* is the same as that of the *1, 2, 3,* and *5.*

1	2	3

Modern Numbers

The modern-style numbers are easier for several reasons, the primary reason being that they are all the same height and in the same position on the base line. In addition, some of the forms have been updated for the twentieth-century scribe.

The top of all of the modern numbers is one-third of the way above the waist line (the height of the minuscule *t*), and they all end at the base line.

The *1, 2, 3,* and *0* are all the same form as the old-style numbers. The others are explained below.

Myrna Rosen, Bat Mitzvah Invitation, 1983. Written with Gillott 303 nib, Higgins Eternal ink, same size.

4

The *4* is the same as the old-style *4*, except that the modern is three-quarters the size of the old. This proportion applies to the *6, 7, 8,* and *9* as well.

The cross-stroke should be placed at about midpoint in the x-height space for the counter to be proportioned accurately.

5

The modern 5 varies in several particulars from the old-style number.

The first stroke is made with pressure on the nib and follows the 55-degree slant line. At the bottom of this stroke, release the pressure before starting the second stroke, so that the curve is graceful.

The third stroke is a curved hairline. Notice the reversal in the weights between the old-style 5 and the modern 5:

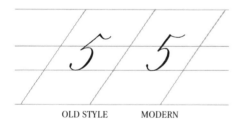

OLD STYLE MODERN

The second and third strokes of the modern 5 are better suited to the pressure-and-release system than those of the old-style number.

6 and 7

The 6 and 7, like the 4, are shorter versions of the old-style numbers. The modern-style 6 has the same relationship among its parts as the old-style 6.

8

The modern 8 is made in a single stroke. Start with a double-curved downstroke, similar to the double curve of the old-style number but with more pressure on the nib. Continue around at the base line, to the left, and back up, crossing the downstroke a little above center.

You can end the 8 by joining the hairline stroke at the top or by continuing upward just beyond the top.

9

The 9, like the 4, 6, and 7 is a shorter version of the old-style number.

HOW TO PRACTICE

Practicing numbers does not have the tantalizing possibilities that practicing letters has. It is, however, important to devote enough time and attention to them, both as individual forms and in combinations.

Once you are familiar with both sets of numbers, try writing number sequences. Write the same sequences first using old-style numbers, then modern numbers. Compare the effect of the two versions. You'll find that in some cases the old-style and modern numbers will be the same, and in other cases they will be quite different from each other.

In the first example, *1032*, both sets of numbers are the same.

In *350*, the 5's vary, but since the difference is in shape, not height, this is not nearly as apparent as in *1987*.

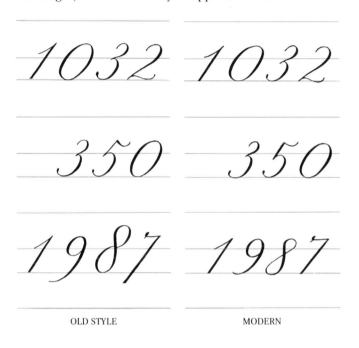

OLD STYLE MODERN

To get the largest range of visual possibilities, write sequences of more than three or four numbers. If you open a telephone directory and copy ten telephone numbers in the order that they appear, you will probably get a good random arrangement of numbers. Leave off the hyphens and just write the seven numerals. This may not sound very exciting, but it is better than writing two lines of *1*'s followed by two lines of *2*'s, etc.

CHOOSING WHICH NUMBER STYLE TO USE

It is not essential that you always use either one or the other style of numbers. Familiarity with both styles, like knowing variations on the letters, increases your range as a calligrapher. There are, however, advantages to each number style that may make you tend to use one style more than the other.

The main advantage of the modern numbers is that they are all the same size. This makes them more suitable in certain number sequences than the old style. A sequence, for example, written with old-style numbers, that contains three or four short numbers and one long one may look like a mistake. This is never a problem if modern numbers are used.

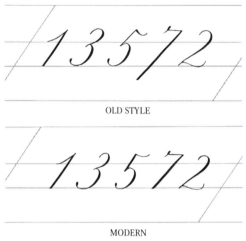

OLD STYLE

MODERN

This particularly applies to New York City zip codes, many of which start with the numerals *100* or *112*.

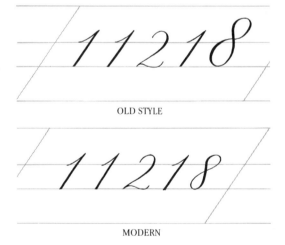

OLD STYLE

MODERN

In addition, as noted earlier, the modern forms of the 5 and the 8 are easier and faster to write than the old-style forms.

On the other hand, many people prefer old-style numbers because the moving base line and variations in height make these forms more dynamic than the modern ones. A sequence such as *1728* or *19567* almost seems to dance on the page.

Punctuation

Copperplate punctuation is quite easy. In most instances, punctuation marks are made by applying the pressure-and-release system to the standard shapes. There are, however, a few subtleties to note.

The period is the same as the dot on the *i*. It sits on the base line.

The comma is a period with a curved tail that goes below the base line. Release the pressure on your nib as you make the curve, so that the bottom of the stroke tapers to a point.

The colon consists of two periods. They are centered in the x-height space and slant along the 55-degree axis.

The semicolon is a period above a comma. The period is at midpoint in the x-height space, and the comma intersects the base line. Like the colon, the semicolon slants along the 55-degree axis.

The apostrophe is a comma that is positioned in the ascender space at approximately the height of the minuscule *d*. The position can vary depending on how it is used. For example, in the word *man's*, it should be a little lower than in the word *Jack's*.

Quotation marks consist of two backward upside-down commas on the left and two regular commas on the right. They are generally positioned at the ascender line, but in some cases they can be lowered.

To write the left (open) quotes, make a short, curved downstroke, allowing your pen to open after you start the stroke, so that the top will be pointed. The bottom of the stroke is a filled-in dot, made by curving to the right, up (very briefly), to the left, and back down.

The exclamation point is the height of the minuscule *d*.

Start the downstroke with a squared-off edge, but release the pressure gradually as you make the stroke. The stroke tapers to a point and ends midway between the waist line and the base line. The dot sits on the base line.

The question mark is the same height as the exclamation point.

At the bottom of the curve, release the pressure before starting the short downstroke. A pause at this point may make the transition from thick to thin to thick somewhat easier. Press on the downstroke and end with a squared-off edge.

The height of the dollar sign is equal to the height of the numbers.

The first stroke is similar to the first stroke of the modern 8, but the curves are a little rounder. Start this stroke just above the waist line and extend the form about two-thirds of the way between the waist line and the base line.

The second and third strokes are the upper and lower parts of a full-pressure downstroke with squared-off edges. They should be of equal length.

A hyphen or a dash can be either a simple horizontal hairline or a short double curve with pressure in the center. The center of this stroke must slant downward or the nib won't open. Try this stroke in several sizes to practice varying from thick to thin.

An ampersand is used in place of the word *and*. The symbol derives from the Latin word *et*, meaning "and", but by the eighteenth century, the *e* and the *t* that were connected to form ampersands in earlier calligraphic hands had evolved into a decorative form that looks very little like the word *et*. If you stretch your imagination, you can surely find the curves of the *E* in these ampersands, but the *t* is gone.

All of these ampersands are made in two strokes, starting at the bottom of the upper loop with a counterclockwise upstroke, curving down into the main downstroke, which is either an S-curve or a C-curve. The second stroke starts at the same place as the first stroke with a lightly weighted downstroke and a decorative upward curve. You can end the ampersand with a variety of loops, curves, and dots.

The height of the ampersand is generally about midway between the ascender line and the waist line, but larger or smaller ampersands are often used.

In the eighteenth century, an ampersand followed by a minuscule *c* was often used in place of *etc.*

CHAPTER 5

Changing the Size of the Letters

Without altering the form of your letters, you can achieve many new effects by experimenting with different sizes. There are two routes to take:

You can write smaller or larger without altering the 3:2:3 ratio.

You can change the 3:2:3 ratio.

WRITING SMALLER

Learning to write smaller without sacrificing the shapes of the letters and the rhythm of your writing is fairly simple, but it takes practice and patience.

First, consider what your letters should look like if they are proportionally smaller—if the 3:2:3 ratio is unchanged, but the actual height of each part of the letter is shorter. The ascender and descender will still be one and a half times the x-height, whatever the x-height may be. But the widths of the counters will be smaller, and the downstrokes will be less heavy. The weight of the upstrokes, however, will not change. This is because the upstrokes are hairline strokes, made with a minimum amount of pressure on your nib. *No matter what size your letters are, letters made with the same nib will have hairlines of the same weight.*

To write smaller, decrease the pressure on your nib on the downstrokes and make all the strokes closer together. How much less pressure to put on your nib and how much closer the strokes should be depends on the size of the writing. This varies from calligrapher to calligrapher. As a general rule, if your letters are one-half as high as your standard ⅜ - ¼ - ⅜ letters, the downstrokes should be half as thick and the counters half as wide. If your letters are three-quarters as high, the downstrokes and counters should be similarly proportioned, and so on.

Making your strokes one-half or three-quarters (or however much) as wide involves retraining your eye and your hand. This cannot be done mechanically.

You may also wish to use a less flexible nib to help you write lighter-weight letters without substantially changing the pressure on your pen. Experiment with various nibs to see which are firmer than the Gillott 404.

It is generally easier to decrease the size of your calligraphy gradually, by writing just a little smaller at first, rather than trying to reduce to half-sized Copperplate in a single move. Here is a method that will help you learn to write smaller.

DRAWING NEW GUIDELINES

You can draw new guidelines either with a ruler or by using photostats.

If you are using a ruler, follow the procedure outlined in Chapter 1 and draw two full guide sheets using these measurements (in inches): $\frac{9}{32}$, $\frac{3}{16}$, $\frac{9}{32}$; and $\frac{3}{16}$, $\frac{1}{8}$, $\frac{3}{16}$. These measurements represent three-quarters and one-half of the $\frac{3}{8}$, $\frac{1}{4}$, $\frac{3}{8}$ spacing you ruled originally. If $\frac{9}{32}$ is difficult to locate on your ruler, find $\frac{1}{4}$ and add $\frac{1}{32}$ ($\frac{8}{32} = \frac{1}{4}$).

If using a ruler for these measurements is defeating you (as well it might be), guidelines can be done mechanically, using photostats.

Take a $\frac{3}{8}$, $\frac{1}{4}$, $\frac{3}{8}$-inch guide sheet that has been accurately drawn in ink to a photostat service and have two positive prints made: one at 75 percent, (this means 75 percent of the original size, not reduced by 75 percent) and the other at 50 percent. The photostat machine will give you perfectly reduced, photographically reproduced copies.

You can, if you like, have other prints made, perhaps at 87 percent and 66 percent, so that you have more intermediate sizes. But do note that if the lines on your guide sheet measure 9″ x 12″ (an 11″ x 14″ page with a 1 inch margin all around), a 50 percent reduction of the page will give you lines that are 4½″ x 6″, and a 75 percent photostat will become 6¾″ x 9″. In addition, your lines will be only one-half or three-quarters as thick as the lines on your original guide sheet.

Neither of these problems is serious, but they do mean that you probably cannot use the photostats as guide sheets, because they are too small and you may not be able to see the lines through another sheet of paper.

It is best to use the photostats as the basis for drawing new lines on an 11″ x 14″ sheet of bond paper. Here is how to do this:

1. Draw 1-inch margin lines on your 11″ x 14″ page.
2. Cut the left and right margins off the photostat, so that the lines extend off the page. Do this carefully, using a metal ruler and a razor blade or X-acto knife, as explained in Chapter 10.
3. Position the photostat against the left margin of your 11″ x 14″ guide sheet, so that the top line of the photostat lines up with the top margin of the guide sheet. Tape it in place with small pieces of masking tape so that it won't shift. (Masking tape can be peeled off without tearing the page. Do this carefully.)
4. Using a well-sharpened pencil, make marks on your margin line equivalent to each line on your photostat. If the lines on your photostat end before your guide sheet ends (they will), move the photostat down and reposition it very carefully before continuing to make your marks.
5. Move the photostat to the right margin and repeat the process.
6. Connect the dots.
7. Make slant lines either in the usual way (with a protractor) or by cutting off the top and bottom margins of the photostat and using the slant lines in the same manner as you used the horizontal lines. If you use a photostat to make slant lines, be sure to mark off one line with dots at each end and connect the dots to give yourself a basic slant line before making any more slant-line marks. If you have a series of dots along your top-margin line and another row of dots further down on the page and do not have a basic slant line, you may not know which dots to connect to which.

The advantage of using the photostat method is that photostats are always accurate. The disadvantage is that getting a photostat generally involves traveling somewhere away from your drawing board and waiting, sometimes until

the next day, for them to be ready. If you live in a big city, this is less of a problem than if you are far away from a photostat company.

If you don't know where to get photostats made, look in the yellow pages or ask a local printer or a commercial artist for recommendations.

USING THE THREE-QUARTER-SIZE GUIDE SHEET
The three-quarter-size guide sheet is either the 9/32-, 3/16-, 9/32-inch sheet that you have drawn with a ruler, or the one you have drawn based on a 75-percent photostat.

Start by writing a Copperplate alphabet — first the minuscules, then the capital letters — working quite slowly. Press somewhat less on the downstrokes than you ordinarily do. Make your counters smaller and your letters closer together.

Then try an alphabet sentence or a line or two of prose. Compare your three-quarter-size writing with your regular writing. The former should be shorter and proportionally narrower and lighter in weight but not radically different.

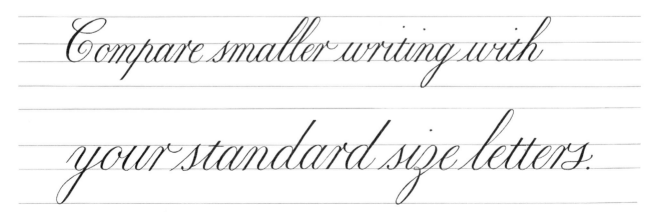

USING THE HALF-SIZE GUIDE SHEET

Only after you are quite used to the three-quarter-size guide sheet should you attempt to write half size. For some students, this may take a half hour of practice. It is more likely that you will need to write several pages at 75 percent before you are ready to write smaller.

Then do the same thing you did in Step 2, only more so. Your letters should be half the height, half the width, and half the weight of your standard letters. This takes a fair amount of pen control. If you find that your stroke weights are uneven, practice with your three-quarter-size guide sheet a little longer and then try the half size again.

Many people find that working three-quarter size is easier than either "full" size or half size, especially when making flourished capital letters. Half size is often the hardest of all because of the quick transitions from thick to thin in the minuscules.

USING INTERMEDIATE SIZES

Working with 87 percent or 66 percent guide sheets is also advantageous if you have the patience to draw them. By starting with the full-size guide sheet and then working your way down in four steps (87 percent, 75 percent, 66 percent, and 50 percent) rather than in only two steps, you will find that you are soon able to feel the subtle differences in pen pressure necessary to change the weight of the downstrokes.

Making the small transition from either 100 percent to 87 percent or 75 percent to 66 percent is easier than the big jump from 75 percent to 50 percent.

WORKING SMALLER THAN 50 PERCENT

It is very difficult to work smaller than 50 percent. To write letters with an x-height of less than ⅛ inch, you will probably have to find a nib that is less flexible than the Gillott 404 or the Mitchell Copper Plate elbow nib. Try using a Gillott 1950.

To write smaller, you could try drawing line spaces of ³⁄₃₂ inch–¹⁄₁₆ inch–³⁄₃₂ inch, which is not easy, or you could get a 25-percent photostat, which is one-quarter the size of the original. You could also try a photostat that is in between 50 percent and 25 percent, such as 33 percent. (Be sure that you don't ask for a 33 percent reduction, or you will get a print that is one-third smaller, not one-third of the original size. Express yourself clearly when ordering photostats.) It is difficult to draw accurate lines at these sizes, even with photostats.

Controlling the weight of the downstroke at an x-height of ¹⁄₁₆ inch or even ³⁄₃₂ inch is no mean feat. Very few calligraphers manage to write Copperplate at this size with any consistency. If you can do it, and enjoy doing it, you are unusual.

WRITING LARGER

Like writing smaller, writing larger should be approached in graduated steps. And within a fairly limited range, larger-scale Copperplate is easy to master; but once you try to work more than approximately one-and-a-half times the standard size, you will run into some difficulties.

The rules and the instructions are similar to those for small-scale Copperplate. The weight of the thin lines remain unchanged, but the downstrokes must be heavier, and the counters and interspaces must be wider in proportion to the greater height of the letters.

Prepare two new guide sheets with the following measurements (in inches): $^{15}/_{32}$, $^{5}/_{16}$, $^{15}/_{32}$ and $^{9}/_{16}$, $^{3}/_{8}$, $^{9}/_{16}$. The first set of measurements is one-and-one-quarter times the standard size (125 percent) and the second is one-and-a-half times (150 percent).

You can also have your standard-size guide sheet blown up using photostats. Ask for a 125 percent and 150 percent print and use them either to draw your lines or to serve directly as guidelines.

Start with the smaller of these two guide sheets and spend some time learning to write your letters 25 percent larger than you ordinarily do. You may find that the upstrokes are harder to make and that the large curves in your flourishes are less assured. Try to keep the pen relaxed in your hand so that the nib doesn't catch in the paper.

After you have become accustomed to working a little larger, try using the second guide sheet.

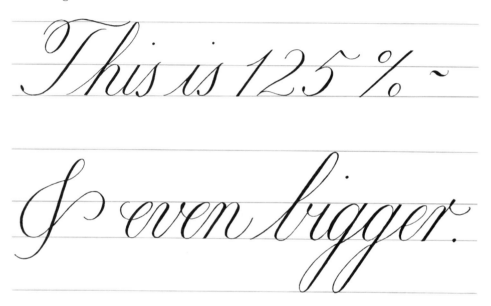

This is probably a good time to try writing with a more flexible nib, such as the Brause 66EF or the Hunt 101 or 56.

WORKING LARGER THAN 150 PERCENT

Even with very smooth paper and a very good nib, working larger than 150 percent (of a ¼-inch x-height) is difficult.

Were you to work double size — ¾ by ½ by ¾ inches — you would be making capital letters that were 1¼ inches high and *f*s that measure 1¾ inches. This is a long way for a pointed tool to go, especially on the upstrokes, without catching in the paper or making uneven hairlines.

It is important to acknowledge the limitations of our tools. Remember that the engraved exemplars of the eighteenth-century masters were retouched and corrected on the metal plate before they were printed. And those spectacular curves and cartouches were made by turning the plate, without moving the engraving tool.

Although exceptions are always possible, letters with an x-height of ⅛ to ⅜ inches tend to be better adapted to the Copperplate hand than larger-sized writing.

Copperplate is, moreover, more difficult to read when written large. In letters of an inch or larger, the contrast between the hairlines and the downstrokes makes the hairlines recede on the page, thus diminishing the impact of the letter and the beauty of the page.

CHANGING THE RATIO

Changing the 3:2:3 ratio offers another range of possibilities. Although the parameters are pretty well-defined, you can vary the look of your Copperplate considerably by making small changes in the relationships among the ascender, x-height, and descender.

It is essential that you understand the reason for the 3:2:3 ratio. Because the standard-form ascenders and descenders have loops, a certain amount of space is needed to make a loop that visually balances the x-height. A looped ascender that is equal in length to the x-height, rather than longer, makes a bottom-heavy letter. Similarly, a letter with a looped descender that is the same length as the x-height is top-heavy.

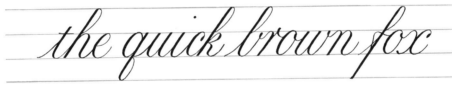

1:1:1 RATIO

Do not, however, rule out the possibility of equal-length ascender, x-height, and descender—a 1:1:1 ratio. If you use alternate forms of the minuscules, without loops, this ratio is not only possible, but called for. An alphabet written with equal proportions using letter variations would look like this:

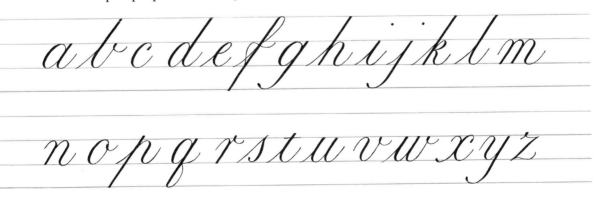

Notice that the *f* and *q* cannot be written without loops. If your lines are equally spaced, you will have to shorten those two loops so that the letters fit into the spaces.

One advantage of using a 1:1:1 ratio is that you can practice on any paper with equally ruled lines, such as school notebook paper. You are not limited to a guide sheet with ¼-inch x-height, but can draw lines 5/16 inch, or ⅜ inch or 7/32 inch apart, if you so desire, without having to figure out a proportional ascender/descender measurement.

OTHER RATIOS

Using longer ascenders and descenders in proportion to the x-height is another possibility. Try drawing new guidelines with ascender and descender spaces that are slightly larger than the standard size. Using a ¼-inch x-height, you might increase the ascender and descender measurements by 1/16 inch from ⅜ inch to 7/16 inch. This would make the ratio 3½:2:3½ or 7:4:7.

Adding another 1/16 inch would bring the ascender and descender size to ½ inch, which would change the ratio to 4:2:4 or 2:1:2. Ascenders and descenders that are twice the size of the x-height are almost always too large, unless there is a particular effect that you wish to achieve.

Compare the difference among the three ratios:

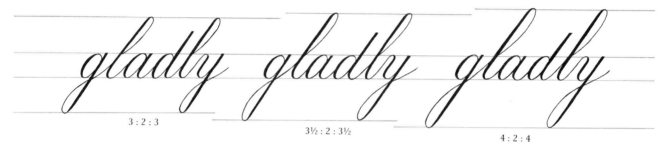

Although the ascender and descender sizes are increased by a mere 1/16 inch each time, the visual difference in enormous.

Decreasing the ascender/descender sizes by 1/16 inch (from ⅜ inch to 5/16 inch) would change your ratio to 2½ : 2 : 2½ or 5:4:5. Letters made with these proportions look like this:

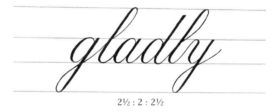

Although a 5:4:5 ratio gives you sufficient space to make looped ascenders and descenders, the counters are not as generous or graceful as those of letters with longer ascenders and descenders.

LIMITATIONS

1. When using looped ascenders and descenders, the ratio of ascender/descender to x-height should not be closer than 5:4:5.

2. Unless you have a good reason, a ratio of more than 2:1:2 will distort the Copperplate characters. Even 2:1:2 is less graceful than a slightly closer ratio.

3. The ascender and descender should never be shorter than the x-height. This is unacceptable.

4. Ascenders and descenders without loops should not vary in length. The 1:1 relationship of the ascender to the x-height (as in the minuscule *d*) always prevails.

HOW TO PRACTICE

Try several ratio variations. Start with the ones suggested in this chapter: 1:1:1, 7:4:7, 2:1:2, and 5:4:5.

You will probably find that drawing the lines takes far more time and is less interesting than testing the letterforms. To save time, draw lines in pencil for two different ratios on the same sheet of paper. Draw the slant lines in ink on a separate sheet of paper that you can place underneath each pencil-ruled page. That way a single slant-line guide sheet can be used for all of your ratio samples.

Annotate the margins so that you will know what the proportions are. Be sure that you have three or four writing spaces (of three spaces each: ascender, x-height, descender) for each ratio you are testing.

Then write a sentence or two in each set of lines and compare the effects of longer or shorter ascenders and descenders. If you write the same sentences each time, it will be easier to compare them, but if you write different sentences, it will be more interesting.

Save these test sheets so that if you are about to do a piece of writing that may call for a ratio change, you can take them out and look at them. They may help you make a decision, or at least choose a direction to pursue.

WHEN TO CHANGE THE RATIO

The instructions in the last few pages should not be misunderstood. It is not my intention to say, "Now that you know the 3:2:3 ratio, forget it and do whatever you want," but rather to show you that variations are possible and acceptable at certain times.

The 3:2:3 ratio is classical, beautiful, and a sure thing. Your Copperplate will always look right (if your letter forms and spacing are correct) at those proportions.

Different letter proportions can change the look of a page of writing. If you shorten the ascenders and descenders, your lines of writing can be closer together. The page can then look denser and the writing more textured. Leaving the loops off makes your Copperplate look simpler and more modern. A page with straight ascenders and descenders and less space between lines looks quite different from classical Copperplate.

A less extreme, but nonetheless interesting variation is the effect of longer ascenders and descenders. A page of writing using one of the larger ratios will look quite open and airy. Longer ascenders and descenders are also more elaborate than standard ones.

More information on line spacing is given in Chapter 8.

There never was such a Goose!

... a feathered phenomenon, to which a black swan was a matter of course — and in truth it was something very like it in that house. Mrs. Cratchit made the gravy (ready before-hand in a little saucepan) hissing hot. Master Peter mashed the potatoes with incredible vigour. Miss Belinda sweetened up the apple-sauce. Martha dusted the hot plates. At last the dishes were set on, and grace was said. It was succeeded by a breathless pause, as Mrs. Cratchit, looking slowly all along the carving knife, prepared to plunge it in the breast; but when she did, and when the long expected gush of stuffing issued forth, one murmur of delight arose all round the board, and even Tiny Tim, excited by the two young Cratchits, beat on table with the handle of his knife, and feebly cried Hurrah!

A Christmas Carol

Linda Dannhauser, "There never was such a Goose", 1983, from The Calligraphers Engagement Calendar 1984, © Taplinger Publishing Co. Written with Gillott 303 nib, Higgins Eternal Ink with gum arabic, reduced approximately 35 percent.

Part Three

Using Copperplate

An understanding of Copperplate letterforms and the flexible pen can take you only so far. Making the transition from practicing on 11″ x 14″ bond paper to doing a finished piece of work on a sheet of good paper or preparing a commercial job for reproduction involves a number of skills and techniques that go beyond making letters.

In this section, you will learn a few of the ways you can put your Copperplate to work. In addition to receiving instructions for simple projects and art pieces, you will also learn about some related skills that are useful in other calligraphic endeavors, such as using color, cropping your artwork, and choosing good paper.

But since the purpose of this book is primarily to teach you Copperplate, the information in this section must be treated as an introduction to these skills that will, it is hoped, give you an idea of how you can continue your calligraphic education.

CHAPTER 6

Writing in Color

Writing in color can transform your calligraphy before your eyes. Volumes have been written on color theory, and years can be devoted to learning elaborate techniques of blending, marbling, and making your own paints.

This chapter, however, is concerned with the basics: the tools and techniques for writing Copperplate in color. After you are familiar with these basics, you can develop your skills by reading, taking a class or workshop, and experimenting with countless possibilities. The information that follows is just the first step.

MATERIALS

PAINT. Calligraphy in color is generally written with paint. For the color to flow easily from your nib, it is essential that you use a water-based paint. The paint most commonly used for calligraphy is gouache, an opaque water-based paint. (Watercolor, on the other hand, is transparent.)

Gouache comes in small tubes. Recommended brands are Winsor & Newton, Linel, and Turner, of which Windsor & Newton is the most commonly available. Other brands may also work well.

Choose colors that you will enjoy working with. Cadmium red, alizarin crimson, spectrum red, cadmium yellow, golden yellow, cobalt blue, and ultramarine are all bright, clear colors. In general, reds, oranges, and yellows are easier to write with than blues, greens, and purples. Although some people have no difficulty with the latter three colors, others find that those paints are less opaque than the reds, oranges, and yellows. A little white paint will increase the opacity of your colors but will also change the hue, making red into pink, for example.

Read the label on the paint tube before you buy it to see if the color is permanent. Winsor & Newton paints have a letter code to indicate permanence. A color labeled "Permanence A" will not fade in bright light. "Permanence B" means that there will be some fading. A paint marked "Permanence C" is a fugitive color; this means that if you write (or paint) with this color and leave the paper exposed to sunlight, the color will quickly fade and may even disappear. If the page is not exposed to light, however, the color will not fade. There is nothing wrong with using fugitive colors if you are writing in a pad and turning the page, but if you plan to hang your work on the wall, be advised: the writing may not be there in a few weeks.

Gouache tends to dry out in the tube. It can, with some effort, be reconstituted, but it is easier to protect your investment by keeping your paint tubes in an airtight container, such as a jar or coffee can with a lid or a sealed plastic container. Gouache is expensive, so choose your colors carefully and take good care of them.

NIBS. Use a new nib to work with color. The residue of ink on even the best-washed nibs will bleed into the paint, polluting the color. Therefore, keep color nibs separate from ink nibs, so that you don't inadvertently get ink on a nib used for paint. Paint, however, washes off a nib quite thoroughly; you won't need a different nib for each color.

BRUSH. You will need a small, inexpensive watercolor brush. Watercolor brushes have soft bristles, as opposed to oil/acrylic brushes, which have stiff bristles. A No.1 or No.0 or the equivalent is about the right size.

It is not necessary to purchase a sable-hair brush or anything similarly priced; you won't be painting with it.

PALETTE. A small plastic or metal palette with several little indentations is a good buy. A china saucer or small plastic containers can also be used, but a palette is inexpensive and a little more functional.

CLEAN WATER CONTAINER. The water container you use when writing with ink is not suitable for writing with paint for the same reason that the nibs should be separate. Water that is blackened by ink will spoil your colors.

PROCEDURE
Writing Copperplate in color is essentially the same as writing in black ink. There are a few tricks involved, but, by and large, it is quite simple.

1. Squeeze a small amount of paint — about ¼ inch — on your palette.

2. With your brush, add a few drops of clean water to one edge of the paint, diluting it gradually. It is not necessary, or wise, to dilute all the paint on your palette. Use your brush to add more paint to the diluted area until it is about the same consistency as ink.

3. Hold the pen in your left hand if you are right-handed, or your right hand if you are left-handed, with the underside of the nib facing up (parallel to the ground). With the brush, add some of the diluted paint to the nib until the reservoir fills. You will, in effect, be painting the underside of the nib.

4. Put the brush down and the pen into your writing hand and try writing with the pen just as you would with ink. Use your scratch sheet to make the first mark, so that you regulate the flow of the paint before you touch the writing surface, just as you do with ink.

If the paint is the proper consistency, the color should flow from the nib evenly and your letters will be opaque and brilliant. Hairlines should be fine and thick strokes even and regular. Of course this does not always happen the first time.

PROBLEMS
If the paint spills out of the nib before you even put pen to paper, it is too thin. Wipe off the nib and thicken the diluted paint on the palette by adding a little more color with the brush.

If the paint flows well but the color dries unevenly — darker and lighter in different strokes — the paint is still too thin. Follow the procedure described in the previous paragraph.

Linda Dannhauser, Christmas Card, Dick Lopez Inc., 1982. Freely written Copperplate with Gillott 303 nib, reduced 15 percent.

If the paint refuses to leave the nib, it is too thick. Either add more water to the dilution or add a drop of water directly to your nib. This sometimes helps, but not always.

If the paint flows but it dries up after a stroke or two, it is either too thick (dilute it), or you didn't put enough paint on your nib (add more).

GOOD ADVICE

Paint is less predictable than ink. Be sure to test your pen on your scratch sheet every time you fill it, to save yourself and your paper from spills, blobs, and scratches.

You will probably get fewer strokes per filling than you do with ink. This means you will have to fill your pen more often and keep checking and read-justing the color dilution. It also requires a lot of hand switching, unless you are ambidextrous. Be patient. Your rhythm in color will be slower but the results are worth it.

Wash your nib frequently. Color dries on the nib faster than ink and it can build up. This will make your calligraphy deteriorate. You will have to dip your nib into water and dry it more often than you do when using ink.

When you change colors, change the water in your water container and make sure all the paint is off the nib. This is especially important when switching from a dark color to a lighter color. A drop of blue water in your yellow paint, for example, will ruin it.

ADVANTAGES OF USING COLOR

Color can greatly increase your range as a calligrapher and as a designer. The use of color in a word, a line, or even a letter can bring an ordinary piece of work to life.

In addition, the texture of gouache often makes it easier to write with than ink. It has an almost slippery quality that helps the nib glide along the paper, making upstrokes and curves less effort to write.

OTHER KINDS OF COLOR

WATERCOLOR. Watercolor can be used in much the same way as gouache. Because it is transparent, the results are generally less satisfactory, unless you specifically want transparent letters. For clear, legible writing, gouache is preferable. For certain special effects, however, watercolor works well.

COLORED INKS. Most colored inks are unacceptable for calligraphy because they are not water-based. Waterproof inks damage nibs and make uneven strokes. The color of the ink in the bottle may be attractive, but it will probably look pretty bad on paper, especially compared with gouache.

Nonwaterproof colored inks flow well and make nice hairlines, but the color tends to be thin and watery. Exceptions are brown fountain-pen inks, some of which are pretty good, and red Japanese ink, which tends to be on the orange side but is quite bright and opaque.

New inks seem to appear on the market every other month. It would be hard to list them all, with or without endorsements. If you are tempted to buy colored ink, by all means do so, but read the label first. If it is waterproof, don't use it for calligraphy.

And remember, after you learn to dilute paint properly, it is easy to use and makes your Copperplate quite vibrant. There are few calligraphers who prefer colored ink.

CHAPTER 7

Using Good Paper

One of the joys of calligraphy is working on good paper. For the student who has spent the first months (or years) of his or her calligraphic education writing on bond paper, the wealth of wonderful writing papers may come as a pleasant surprise. But being faced with the names of dozens of kinds of paper or a store filled with shelves of "calligraphy paper" can be daunting, if you don't know what to look for.

Paper that is good for calligraphy has a writing surface that is neither so rough that the nib catches, nor so smooth that it slips and slides. It should be made of good materials so that it won't discolor or disintegrate with the passing of time.

The first criterion allows an enormous range of possibilities for calligraphy in general, but relatively few for Copperplate. The sharp point on the Copperplate nib makes writing on all but the smoothest papers difficult if not impossible. Consequently, the task of selecting paper for Copperplate is easier than for broad-pen calligraphy, but a little less interesting.

The second criterion, that of quality, depends on what the paper is made of and how it is made. It is generally advantageous to work on 100 percent rag paper. "Rag content" refers to the actual composition of the paper. Paper made entirely or nearly entirely of rags or cotton or linen pulp lasts longer than paper made from wood, which may in time discolor or deteriorate.

Another significant factor affecting the life of paper is its pH value, a number indicating its relative acidity or alkalinity. Try to use neutral-pH papers, with pH values of 6.5 or over. Paper with a high acid content (low pH) tends to yellow and become brittle.

Many art-supply stores sell individual sheets of handmade as well as machine-made papers. Handmade paper is made sheet by sheet and is characterized by varied and beautiful surfaces and tones, deckle edges, and, generally, a higher price tag than mass-produced machine-made paper.

The advantages of using handmade rather than machine-made paper are arguable. Handmade sheets are often beautiful to look at and wonderful to handle. Unfortunately, it is not always easy to find handmade papers with a sufficiently smooth surface for Copperplate. This is particularly true for beginners, who will probably find an irregular surface a handicap. As you progress, however, you will find the qualities of a fine handmade paper well worth the effort of learning to move your pointed nib across its surface. There are, of course, many fine machine-made papers for Copperplate calligraphers to try.

HOW TO SELECT PAPERS

Apart from taking the advice of other calligraphers, the only way to evaluate the surface of a sheet of paper is to test it. This involves more than merely writing on it.

To make an effective evaluation and save yourself the trouble of repeating the experiment, it is worthwhile to proceed as follows: For each paper to be tested, whether it is purchased by the sheet or taken from a pad, cut off a swatch—a small section measuring perhaps 3 by 5 inches. The size is not important as long as it is large enough to be functional but small enough to be efficient.

On this paper sample, write the following information:

1. The name of the paper
2. The dimensions of the full sheet (if it comes in more than one size, note the other available sizes)
3. Where you purchased it
4. How much it cost
5. Other colors available
6. Other weights available
7. The date it was acquired

All of this information becomes important when you wish to buy another sheet of the same paper. This is particularly true after you have accumulated numerous paper samples; you might remember this information about one kind of paper, but not about many kinds.

Knowing the size of the full sheet is necessary if you are planning a finished piece of writing and need a particular size sheet to write on. If the paper is bigger than you need, you can cut it down, but if it is smaller, you are out of luck. Having this information on your paper sample can save you time and trouble.

Equally important is the effect your pen and ink have on the paper. On each paper sample, make a letter or two with your Copperplate pen. Examine it. Does the paper absorb the ink? Does the nib catch or bump on the paper surface? Does it skid? Are your hairlines smooth? How does it feel to write on it? How it looks and how it feels are both important. Sometimes a slightly rough paper feels a little uncomfortable to write on, but the visual effects may be worth the effort.

Try writing with paint on your samples. Sometimes paint goes on more smoothly than ink.

After you have tested your paper samples, put them in a folder or an envelope. Label it and remember where it is. Whenever you get a new piece of paper to work on, cut off a swatch, label it, test it, and add it to your file.

When you are ready to do a finished piece of calligraphy and want to work on good paper, take out your paper file. Select one or two samples that seem most suitable for the job at hand. At your fingertips will be all the information you need to get more of the paper you chose.

SOME SUGGESTIONS

Here are some paper recommendations. Most of these papers are available by the sheet, although a few come in pads. Some may be easier to find than others.

This listing is neither exhaustive nor infallible. You will certainly find some good papers that are not on this list and may not get good results with some of those included. But they are all worth trying.

Juan D. Quiróz Stone
Myrna Rojas de Quiróz
Shucri Kafati Simon
Evelyn Canahuati de Kafati

tienen el honor de invitar a usted
al matrimonio de sus hijos

Deborah y Jacobo

a las veinte horas del
día sábado ocho de marzo
de mil novecientos ochenta y seis

Santa Iglesia Catedral
"San Pedro Apóstol"
San Pedro Sula, Honduras.

Formal

Georgina Artigas, Wedding Invitation, 1986. Written with Gillott 170 nib, Japanese stick ink, reduced 50 percent.

Some of these papers come in several colors. You may find that some, especially the Canson papers, have smoother or rougher surfaces depending on which color you select. In other cases, one side of the paper is rougher than the other. Although technically speaking the rough side is considered the "right" side, writing on the back may give you better results.

PAPER BY THE SHEET
Cranes Parchment
Rives Opale
Canson Ingres
Canson Mi-Teintes
Niddegan
Fabriano Artistico
Fabriano Ingres
Basingwerk
Arches Hot Press
Saunders Waterford Hot Press
J. Green

AVAILABLE IN PADS
Ledger Bond
Vellum Surface Bristol
Strathmore Drawing
Bienfang Graphics
Visual/Layout Bond
Canson Ingres
Canson Mi-Teintes

Myrna Rosen, Greeting Card, 1987. Written with Gillott 404 nib, Higgins Eternal ink, reduced for reproduction.

CHAPTER 8

Writing Out a Page

Writing out a page in Copperplate may at first seem simple, but there are a number of points to consider and decisions to make. For our purposes, "writing out a page" may be defined as writing one or more sentences on a single sheet of paper with properly balanced margins, but with no decoration, embellishments, or variation in letter size or ratio.

The instructions and suggestions in this chapter are for writing a paragraph, a short prose piece, a short quote, or a poem. Before you even think about more complex projects, you should be able to write several consecutive lines of Copperplate with consistent and correct letterforms and spacing. A well-written Copperplate passage, thoughtfully placed on the page, is no insignificant achievement.

Included in this chapter is information on margins and line spacing as well as suggestions for enhancing this basic layout.

WRITING A SIMPLE PARAGRAPH

The first step must be to set some parameters. All of the following guidelines are flexible, but for the purpose of learning the procedure, limit yourself to the following:

1. Choose a prose passage of approximately forty to fifty words. (Do not use poetry; it has its own rules and problems, which will be discussed later.) Whether your text is one sentence or several is not important, but it should all be continuous. It should not be a letter, a shopping list, or a series of short quotes. Pick a passage that you like; it is always preferable to write something that interests you.

2. Include a title, author, or text reference for your piece.

3. Use a standard-size guide sheet, rather than working smaller or larger or changing the ratio. You can do that next time.

4. Work on 11″ x 14″ paper, held horizontally.

5. For your first draft, try using a fine-point felt-tipped marker. If you write slowly and carefully, you can use this pen to make layout and line-spacing decisions without spending the amount of time you would need to write with a Copperplate pen. (Many of the illustrations in this chapter were written with a felt-tipped pen. They were reduced 33 percent to fit the format of this book.)

PROCEDURE

Keeping an even left margin, write out the passage slowly and carefully, using each writing space (ascender, x-height, descender) on the guide sheet. Do not repeat or correct letters or words. Try to write with a steady, regular rhythm.

You may indent the first word to make a paragraph if you wish to, or keep it in line with the rest of the text.

If the piece has a title, put it on the first writing line and start the text on the second line. If there is no title, but your piece has an author and/or a text reference, start the text in the first writing space and put the author or reference on the last line. You will probably use five or six writing spaces with six or seven words per line, not including your title or author/reference line.

In almost any calligraphic project, more than one draft is necessary. It is virtually impossible to predict with complete accuracy how a piece of writing will fit on a page. The page that you are writing on will serve as a first draft, which will be used to make the decisions and calculations necessary to do the finished piece.

MARGINS

A balanced piece of writing has visually equal left and right margins. The top margin should be approximately equal to the left and right margins, and the bottom margin should be a little larger.

Do not attempt to justify the right margin. Because calligraphy is hand-written, it is rare that lines of writing come out equal in length. By no means should you force this by stretching out or condensing the spacing of letters or words. An unequal but visually balanced right margin is to be expected in a good piece of calligraphy.

Your page will probably look something like this (written with a felt-tipped pen):

Nobody seemed to know where they came from, but there they were in the Forest: Kanga and Baby Roo. When Pooh asked Christopher Robin, "How did they come here?" Christopher Robin said, "In the Usual Way, if you know what I mean, Pooh," and Pooh, who didn't, said, "Oh!"

Winnie-the-Pooh, A. A. Milne

If it looks like this:

Nobody seemed to know where they came from, but there they were in the Forest: Kanga and Baby Roo. When Pooh asked Christopher Robin, "How did they come here?" Christopher Robin said, "In the Usual Way, if you know what I mean, Pooh," and Pooh, who didn't, said, "Oh!"

try redistributing the words so that the right margin looks more like the example in the previous illustration.

Measure the distance from the beginning of any line to the end of an average-length line (this does not include the title or credit line). If you are using 11″ x 14″ paper with 1-inch margins, an average line will probably measure between 10 inches and 12 inches. The difference between the average-length line and 14 inches gives you the total left- and right-margin space.

If your average line measures 11 inches, for example, the total margin space would be 3 inches. Half of this space should be on the left side of the piece and half on the right. The left margin will therefore be exactly 1½ inches, and the right one will be approximately 1½ inches, depending on the length of the line. Because you based your calculations on an average line of writing, some of the lines will be a little longer and some will be a little shorter. The right margin will therefore vary, but it will be visually equal to your left margin.

> *Nobody seemed to know where they came from, but there they were in the Forest. Kanga and Baby Roo. When Pooh asked Christopher Robin, "How did they come here?" Christopher Robin said, "In the Usual Way, if you know what I mean, Pooh," and Pooh, who didn't, said, "Oh!"*
>
> *Winnie-the-Pooh, A. A. Milne*

Now measure the piece from top to bottom. Add a little extra space to separate the title from the text or the text from the author's name. If the piece measures 7 inches, allow an extra ½ inch, making the total 7½ inches.

Subtract this figure from the height of your page (11 inches) to get the total top/bottom-margin space. In this case, the difference is 3½ inches (11 minus 7½ equals 3½). Of this 3½-inch total, allow 1½ inches for the top margin, so that it is equal to the left and right margins. This leaves 2 inches for the bottom.

To set your page up for your second, and perhaps final, draft, draw pencil lines on the left, top, and right, measuring 1½ inches on each side. You can, at this point, use your guide sheet underneath this page, lining up the top line on the guide sheet with your pencil-drawn top margin.

If the first line of writing is not a title, write out the piece from beginning to end with the exception of the credit line. Move the guide sheet down ½ inch before writing this bottom line.

Try to line up the credit line so that it ends at the right margin. To do this, measure the length of this line on the first draft and measure this distance from the right margin of your second draft. Then make a pencil mark on the page to show you where to start writing the credit line.

Nobody seemed to know where they came from, but there they were in the Forest. Kanga and Baby Roo. When Pooh asked Christopher Robin, "How did they come here?" Christopher Robin said, "In the Usual Way, if you know what I mean, Pooh," and Pooh, who didn't, said, "Oh!"

Winnie-the-Pooh, A. A. Milne

If the first line is the title, center it by first measuring the length of the line on the first draft. Then find the center of the top line on the second draft and measure one-half the length of the title to the left of the center. Make a pencil mark on the second draft, so that you'll know where to start writing. If, for example, the title is 6 inches long, put a dot or an *x* 3 inches to the left of the center.

After you've written the title, move your guide sheet down ½ inch before starting to write the passage.

Winnie-the-Pooh

Nobody seemed to know where they came from, but there they were in the Forest: Kanga and Baby Roo. When Pooh asked Christopher Robin, "How did they come here?" Christopher Robin said, "In the Usual Way, if you know what I mean, Pooh," and Pooh, who didn't, said, "Oh!"

If you measured the first draft accurately and drew your margin lines correctly, the finished piece will be visually centered with equal top, left, and right margins and a larger margin on the bottom. If you are writing a passage of approximately forty to fifty words using a ¼-inch x-height on 11″ x 14″ paper it should work out pretty well. If the passage is shorter, the margins will be larger. If you have no title or credit line, your calculations will be simpler. If you have both a title and a credit line, they will be a little more complicated.

But the basic procedure is applicable to many situations, even if you use a larger sheet of paper or a smaller guide sheet and change the letter proportions. A visually balanced page has white space all around it and generally has at least a little more space on the bottom than the top and sides.

When writing a shorter passage on 11″ x 14″ paper or writing on larger-format paper, you have the option of leaving more white space—which more

often than not enhances the writing—or trimming the paper. Instructions on how to cut paper are included in Chapter 10.

LINE SPACING

The measurements used in this project are based on the line spacing of your standard guide sheet. This spacing, as you know, allows for one descender space and one ascender space between each writing line. There is, therefore, no extra space between writing spaces, if you define writing space as an ascender, x-height, and descender space. The descender line of each writing space is the ascender line of the space below.

When you use this line spacing, there is the danger of ascenders and descenders bumping into each other. To prevent this, shorten the ascender very slightly—a fraction of an inch is sufficient—if it would otherwise touch the descender of the line above.

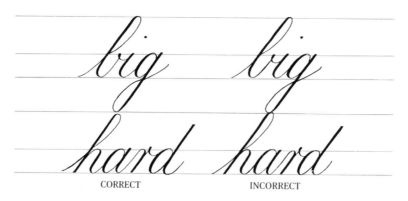

CORRECT INCORRECT

Nowhere is it written, however, that your line spacing must always be the same. The ascender/x-height/descender/ascender/x-height/descender lines that you drew are often suitable for writing out a passage, but you always have the option of changing the amount of space between lines.

WIDER LINE SPACING

To test the possibilities for increasing the distance between lines, it is easier to draw new lines than to keep moving your guide sheet (you can move it down ½ inch or whatever distance you need to separate a title or credit line from a body of text, but to move it after each line of writing would more than likely result in inaccuracy). If you make a separate guide sheet in ink with only slant lines on it, you can simply rule horizontal lines in pencil for several test sheets and use the same slant lines under each one.

As you did when experimenting with letter proportions, try writing the same passage using a variety of line spacings. You can increase the distance between writing spaces by small amounts and then use the results for comparative and reference purposes.

Rule sets of four writing spaces with extra space between them in increments of ⅛ inch, as shown opposite.

You will find that an extra ⅛ inch can make an enormous difference in the way the page looks.

A
X
D

A
X
D

A
X
D

A
X
D

A
X
D

A
X
D

A
X
D

NARROWER LINE SPACING

It is a little harder to create narrower line spacing, although you can, of course, change to a 1:1:1 ratio, as described in Chapter 5. Alternately, you can keep the 3:2:3 ratio but pull the x-height spaces together by letting the ascender and descender spaces overlap. Here is an example:

In the illustration above, the combined ascender and descender space is ⅝ inch. The ascenders and descenders are still ⅜ inch long, but they are sharing a common ⅛ inch. (The following illustration was reduced by 25 percent.)

You can add texture to your layout by decreasing the total space allowed for ascenders and descenders. Try varying the measurements in other ways.

This can only work when ascenders and descenders don't bump. This depends entirely on the words you are writing and how well you plan. You will have to try the text at least once to see if it works. It often does, although as you decrease the total ascender/descender space (thereby increasing the shared space), it gets trickier. When this is successful, it can be effective. Reducing the space between writing lines gives your Copperplate a textured quality that is quite attractive.

If you decide to write out a passage with line spacing other than that of your standard guide sheet but you made your first draft using it, remember that you must draw new lines and make new margin calculations. If your first draft was written on a standard guide sheet and measures 6 inches from top to bottom, for example, and you decide to increase the space between lines by ⅛ inch, remember to add ⅛ inch for each writing space to figure your top and bottom margins.

You may also wish to add some extra space under your title or above your credit line. That, too, must be included in your calculations. The left and right margins, of course, won't be affected.

Then either draw a new guide sheet, allowing the extra ⅛ inch between writing spaces, or draw the lines in pencil directly on the paper. This all takes a fair amount of patience and concentration, but it would be foolish to allow yourself to be restricted as a designer by the measurements of a single guide sheet.

WRITING A SHORT QUOTE

For the purposes of calligraphy, a quote can be a single word or a few words, written on one line or on several lines. It can be poetry or prose and can be written in any size on any size paper, within limitations.

Familiarity with basic rules about margins and line spacing is necessary before attempting more complex projects.

Writing a short quote is more difficult than writing a six- or seven-line block of prose because every letter in every word is important. An irregular letter or badly spaced word is far less obvious on a full page of text than it is in a single line of five or six words. The writing itself may not be more difficult to do, but you may be less easily satisfied with the results.

On the positive side, however, it is easier to redo a short quote than a long passage. If you are anything like the rest of us, you will probably find yourself doing the same line over and over until you are satisfied, and still want to do it just once more to get it right.

PROCEDURE

1. Pick your text (five to fifteen words). Be sure that there is an author or some sort of credit—a book title, the name of a person, a chapter and verse.

2. Using a pencil or a fine-point marker, write the quote two or three times, arranging the lines differently each time. Use the standard guide sheet.

You might, for example, write the quote on one line with the credit line centered underneath. Or you might write the quote in two lines with the first line shorter and the second longer, or the reverse.

Don't try to do it perfectly; the purpose of this step is to get a general idea of how the words look. You may have to try each of the options more than once to correct spacing errors. This is easy to do in pencil or marker.

Be wise with speed; a fool at forty
is a fool indeed.
Edward Young

Be wise with speed;
a fool at forty
is a fool indeed.

Be wise with speed;
A fool at forty is a fool indeed.
Edward Young

Be wise with speed;
a fool at forty
is a fool indeed.

Edward Young

3. Look at your pencil/marker versions and think about what you have done. Choose a direction to take and pursue it with variations. For example, if you wrote the quote in two lines plus a credit line, you might try writing the credit line smaller. You would need to change guide sheets to do this. You might also try writing one or two significant words larger. You could try writing the first letter larger or use a more elaborate capital letter.

Each of these options can be tested without rewriting the whole passage. What you are doing is creating the raw materials to choose from when designing the final version.

Be wise *Be wise with speed*

a fool at forty *40*

Edward Young *Be wise*

Be wise *Be wise*

A fool

4. Select the best options and write them carefully in pen and ink. Write each line or individual element separately without trying to center or arrange them on the page.

5. Now cut out the pen and ink version of the quote and all the separate options you have tested in individual strips or pieces. You may have two or three versions of the credit line, for example, written in different sizes or one or two words from the quote written in more than one size.

6. On a clean sheet of white paper, position the strips of writing according to your pencil draft. Look at them. Move them around. Move them closer together and further apart. Put the lines of writing closer and the credit line further away. Make them symmetrical and then flush left (with an even left margin). Replace the lines you have written in several sizes with each alternate version.

Try cutting the last word off the first line and putting it at the beginning of the second line. Or try the opposite: cut the first word off the second line and move it to the end of the first line.

Maybe the quote should be in one line after all. Put the two strips together. Or maybe it should have three lines (especially if it's longer than five or six

words). Cut the lines up and arrange the words in three lines. Decide what looks best. It is much easier to make these decisions by moving strips of paper around than by drawing lines and writing the quote over and over again.

7. Think about color. Do you want to do a letter in color? A word? A line? All of it? In one color, two colors, more? Making color tests is slower, but this too will save you time in the end. Write the word, letter, or whatever, in color; cut it out; and substitute it for the black version. Is it better? Is it too much? Too little?

8. Take a break. Look at your layout after an hour or two, or, preferably, the next day. Often the perfect solution comes to you while you are washing the dishes or taking a shower. The next time you look at your layout you'll know exactly what to do to make it work.

9. After you have made your decisions, you are ready to start your finished piece. (The very important question of how much space to leave around your quote will be discussed later in this chapter.)

Draw the lines very carefully, either in pencil directly on the paper you will be writing on, or in ink on a guide sheet if the paper is sufficiently transparent.

Measure the distance between lines on the paper-strip layout and follow these measurements when drawing the horizontal lines. Don't forget to draw slant lines. If you change letter size for a line, a letter, or a word, draw the guide lines accordingly.

Position the lines so that the piece is more or less centered on the page, leaving lots of white space around it. It is always a good idea to use a sheet that is bigger than you need and to trim it after you do the writing.

If the layout is symmetrical, draw a pencil line down the center of the sheet and indicate to the left and right of center on each base line where the line of writing begins and ends.

If the layout is flush left or right or asymmetrical, indicate where each writing line begins. Make all these marks in pencil so they can be erased later.

10. Now write out the piece. You may very well find that your lines come out a little longer or shorter than they did on the first draft. If the difference is small, don't worry about it. On your next attempt (if there is a next attempt), start a little further to the left or right as necessary.

Be wise with speed;
a fool at forty is a fool indeed.

Edward Young

If there is a big difference between your layout measurements and the finished piece, recheck your measurements and guidelines or examine your writing to see if you have varied the spacing significantly. You may have to change the beginning/ending indicators and redo the piece.

MARGINS

After you are reasonably satisfied with your calligraphy and layout, consider the white space around the writing (the instructions that follow assume that you followed the suggestion in Step 9 and left extra space around your writing).

Remember the general margin rule: The space to the left, right, and top of your quote should be visually equal, and the bottom margin should be bigger. A further guideline to determining the total amount of white space on the page is that it should be equal to or greater than the total amount of writing space. Wide margins almost always improve the visual effect of good writing.

Keeping these rules in mind, the best way to determine the size of the margins is visually, not mathematically. A simple way to make margin decisions is to cut out four strips of black or colored paper, approximately 2 inches wide and longer than the larger dimensions of the sheet on which you wrote your quote. Tape the corners of two sets of two strips together at right angles so that they each look like an *L*.

Position the two *L*s around your work so they form a frame. This frame can be moved in and out, away from and toward the center of the page, so that greater and lesser amounts of white space show. By varying the position of the frame, you can see what your piece will look like with larger or smaller margins.

Find a position for the frame that gives you visually balanced margins and leaves plenty of white space around the writing. After you are satisfied with the margins, mark off the inside four corners of the frame with a pencil. These four dots will give you the approximate points for cutting your piece.

Before you cut it, check the points to see that the horizontal lines formed by connecting the dots are parallel to the writing lines and that the vertical lines

Lover, whom the darkness so becomes
that I rejoice to lie upon your breast
and listen to the never-ending plaint
which murmurs to itself in marble pools
among the trees disheveled by the wind:
moon, melodious water, marvelous night,
your sorrow is the mirror of my love!

CHARLES BAUDELAIRE

Caroline Leake, Baudelaire Quote, 1987. Written with Gillott 404 nib, Higgins Eternal ink, reduced. Drawing in pencil.

are parallel to the left and right margins. Make any adjustments necessary in pencil before cutting.

Follow the cutting instructions in Chapter 10 pp. 187–188.

WRITING OUT POETRY

Writing out poetry has stricter limitations than writing out a quote. You can use much of the information given in this chapter on writing out a paragraph, as well as some of the instructions for writing out a quote, provided you are aware of specific rules concerning poetry.

Poetry should be written out in the same format that the poet chose. If all the lines are flush left, or if they are alternately indented, or however they are arranged in type, they should be done the same way in calligraphy. This actually simplifies your task. Of course, you still must decide about space between lines, position on the page, color, and letter size, but the format of the poem is preset.

Make a first draft and try variations on the size of the title and the poet's name, on line spacing, and on color. Make the same visual tests that you would if you were designing a quote. After you have made your decisions, you can draw your lines and write out the poem.

If the format calls for an even left margin, draw a vertical guideline so you start each line in the same place. If the lines are alternately indented, a second vertical line is necessary. By cutting out the lines in your first draft and moving them to the right and left, you can decide how much to indent.

If you are writing a sonnet, the first twelve lines should be flush left and the last two should be indented. Cut out those two lines in one piece and move it in and out, relative to the other twelve lines, to find a good visual relationship.

When laying out a poem, you can put the title and poet's name at the top or the title at the top and the poet's name at the bottom. If there is no title, the name belongs at the bottom. The title should be the same size as the text or larger. The poet's name is generally written smaller and can be either centered or moved to the left or right. It should never be in the lower right corner of the page.

Figure out your margins by using the *L*s. Give yourself plenty of white space to work with; it's easier to cut the margins than to redo the entire piece because you haven't left enough space.

CHAPTER 9
Commercial Calligraphy

There comes a moment in the life of just about every calligraphy student when someone says, "You're a calligrapher; could you address my wedding invitations?" or "Can you fill in the names on certificates for my company?" If you feel that your Copperplate is of sufficiently high quality to do a professional job, you should know how to get the job done quickly and accurately.

In this chapter, the procedures for doing the most frequently called-for freelance jobs are outlined.

ENVELOPES

Addressing envelopes will probably be the first calligraphy job you attempt. Whether it is for your own party invitations or greeting cards or for those of a client, the procedure is the same.

The instructions are for addressing a series of white or off-white (also known as ivory, eggshell, or ecru) envelopes, all of which are the same size.

You will be making a guide sheet that fits inside each envelope. If the envelope is a light color, you can see the guidelines through the envelope and avoid the necessity of drawing lines on each envelope.

This method will not work if the envelopes are a dark color or even certain bright colors. Nor will it work if the envelope has a paper insert, especially if it is shiny, such as the kind used in some wedding or Bar Mitzvah envelopes.

MATERIALS

Two pieces of lightweight or medium-weight white cardboard, measuring approximately 9 by 12 inches

A metal-edged ruler

A well-sharpened 3H or 4H pencil

A fine-point felt-tipped black marker or technical drawing pen

A protractor

Masking tape

PROCEDURE

1. Before making your guide sheet, test the envelope to see if this method will work. To do this, use your felt-tipped marker or technical pen and make a line on a piece of white paper. Put the paper into the envelope. Press the envelope

against the paper and see if you can see the black line. Most light-colored envelopes (without paper inserts) are sufficiently transparent, especially if your line is quite black and the light is good.

2. Cut one of the pieces of cardboard so that it is approximately ⅛ inch narrower and shorter than the envelope. It should slip in and out of the envelope easily but not move around inside.

An easy way to do this is to trace the shape of the envelope on the cardboard and then rule lines that are a little smaller, parallel to the outline of the envelope. Cut on the inner lines. If you position your envelope against two edges of the cardboard before you outline it, you will have to make only two cuts.

3. Draw guidelines on your cardboard. The top of the highest ascender line should be approximately halfway down and there should be space for four writing lines and about ½ inch of white space at the bottom. Proportions (in inches) of ³⁄₁₆:⅛:³⁄₁₆ will give you enough space for an envelope that is 5 inches high.

If the envelope is shorter, draw your top line above center. On an envelope that is 4 inches high, start 1¾ inches down the top and leave only ¼ inch at the bottom.

If the envelope is more than 5 inches high, you can draw bigger guidelines (in inches) ⁵⁄₃₂, ³⁄₁₆, ⁵⁄₃₂, for example. The ⅜, ¼, ⅜-inch size used in Part Two of this book is too large for most envelopes. Working smaller than a ⅛-inch x-height is very difficult.

Using the protractor, draw slant lines that are fairly close together.

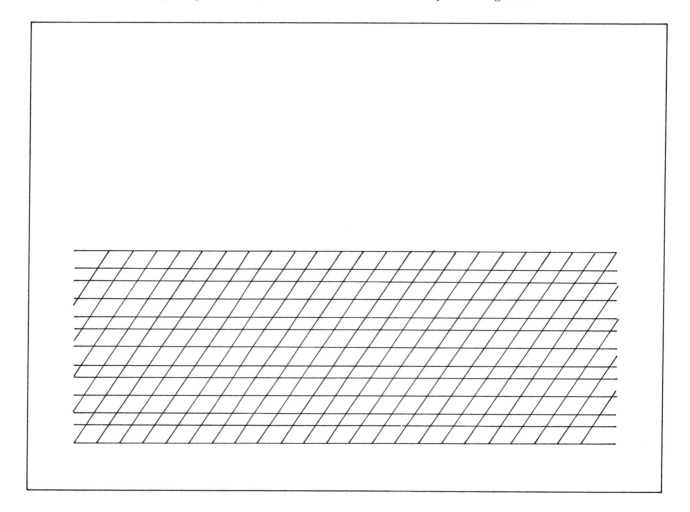

4. Make a diagonal line of approximately 45 degrees starting about 1 inch from the left. This will help you indent the address lines equally.

Put a large dot at the point where the diagonal intersects each base line so you will know where to start writing each line. This saves you from the easily made error of writing on the wrong line.

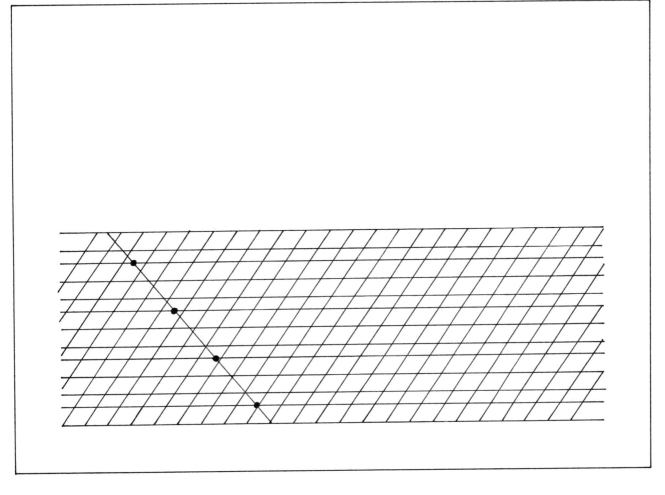

The fourth writing line is for the zip code if it is an American address, or the country if it is a foreign address. The dot on the left side of this line indicates the writing line, but not where the zip code begins. It is best to center the zip code visually under the third line of the address. If you start it at the dot, the zip code will be too far to the left.

5. Tape the top of the guide sheet to the second piece of cardboard so that you can flip it up and slide the envelopes on and off the guide sheet without handling them too much. Be careful that you do not extend the tape beyond the width of the guide sheet or it will not flip up.

6. Slip an envelope on the guide sheet. Be sure it is securely in place and the guidelines do not go uphill or downhill. Use your guard sheet to press the envelope against the guide sheet so you can see the lines.

7. Address the envelope so the entire address is visually centered from left to right. This will rarely be exact and it is not necessary to make it so. After you have tried it a couple of times, you will know by looking at the name and address whether to start the top line at the diagonal or to the left or right of the diagonal.

The diagonal line and dots are to help you balance the address, not to force you to start each address at the same point. If the name is short, start further to the right; if it is long, start further to the left. If the name is long but the address is short, start the name at the top dot and indent each of the next two lines a little more than the amount indicated by your diagonal.

Use your judgment. You will find that with a little experience you will make very few bad guesses.

Mr. and Mrs. John Winston
234 Broad Street
Plainfield, New Jersey
01231

ADDRESSING AN ENVELOPE YOU CAN'T SEE THROUGH

If an envelope is any color besides white, off-white, or very pale, you probably won't be able to see through it. Paper liners also make most envelopes opaque.

To address a series of such envelopes you will, therefore, have to make lines on each one. You should, of course, test it before drawing any lines; it might be transparent enough to use a guide sheet.

After you have determined that your envelope is opaque, there are a few shortcuts you can take. One method is to set your envelope up on a guide sheet that is larger than the envelope so that the horizontal lines extend to the left and right of the envelope and the slant lines extend above and below. Using a ruler and a 3H pencil, draw the lines on the envelope by connecting the lines on the left to the lines on the right and connecting the slant lines from top to bottom.

Be sure to indicate the position of the top ascender line and the bottom of the envelope on the guide sheet and then position each envelope carefully before drawing any lines.

Make your indentation diagonal on each envelope. This is slow, but not nearly as slow as using a ruler to measure the spaces, making dots, and connecting them.

Another method is to use one of the line-drawing devices manufactured by some calligraphy companies: templates or Phantom Liners that project lines onto envelopes. Neither of these methods gets good reviews from all users, but you can certainly try them and make your own judgments. Guide sheets or pencil lines are usually more accurate than other methods.

If you draw pencil lines, however, whether it is with a template or a guide sheet, you must erase them. See Chapter 10 for erasing instructions.

USING A LIGHT BOX

A light box is helpful for addressing envelopes and doing many other commercial jobs. It is a flat or sloped rectangular structure that looks like a box. It has one or two fluorescent bulbs set inside, and the top is made of frosted glass or plastic.

When the light box is switched on, your work is illuminated from below. If you tape guidelines to the top surface of the light box and place the page on which you will be writing over the guidelines, the light will make the lines appear clearly on your paper, even if the paper is quite thick. Even with a light box, however, dark-colored envelopes or envelopes with paper liners are difficult if not impossible to see through.

If you have a light box, you still need to make a guide sheet for addressing envelopes, but you will be able to put the envelope on top of the guidelines, rather than putting the lines inside the envelope. With the light shining underneath, your lines will be much clearer through the two thicknesses of paper than they would be through a single thickness without a light box.

One disadvantage of a light box is that it may make your eyes tire faster than overhead light and may give you a headache. The other problem is that the hard surface of the glass or plastic is less comfortable to write on than the sheets of paper that you customarily keep under your guide sheet for padding. Despite these disadvantages, however, most people find a light box a boon and a blessing for doing commercial work.

Light boxes are available at most large art-supply stores or from calligraphy-supply companies. It is worth shopping around because the price range is enormous. A recent variation on the light box, available from calligraphy supply companies, is a combination of a piece of bent Plexiglas and a separate fluorescent-light fixture. This seems to work very well.

NAME CARDS AND FILL-INS

Name cards and fill-ins are among the simpler projects.

Name cards can be table place cards or escort cards for a formal party, or badges, often worn under a plastic covering, for business meetings or conventions. Either way, they are generally fairly small in format.

Fill-ins are names and sometimes dates that are to be written on preprinted certificates, diplomas, or forms of one sort or another. Sometimes they are individual names, sometimes the names of companies or organizations.

The instructions that follow are for lists of names that are to be written on individual cards or forms, all of which have the same layout.

CENTERING

In most jobs of this kind the words must be centered. This involves writing some or all of the words twice.

If you have only a few names to center or if you feel more confident doing it this way, write out each line (name or company name or whatever is called for) and measure it. Write the measurement next to each line of writing. It is easier to measure if you use an even left margin. Make a pencil mark at the center of each line.

Marion Gutmann $3\frac{1}{4}$

Carole Maurer $2\frac{7}{8}$

Roberta Wetherbee $3\frac{1}{2}$

John Gold $2\frac{1}{4}$

Richard Andrews $3\frac{1}{2}$

Eustace Sinclair 3

If you have many lines to write, get a typed list of names (or type it yourself) with an even left margin. Write out and measure the first few lines and then any others that are very long or short.

Generally, names that are equal in length when they are typed will be equal when written out. Exceptions are names with lots of *m*'s and *w*'s, which are wider, or *i*'s and *j*'s, which are narrower. With this in mind, you can estimate line lengths based on the samples you have written and measured.

SET UP

If your cards or certificates are transparent (often certificates are; cards are usually not), or if you are using a light box, you can make a guide sheet. The guide sheet should have lines to indicate the placement of the certificate or card and the guidelines for filling in the names.

To center the names accurately, draw a center line on your guide sheet and mark off ¼-inch increments to the left and right.

Each ¼ inch is actually equal to a ½-inch measurement because you are dividing the length by two. Thus, if a name is 2 inches long, it starts 1 inch to the left of the center line and ends 1 inch to the right.

The numbers on your guide sheet should therefore reflect the total length of the line, not the distance from the center. One inch to the left of the center line should be indicated with a *2*: the total length of a line that begins 1 inch from the center.

In the illustration above, the numbers show the length of a centered name. If this is confusing, measure the distance between the 2-inch mark to the left of center and the 2-inch mark to the right.

If there is more than one line to be written on the certificate or name card, draw the necessary guidelines on your guide sheet. If the lines are directly above each other, you can use a single set of centering guides.

After you have your guide sheet set up, you can put each certificate or card over the guide sheet, with or without a light box. Arrange it carefully so that the guidelines are in the correct position.

Referring to your list of names to be written and the samples you have measured, you can write each name or line on the place card or certificate, being reasonably certain that the centering will be accurate.

The center mark that you made on your test sheet will help you determine whether you are accurately reproducing the spacing of your first draft when actually writing the name on the certificate or card. If, for example, the center mark on "John Smith" is in the middle of the *S*, and on your finished piece, you reach the center guideline two letters before that, your centering will not work as expected. Sometimes you can make adjustments; often you have to redo the card.

It is important, when doing envelopes, name cards, certificates or any other job that involves multiples, to get lots of extra envelopes or whatever you are writing on. Having an extra package of envelopes or place cards, which you can return unused if necessary, is far better than trying to get a few extras after the job is complete to redo errors. It also gives you a modicum of peace of mind.

INVITATIONS

The instructions that follow are for doing a formal invitation that is to be printed. Unlike envelopes or certificates, this kind of job calls for a single finished piece of work that will be reproduced in quantity.

Making a well-designed invitation involves using much of the information in this chapter as well as in the previous one. You will have to make decisions about line spacing, margins, and layout.

You will have to draw a guide sheet for the job, so that you can redo it more than once, since a single finished piece must be the best-quality work you can do. (You should also do your best when addressing envelopes or doing fill-ins, but when you have a hundred envelopes to address or two hundred and fifty name cards, an occasional imperfection is to be expected.)

Generally, invitations must fit a specified format, usually a vertical that measures approximately 5-by-7 inches, 4-by-6 inches, or a similar width-to-length proportion. Find out the size you need to fit or the options that you can choose among. You will be able to write out the invitation at the size that is comfortable to work in and have it reduced to fit the necessary size of the invitation.

Here is a step-by-step procedure for a symmetrical invitation:

1. Use one of your smaller guide sheets, but not one that is too small for you to write accurately. More often than not, standard line spacing works well on an invitation, so you can use the ascender/x-height/descender/ascender/x-height/descender ruling that you ordinarily use.

2. On a sheet of white paper, write out each line of the invitation in a separate space, making no attempt to center the lines. You can line them all up with the same left margin; it makes the next step a little faster.

As you write these lines, be sure your spacing is accurate and don't rewrite any words or letters. If your spacing is unsatisfactory or you write the wrong word or leave something out, rewrite the whole line.

Mr. and Mrs. Thomas Whoever $3^{1}/_{4}$

request the pleasure of your company $3^{3}/_{4}$

at the marriage of their daughter $3^{1}/_{4}$

Lolita $3^{1}/_{4}$

to $^{1}/_{4}$

Mr. James Someone $2^{1}/_{8}$

on Friday, December 25 $2^{5}/_{8}$

at six o'clock $1^{3}/_{8}$

at the Hotel Royal $2^{1}/_{4}$

New York $1^{1}/_{4}$

3. Measure each line and write the measurement next to it as shown on page 172. You can also mark the center of each line to double-check your centering when you do the finished piece. This is the process previously explained under "Centering."

4. Prepare your guide sheet. You can either use the same guide sheet that you used for Step 2, or draw a new one with the same line spaces. If you draw a new guide sheet, hold the page vertically. If you use the one used previously, you may find that it does not have enough lines to write the entire invitation. If that is the case, you will have to move your page up when you run out of guidelines. This is no problem if you reposition it carefully. Most invitations have at least seven or eight lines; often they have more.

Draw a center line on your guide sheet. Using the measurements you made in Step 3, indicate where each line of writing begins and ends relative to the center line by making marks on each base line on your guide sheet.

5. If there is an RSVP, it should be positioned below the bottom line with some white space in between. It is simplest to leave one blank writing space between the invitation and the RSVP, although you may wish to leave more or less space.

Position the RSVP so that it is in line with the first word of the longest writing line of the invitation. If there is another line that belongs under the main text of the invitation, such as "Black Tie" or a phone number, you can put it on the same line as RSVP, lined up on the right or directly under the RSVP.

6. Place your guide sheet under a piece of smooth white paper (with or without a light box) and write the invitation out carefully, checking your centering for each line against your first draft. You may have to write it several times before you are happy with the results. This is normal.

If the centering is off by a lot relative to the measurements of your first draft, it could be because you measured wrong, you divided wrong, you put your beginning and ending marks in the wrong place on your guide sheet, or you were more tense when making the second draft and therefore made your letters closer together or, possibly, but not as likely, further apart. Whatever the reason, you may have to reposition your beginning/ending marks on your guide sheet before redoing the invitation.

7. When you have a satisfactory version of the invitation, you will want to retouch it. This is explained in the next chapter.

8. It is often necessary to reduce the finished artwork to fit the card upon which it will be printed.

The reduction should allow at least ¾ inch of white space to the left and right of the widest line. Measure the longest line on the invitation. If it is 6 inches, for example, and your card is 5 inches wide, you should have the invitation reduced so that the 6 inch line will fit into a 3½-inch space ($5'' - [\frac{3}{4}''$ \times 2]) or $5'' - 1\frac{1}{2}''$).

The reduction will be in the form of a photostat. Order your photostat as follows: "Direct Positive, 6 inches → 3½ inches." This will give you a black on white print. Your widest line will measure 3½ inches and everything else on the original will be reduced proportionally. This includes the height of the piece as well as the length of the lines. If, for example, the writing on your invitation measured 8 inches from top to bottom, it would be reduced to 4⅝ inches.

In the two examples that follow, the artwork was written using a guide sheet with an x-height of ³⁄₁₆ inch. The widest line measured 6¾ inches. Shown here is a photostat that is 55 percent of the original size. The two previous examples were also reduced by the same amount.

Mr. and Mrs. Thomas Whoever
request the pleasure of your company
at the marriage of their daughter
Lolita
to
Mr. James Someone
on Friday, December 25th
at six o'clock
at the Hotel Royal
New York

R.S.V.P.

Mr. and Mrs. Thomas Whoever
request the pleasure of your company
at the marriage of their daughter
Lolita

to

Mr. James Someone
on Friday, December 25th
at six o'clock
at the Hotel Royal
New York

R.S.V.P

9. After you have the photostat in your hand, you will be able to see what the invitation will look like when it is printed. If you are not satisfied, this is the time to change it. If you wait until after the invitation is printed, it will be too late to change anything.

A photostat costs a few dollars; one hundred printed invitations cost much, much more. This is a good reason to have a photostat made rather than instructing the printer to reduce your artwork during the printing process. Reduced calligraphy does not always look like what you expect it to look like.

Look carefully at the photostat. Is it too small? You can get another photostat that is reduced a little less. Is it too big? Get a photostat that is reduced more. Is your spacing off or is some of the lettering bad? Fix the original and get a new photostat.

10. When you are satisfied, you can paste the photostat to a piece of white cardboard, illustration board, or mat board and draw an outline showing the outside dimensions of the piece. Your left and right margin should be equal and your bottom margin should be a little larger than the top.

Because you cannot control the number of lines of writing, the size of the top and bottom margins are not as easy to arrange as the left and right margins. You can, of course, vary the space between writing lines, but that will increase the complexity of your task and can make the mathematical calculations considerably more complicated.

Draw your outline with a nonreproducing blue pencil or pen, available in any art-supply store, and make crop marks with a black fine-point marker, as shown opposite.

This will show the printer where to cut out the invitation.

It would probably be helpful to hone your graphic-art skills by taking a course in pasteups and mechanicals, as well as instruction on preparing artwork for reproduction, working with photostats, dealing with printers, and using a proportion wheel for reductions.

Even if you haven't been commissioned to address envelopes, design invitations, or fill in certificates, it's a good idea to try all of these projects. If you follow the instructions you will find that none of these tasks is difficult. By completing each project for practice (or fun), you will be ready for the real thing when the time comes and will also have examples to put into a portfolio to show potential clients.

Mr. and Mrs. Richard Burnett

request the honour of your prescence

at the marriage of their daughter

Eleanor

to

Julian Epstein

Saturday the ninth of June

at six o'clock

Montauk Yacht Club

Montauk, New York

R.S.V.P.

One East 64th Street, New York City 10022

Linda Dannhauser, *Wedding Invitation*, 1982. Written on graph paper with Gillott 170 nib, Higgins Eternal ink, reduced approximately 50 percent.

*W*e would like you

to join us

for dinner

Friday the sixth of May

eight o'clock

at The "21" Club

21 West 52nd Street

New York NY

M

will _____ attend wedding

will _____ attend dinner

Linda Dannhauser, Invitation, Response Card, 1983. Combination of Copperplate and typography. Initial capital letters written with Gillott 170 nib, Higgins Eternal ink, reduced 20 percent.

CHAPTER 10

Retouching, Correcting and Cropping

Students about to embark upon calligraphic projects frequently ask, "What do I do if I make a mistake?"

Depending upon the purpose of the piece of calligraphy, there are a number of answers to that question. If you are working on artwork for reproduction, you have many options. If your calligraphy is to be used in its original form (framed, mounted, or presented as a "piece of art"), there are also ways to make corrections, but you are more limited.

RETOUCHING FOR REPRODUCTION

Learning how to make corrections on artwork that is to be printed can save you much time and frustration.

There are two ways to make changes and corrections on an invitation, menu, or advertising piece before it goes to the printer. The first method is by retouching; the second involves redoing the words or lines that need to be corrected, cutting them out, and pasting them over the original art. Often a combination of the two methods is required.

Learning to cut, paste, and prepare camera-ready artwork is highly recommended for all calligraphers who are interested in entering the commercial art world. For those who do Copperplate, however, learning how to retouch comes first. The information that follows is on retouching for reproduction.

MATERIALS

1. A pointed nib in a straight-pen holder. The nib can be a Copperplate nib as long as it is not an elbow nib. It should not be too flexible.

2. Your regular Copperplate nib

3. Ink

4. Krylon Crystal Clear, or similar acrylic spray coating

5. Pro White, Flo White, or similar opaque white watercolor retouching paint

6. A good-quality small watercolor brush, size 0 or 00. To test the quality of a brush, wet the end. A good watercolor brush will come to a point when it's wet. If it does not do so, don't buy it; it will be useless for retouching. Always keep

your retouching brush separate from any other paintbrushes you may have. If it is used for color it can no longer be used for retouching.

7. A clean water container

WHEN TO RETOUCH
Calligraphy for reproduction should be written in black ink on white paper. You can give the printer either the original art, preferably written on smooth paper, or a photostat. The photostat can be the same size as the original or smaller, depending on the requirements of the job and the size you are most comfortable writing. You can also get photostats that reverse your artwork, that is, give you white writing on a black background. These can also be retouched.

Because the printing process involves photographing the artwork to make a printing plate, you can make changes and corrections on your artwork with white paint. The camera will not pick up the texture of the paint, nor will any small color variations between the white paint and the white paper be visible.

Retouching is required to correct misshapen letters, shaky or broken strokes, small spelling errors, or spots that have to be removed from the artwork. It is fairly difficult to change a whole word into another word, but a single letter can often be changed into another single letter, if it occupies the same position. You can, for example, change "merry" into "marry" or even into "happy." You cannot change one letter into two or three without destroying your spacing; you cannot change, for example, "merry" into "Christmas."

PROCEDURE
1. Look at the piece you are about to retouch. Pick out the most obvious errors: the shakiest lines, the sloppiest flourishes, the letters that have to be rewritten. It is important to look at the entire piece before you begin so that you can first correct what is most obvious. If you start retouching with the first letter of the first word, you will find that your task becomes enormous. Often making two or three corrections can make your artwork look considerably better without your having to devote too much time to the process.

2. Using a straight nib and black ink, correct any broken or irregular strokes or curves. It is not necessary to write directly on top of the line you are correcting, as long as you put the line or curve where it should be.

You are cordially

3. If you wish to change a letter, rewrite it over the one that is to be changed, concentrating on the form and spacing of the new letter.

Steven Frankll

In the illustration above, the name "Frankel" was incorrectly spelled "Frankle." The *e* was subsequently written directly over the *l* and the *l* was written on top of the *e*.

4. After you have written over the most obvious errors, scan the page again for any others that catch your eye. Look a little more closely this time. Then follow steps 2 and 3 as necessary.

5. Following the directions on the can, spray the page with Krylon Crystal Clear. Two or three light coats is preferable to one heavy coat. Allow a few minutes for the page to dry after each coat.

It is advisable to spray outdoors or at least somewhere away from where you are working (or anyone else may be) because it is not healthy to inhale the fumes of the acrylic spray.

The purpose of spraying your work is to enable you to use a water-based retouching paint with a minimum of bleeding, which would be the result of the paint mixing with the ink. Without the acrylic coating, the white paint would combine with the ink, turning your artwork grey.

Crystal Clear will make your page water-resistant, not waterproof. It protects the art to a certain extent, but if water is spilled on the page, the page will be ruined.

6. After the acrylic spray is dry—this may take a few minutes—you can use the white retouching paint.

Using the watercolor brush, add a little water to the white paint, diluting one spot until the paint can be applied smoothly to the paper.

The white paint should be neither too wet nor too thick. It takes a little testing to get the consistency right, but you should be able to paint over a black mark without getting the paper wet, which will make the ink bleed. If the paint is too thick, however, it won't cover the ink smoothly and may not leave the brush at all.

Practice retouching before you try it on an important piece of artwork. It's really quite easy to regulate the consistency of the paint, but it might not work exactly right the first time you try it. Before putting brush to paper, make a test stroke on a separate piece of paper to be sure the consistency of the paint is right.

Working slowly and carefully in good light, paint out anything that you wish to remove from your artwork. This includes tiny irregularities in a stroke, the shaky part of the curve that you have redrawn, spatters and spots on the page, and the parts of the letters that you have rewritten that don't coincide with the new letters.

If, for example, you are replacing a *g* with a *y*, you only have to paint out the upper part of the curve of the o-form of the *g*. If you are changing an *e* to an *a*, you have to remove the center loop of the *e* and most of the exit stroke.

To paint out parts of letters or strokes, you must keep turning your paper so the brush is always positioned to the right of or below the stroke you are correcting or to the left of the stroke if you are left-handed.

If you accidently paint over something that should not be removed, wait until the white paint is dry and then carefully scrape off the paint with a single-edged razor blade or an X-acto knife. If you retouch the black with ink, you will have to spray the area again before adding more white paint.

You will probably notice that despite the acrylic spray, some bleeding occurs, especially where you painted out large areas or where the paint was a

little thin. Wait until the white paint is completely dry and add another coat. If necessary, add a third coat as well, but be careful not to pile the paint on too thickly or it will form a small hill on your paper that will chip off. If this happens, scrape the excess paint off carefully with a sharp blade and retouch the area once again.

7. Sometimes after retouching you will notice areas that need more pen and ink work. If the acrylic spray was not too heavily applied, you can fix these areas at this point.

It is difficult to make such extensive corrections as adding a line of writing on top of the spray coating, but small changes can be made. After you make your pen and ink corrections, spray the area again if you have to add more white paint over the fresh ink.

If you remember the following points, retouching is easy:

• The sequence must always be *ink/acrylic spray/paint* to prevent bleeding.

• Use a good light, so that you can see what you're doing.

• For retouching, use a good-quality watercolor brush that you use for nothing else. If the brush doesn't come to a point when wet, it won't be effective for retouching.

• Work very slowly and carefully. A good eye, a steady hand, and patience are all essential.

CORRECTING ERRORS ON ORIGINAL ART

Original art, in this case, is defined as a piece of calligraphy that will be used in its original form, not reproduced. Unlike artwork for the printer, original art can be done in any color, on any paper surface.

The corrections you make are, of necessity, limited by what can be done that does not show. More often than not, this rules out rewriting letters on top of existing letters or redrawing curves or flourishes. There are, however, some exceptions, as explained below.

There are two routes to take when correcting original art. Sometimes you can erase a stroke or an error and sometimes you can scrape it off with a razor blade or an X-acto knife. To save yourself an enormous amount of frustration, read and memorize the following rules:

RULE 1. *Never correct an error on original art without testing the correction method on a separate sheet of the same paper.*

To do this, take a scrap of the same paper that the artwork was done on and make a stroke or two in the same ink or paint that you used on the artwork. Then, following the instructions below, try both correcting methods on this test sheet.

Usually, one method works far better than the other, but it is difficult to guess which one will work. If you guess wrong directly on your artwork, you will ruin it.

RULE 2. *Never make a correction immediately after making the error.*

There are two reasons for this. First, the ink must be completely dry before it can be removed with any success. Wait several hours, if possible, especially when it is humid.

The second reason is that you should never make a correction when you are agitated. Erasing and scraping, like retouching, demand a steady hand and a fair amount of patience. If you are upset and nervous, you will probably move too quickly and make things worse. This may not sound important, but every calligrapher has made this mistake at least once.

If you make an error, put down the pen, take a deep breath and leave it alone for a while, unless you're sure it's not correctable. In that case, you'll just have to start over. (It's probably a good idea to take a break either way.)

ERASING

Some papers respond well to erasing. Try several kinds of erasers. Old-fashioned pencil-shaped typewriter erasers, which can be sharpened to a point, usually erase ink quite well. Various kinds of ink erasers, available in stationery stores, are also worth a try. Pencil erasers usually won't remove ink, but will occasionally; they are also worth testing. Some calligraphers like using an electric eraser.

Try each eraser on your test sheet. See if they remove the ink completely, if they tear the paper, if they change the color of the paper. Sometimes you can remove a stroke or even a whole letter, and the only evidence will be that the paper surface looks a little rougher. You can smooth out the surface by going over it lightly with a kneaded eraser.

Erasing generally works best in a small area, away from the piece's center of interest. It rarely does not show at all.

When erasing on a finished piece, cover any areas that the eraser should not touch. If you erase over ink that is meant to remain on the page, it will fade, and probably smear, too. To prevent this from happening, use sheets of paper to mask the area that you wish to remove. An eraser in pencil form is useful because it enables you to work on a small area without affecting other parts of the word or line.

If you must write over the part you erased, experiment first on your test sheet. You will probably find that if you erase too hard, you remove a layer of paper, and the ink may be absorbed by the layer below. Try erasing lightly if you have to rewrite a letter or stroke.

Erasing is, as you can see, at best only occasionally successful. There are, however, times when it works quite well. It is certainly worth testing before you throw up your hands (and throw away your artwork) in despair.

ERASING PENCIL GUIDELINES

To erase pencil lines on an original piece, a kneaded eraser is generally the best tool. Test it first on a separate sheet, just as you test ink erasers, to see if the lines come off the page without damaging the paper. A plastic eraser is sometimes better if the paper is fragile.

An advantage of a kneaded eraser is that you can shape it to a point that will enable you to erase the pencil lines without rubbing the eraser over the ink. Be sure to work slowly and carefully, so that you do not damage either the paper or the artwork.

SCRAPING

Scraping off ink with a razor blade is surprisingly effective, especially on slightly textured paper.

Always use a new or almost new blade, whether it is a single-edged razor blade or an X-acto blade. It should be sharp and clean. (Never use a double-edged razor blade. The reason should be obvious.)

Using the corner of the blade, very slowly and carefully scrape off the ink that you wish to remove. Use a light, repeated motion. Do not dig the blade into the paper.

Press a kneaded eraser lightly against the paper to pick up any loose ink scrapings. Do not blow on the paper. (You might spit. It's true; it happens.)

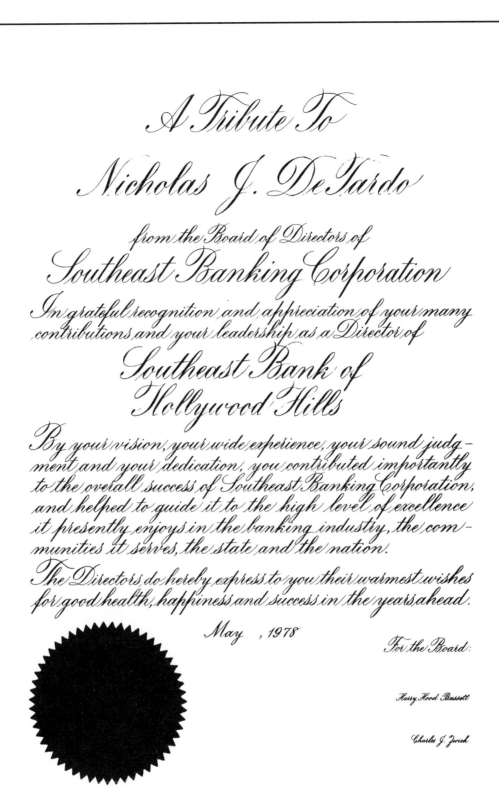

A Tribute To

Nicholas J. DeJardo

from the Board of Directors of

Southeast Banking Corporation

In grateful recognition and appreciation of your many contributions and your leadership as a Director of

Southeast Bank of Hollywood Hills

By your vision, your wide experience, your sound judgment and your dedication, you contributed importantly to the overall success of Southeast Banking Corporation, and helped to guide it to the high level of excellence it presently enjoys in the banking industry, the communities it serves, the state and the nation.

The Directors do hereby express to you their warmest wishes for good health, happiness and success in the years ahead.

May , 1978

For the Board:

Harry Hood Bassett

Charles J. Zwick

Georgina Artigas

Georgina Artigas, Testimonial, 1978. Written with Principality #1 nib, Japanese stick ink, reduced.

<div align="center">
<i>Sunday Brunch at The Barclay</i>
</div>

From the Buffet	8.75
Fresh Roast Beef Hash with Poached Egg	9.50
Creamed Diced Chicken A La Maison on Toast Points	9.00
Eggs Benedict	5.95
Veal Saute Swiss Style	11.00
Petit Filet Mignon	13.50
Minute Steak with Eggs of Your Choice	12.50
Broiled Fresh Flounder with Sauteed Potatoes	9.75
Barclay Salad	8.00
Salad Nicoise	8.00
Fresh Fruit Salad with Cottage Cheese or Sherbert	8.00
Coffee, Espresso, Sanka, Tea, Milk, Skim Milk, Hot Chocolate	1.00

Desserts

On our pastry cart, an assortment of fresh baked goods from The Barclay Pastry Shop are on display	1.50
Fresh Melons of the season	1.95
Fresh Fruits of the season	1.50

Philadelphia Ice Cream Specialties
Served with our own fresh whipped cream

Rum Raisin		
Vanilla	Butter Pecan	
Butter Brickle	Coffee Bisque	
Chocolate	Strawberry	2.15
Sherbert		1.75

Champagne (Served after 1 p.m.)	
Full Bottle	12.50
Half Bottle	6.95
Irish Coffee	3.25

<i>Robert Boyajian,
Sunday Brunch Menu, 1980.
Written on bond paper
with Esterbrook 355 nib,
Higgins Eternal ink, reduced
25 percent, not retouched.</i>

If you're cleaning up a rough edge or a partially filled-in counter, scrape the ink toward the rest of the stroke rather than away from it. To remove the excess ink at the bottom of the counter in the illustration above, scrape the ink down and to the left rather than up into the counter.

Scraping, like erasing, is limited in its scope. It is rare (although occasionally possible) that you can scrape off a whole word or even a whole letter. But you can clean up many small imperfections, thereby improving the look of your page.

CORRECTING MAJOR ERRORS

Short of being creative, which might involve redesigning a piece to compensate for an error (which rarely works), or adding some clever camouflage (which also doesn't usually work), you will have to redo the piece if the original art has a big error on it. This is the reason calligraphers always buy extra sheets of paper and allow extra time to get a job done. Everyone makes mistakes. Every calligrapher leaves words out or spells something—usually something ridiculously easy—wrong. Calligraphers tend to be so engrossed in letterforms that they make a *g* instead of an *a* or reverse the letters in a word.

There is one compensation: You can usually put a piece with a misspelling or a word left out into your portfolio. If you have to redo a job, at least you're left with an "automatic" portfolio piece. When clients look at the piece in your portfolio, they will be so impressed by the calligraphy that they will rarely notice that you left out a word or wrote *1978* instead of *1987*.

CROPPING YOUR WORK

In Chapter 19, you learned how to figure out how much space to leave around your calligraphy so that the artwork and the white space are in harmony. After you have made this determination, it is important to learn how to cut your work to the size it should be without doing damage to either your artwork or your fingers.

MATERIALS

1. Either a single-edged razor blade or an X-acto knife. The blade should be new or almost new.

2. A metal ruler with either cork or masking tape on the reverse side.

3. A piece of cardboard larger than your artwork. This goes underneath the page you are cutting to protect the desk or table from your blade. Replace this cardboard from time to time; if it has too many grooves cut in it, your blade will catch and spoil what you are cutting.

PROCEDURE

1. Rule lightly in pencil the lines that you wish to cut along. Double-check that the corners are square and the margins are exactly as you want them to be.

2. Stand up. Your arm will be freer to move if it isn't resting on the table. Cuts should be made from the shoulder, not the wrist. Cut on a flat surface.

3. Place the ruler over the artwork, with the pencil line on the outside of the ruler. The ruler is thus between the cutting line and the artwork, so that if the blade slips, you will not cut into the artwork area.

4. Keeping your fingers well away from the edge of the ruler and putting more pressure on the ruler than the blade, make several light cuts rather than

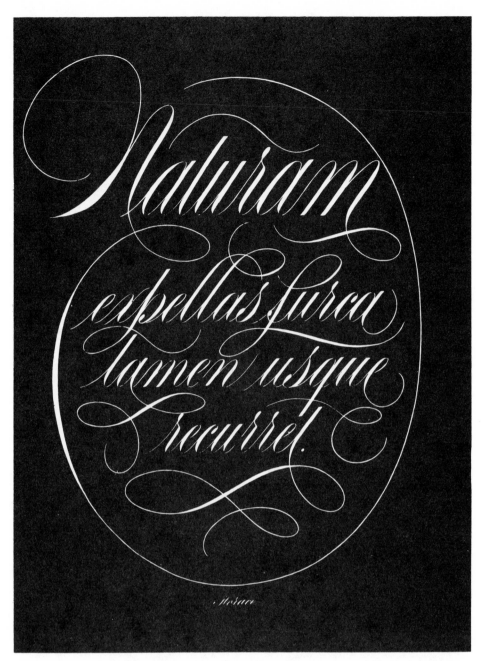

Georgina Artigas, "Naturam," 1984, from The Calligraphers Engagement Calendar 1985, *© Taplinger Publishing Co. Written with Gillott 170 nib, Japanese stick ink, reduced approximately 30 percent.*

trying to cut with a single stroke. If you're right-handed, press on the ruler with your left hand and cut with your right. If you're left-handed, do the reverse.

Cut with the corner of the blade, not the flat edge. As you cut, move the blade toward you, as if you were making a downstroke with your pen. The blade should be perpendicular to the page that you are cutting; be sure that it doesn't lean toward or away from the ruler.

Some papers can be cut with a single stroke; others take several. Be patient and work slowly.

Here are some rules to remember, so that your cutting is accurate and your fingers are unharmed.

- Never cut with a pair of scissors or a paper cutter. A blade and ruler are far more accurate.

- Put more pressure on the ruler than on the blade.

- Throw the blade away as soon as it starts to wear out. Buy several at a time.

- Always cut toward yourself.

- Use a ruler with cork or masking tape on the reverse side, so that it won't slip or slide.

- Relax.

Bibliography

Anderson, Donald M. *The Art of Written Forms.* New York: Holt, Rinehart and Winston, 1969.

Ayres, John. *The Accomplish'd Clerk or Accurate Pen-Man.* London, 1683.

———. *A Tutor to Penmanship.* London, 1698.

———. *The A la Mode Secretarie.* London, 1680.

Beauchesne, Jean de, and John Baildon. *A Booke Containing Divers Sortes of hands.* London: Thos. Vantrouillier, 1581.

Bickham, George. *The Universal Penman.* Reprint. New York: Dover Publications, 1954.

Clark, John. *Writing Improved or Penmanship Made Easy.* London, 1714.

Cocker, Edward. *England's Pen-man or Cocker's New Copy-Book Containing all the Hands Used in Great Britain.* London: H. Overton and J. Hoole, 1668.

———. *The Pen's Transcendencie.* London, 1657.

Day, Lewis F. *Penmanship of the XVI, XVII and XVIII Centuries.* New York: Taplinger Publishing Company, 1979.

Fairbank, Alfred. *A Book of Scripts.* London: Faber and Faber, 1977.

Gillon, Edmund V., Jr. *Pictorial Calligraphy and Ornamentation.* New York: Dover Publications, Inc., 1972.

Heal, Ambrose. *The English Writing-Masters and Their Copy-Books 1570–1800.* Cambridge: Cambridge University Press, 1931.

Hector, L. C. *The Handwriting of English Documents.* London: Edward Arnold, 1966.

Jackson, Donald. *The Story of Writing.* New York: Taplinger Publishing Company, 1981.

Massey, William. *The Origin and Progress of Letters.* London: J. Johnson, 1763.

Nesbitt, Alexander. *The History and Technique of Lettering.* New York: Dover Publications, 1957.

Schwandner, Johann Georg. *Calligraphy.* New York: Dover Publications, 1958.

Seddon, John. *The Pen-Man's Paradise, both Pleasant & Profitable.* London, 1695.

Shelley, George. *Natural Writing in all the hands with variety of ornament.* London, 1709.

Snell, Charles. *Art of Writing, in its Theory & Practice.* London: Henry Overton at the White Horse, 1712.

Whalley, Joyce Irene. *English Handwriting 1540–1853.* London: Her Majesty's Stationery Office, 1969.

Index